Robert

Lehman

Lectures

on Contemporary Art

Dia Art Foundation, New York

No. 5

Robert

Lehman

Lectures

on Contemporary Art

EDITED BY LYNNE COOKE AND STEPHEN HOBAN

Funding for the Robert Lehman Lectures on Contemporary Art series was provided by the Robert Lehman Foundation, Inc.

Printed in the United States by Puritan Capital, Hollis, New Hampshire

First printing 2014
ISBN 978-0-944521-80-9

"Gerhard Richter's *Eight Gray*: Between *Vorschein* and *Glanz*" by Benjamin H. D. Buchloh was previously published in *Gerhard Richter: Eight Gray* (New York: Solomon R. Guggenheim Museum, 2002).

Dia Art Foundation
535 West 22nd Street
New York, New York 10011
www.diaart.org
www.diabooks.org

Distributed by D.A.P. Distributed Art Publishers, Inc.
ARTBOOK | D.A.P.
155 6th Avenue, 2nd Floor
New York, NY 10013
T: (212) 627-1999
F: (212) 627-9484
artbook.com

Edited by Lynne Cooke and Stephen Hoban
Editorial assistance by Maria Marchenkova
Research assistance by Claire Dilworth
Designed by Laura Fields
Cover image by Bill Jacobson Studio, New York

Contents

Preface

From 1992 to 2003, the Robert Lehman Lectures on Contemporary Art gathered a sustained critical discourse around Dia's exhibition program at 548 West 22nd Street in New York City. The series was founded with a generous grant from the Robert Lehman Foundation, Inc., and showcased a distinguished array of scholars, critics, art and cultural historians, and artists.

Beginning in 1996, Dia has collected these lectures into a related series of publications. This fifth and final volume represents the culmination of a long effort, and it could not have come at a more appropriate time. Over the past few years Dia has reinstituted its program of lectures, symposiums, and talks in New York City, most prominently its Artists on Artists Lecture Series, Readings in Contemporary Poetry, and Discussions in Contemporary Culture. The Robert Lehman Lectures series is a testimony to Dia's ongoing commitment to inquiry and discussion.

We would like to thank the authors for their generosity and patience in preparing these inspired talks for publication. We must also express our gratitude to the artists and their galleries. The dedication of Dia's staff through the years made this series a success and saw it through completion. Former curator Lynne Cooke conceived and organized the series, with the coordination and assistance of Armelle Pradalier, Patrick Heilman, and Sarah Thompson. This book was first developed by Karen Kelly, and realized by Stephen Hoban and Maria Marchenkova with the assistance of Claire Dilworth; Laura Fields's expert design gave thoughtful and elegant form to this material.

Charles Wright, Interim Director

Introduction

LYNNE COOKE

The five volumes in the Robert Lehman Lectures on Contemporary Art series span Dia's exhibition program at its former facility at 548 West 22nd Street in Manhattan from the beginning of the 1990s until its closure in 2004. This singular program—one artist, one floor, one year—was presented in a converted warehouse building, the kind of space deemed best suited to the long-term presentation of artwork by Joseph Beuys, Dan Flavin, Donald Judd, and others collected by the institution's founders in the late 1970s and early 1980s. Featured in this setting were artists who belonged to one of two generations: those who came to maturity in the 1960s and 1970s, and who were, therefore, of the generation of artists in Dia's collection; and a younger generation who had entered the public arena in the 1980s and 1990s. Like their predecessors these artists too gravitated toward environmentally scaled or site-sensitive work when taking up the invitation to conceive work for Dia's "raw" industrial spaces.

Pierre Huyghe's *Streamside Day Follies*, the last exhibition to open at Dia:Chelsea, is the focus of two essays in this book. Among other exhibitions installed there was the 2003–04 retrospective of Robert Whitman's work, assembled largely with works from Dia's collection, which is also the subject of two texts in this volume. In 2002, Gerhard Richter (who in 1995–96 had presented *Atlas*, a monumental photographically based work begun in the early 1960s) was commissioned to create a site-related work for the central gallery in Dia's new museum in upstate New York. Benjamin H. D. Buchloh's contribution to this anthology examines the genesis of Richter's monochrome paintings on glass, among which *Six Gray Mirrors* in Dia:Beacon has a pivotal place.

But no artist in this volume more directly engages the question of site when generating her work than Vera Lutter. German-born,

Lutter first gained critical attention in New York in the mid-1990s with an exhibition of large scale black-and-white photographs that surveyed the waterfront of lower Manhattan from the four cardinal directions. The images were made with a camera obscura she had constructed in an office on one of the upper floors of a downtown skyscraper. In 2000, Dia commissioned Lutter to photograph the interiors of an abandoned box-printing factory, located on the edge of the Hudson River at Beacon, that it was about to renovate into a museum to house its collection. A duration of several days was required in order to capture the ambiance of the luminous ground-floor spaces, whose extensive skylights had been designed to facilitate printing in daylight, the most economic of conditions. By contrast, extended periods of time, lasting up to two months, were needed to create the photographs made in the gloomy basements. Industrial relics have long fascinated Lutter. In his essay Brian Dillon charts Lutter's tribute to this fragile architectural heritage in works that range from the iconic Pepsi sign that once graced the rooftop of a warehouse on New York's East River to the forlorn cavernous interiors of London's Battersea Power Station prior to its conversion into luxury residences. The expanded time frame these works require separates them from the vast bulk of photography, which freezes a fleeting moment. As if testimony to their drawn-out processes and etiolated time frames, the haunting melancholy that permeates this body of Lutter's works evokes a rapidly vanishing era.

Six Gray Mirrors (2003), Richter's response to the Dia:Beacon site, is an offspring of *Eight Gray*, a body of work Richter initiated at the Deutsche Guggenheim in Berlin in 2002. Both series have their origins, as Buchloh demonstrates, in a work Richter conceived in 1965, composed of four movable panels of translucent glass, which first bracketed the painterly episteme of the window with the paradigm of the monochrome. Setting aside, albeit briefly, his abiding involvement with the ways photography had usurped and transformed painting's canonical representational modes, Richter embarked on an austere form of abstraction very different from what his American peers were then debating. In New York, Jo Baer, Robert Mangold, Robert Ryman, and other painters associated with

a Minimalist aesthetic found themselves under siege from colleagues such as Judd and Robert Morris, who argued that painting was outmoded, obsolete. When pushed to defend their chosen art form in political as well as aesthetic terms, no one proved more articulate in that cause than Baer, as Mark Godfrey demonstrates in his finely grained study of her work and words, "Programmatics, Poetics, Painting: On Jo Baer." As he traces the formal evolution of the works that comprised Dia's show, Godfrey contextualizes her thinking in relation to that of a broad range of contemporaries, including Robert Smithson and Mel Bochner. Radically singular in its pictorial solutions, this phase of Baer's work culminated in what became known as the Radiator paintings, boxy works with wide stretchers. Irregular forms, limned in a subdued palette, elide one surface with another, adjacent and perpendicular to it. Struggling to decode these elusive shapes, viewers might be tempted to identify them as figurations, and hence anticipations of the representational idioms that would become the core of Baer's practice following her relocation to Europe in 1975. Henceforth, for Baer, the issues central to painting would reside in pictorial languages, styles, and motifs that could be found in that art form's earliest incarnations, not least Paleolithic cave paintings and ancient Greek vases. By contrast, Richter, who was dismissive of the demand to choose between figuration and abstraction that beset his American peers, undertook a rigorous exploration of the role and place of painting in contemporary culture. This has led him over a career now spanning some five decades into what Buchloh describes, in his challenging overview of Richter's practice, as a "critique of ocularcentrism"— that is, of "vision . . . as the compulsion, the site, and the sense of a fraudulently obtained gratification, if not even as the practice of deceit." The "extreme ambivalence with regard to the desirability . . . of an ever-expanding regime of exhibition value and its associated spaces and objects" that Buchloh perceives embodied in these exigent monochromatic works, has produced, in the indelible phrase he borrows from Theodor Adorno for the epigraph to his text, "a kind of crying without tears."

There was no question that painting as an art form was
moribund in the eyes of Whitman and other artists caught up
with new media technologies in the early 1960s. *Playback*, Dia's
retrospective of Whitman's work, included restagings of his
groundbreaking historic performances, a new performance piece,
early sculptures incorporating projected imagery, and a suite
of works on paper, titled the *Dante Drawings*, never previously
shown. In the Lehman lecture he gave in response to works he
had previously known only by reputation, art historian Tom
McDonough focused on *American Moon* (1960), with its quirky
proto-cinematic mise-en-scène. McDonough situates Whitman's
landmark early performance piece in its artistic and social landscape,
by first charting its roots in the Happenings of Allan Kaprow,
Whitman's teacher, and the coterie of artists, including Claes
Oldenburg and Jim Dine, affiliated with the Reuben Gallery in
downtown Manhattan, where Whitman's own early work debuted.
Referencing children's nursery rhymes and unstructured forms of
play as some among its broad nexus of sources, McDonough relates
American Moon to Whitman's notion of an "abstract theater" in
which audiences are galvanized into self-conscious engagement
with myriad mundane, even familiar, kinds of activity as things
become performers and performers become things. Hermetic,
even cryptic, these innovative works have aptly been described as
"a kind of dream with meanings around its corners." McDonough
worries that *American Moon* never quite escapes co-optation by the
logic of commodity culture, by "the force of reification and the
all-consuming logic of the market." Branden W. Joseph articulates
a similar concern in relation to Whitman's later work, in particular
the multimedia performance *Prune Flat* (1965), often considered
the artist's signature statement. For Joseph, Whitman's expanded
cinema is premised on a heightening of spectralization, effected
by recourse to an arsenal of haunting image-objects. "Mourning is
a form of introjection which is never complete . . . the alterity of
the death of the other," he contends, "refuses absorption within the
self." It was only by refusing "to let go of the memory of the dead
that hovers about his every image," that Whitman, in his view,

GERHARD RICHTER

Gerhard Richter and Jorge Pardo: Refraction

September 5, 2002–June 15, 2003

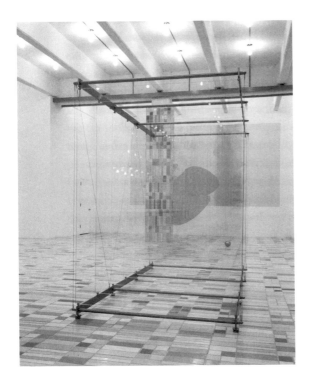

Installation view, *Sieben Stehende Scheiben* (*Seven Standing Panes*), 2002

GERHARD RICHTER
Six Gray Mirrors, 2003
Long-term view, Dia:Beacon

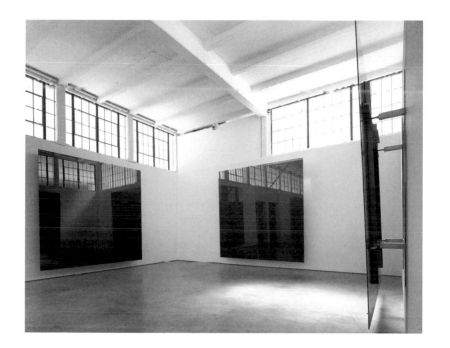

ROSEMARIE TROCKEL

Spleen
October 16, 2002–January 11, 2004

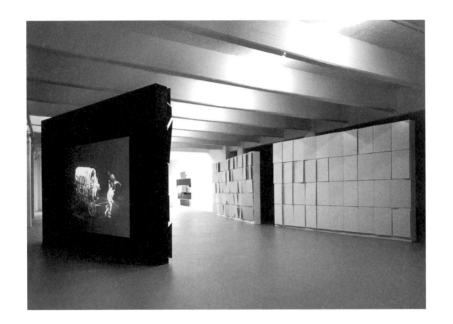

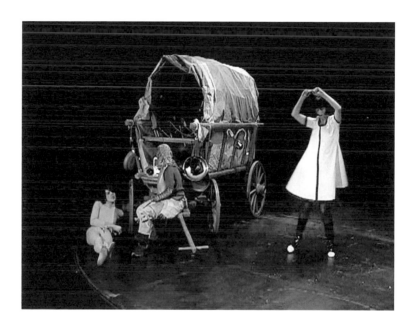

Manu's Spleen 4, 2002, video still

JO BAER
The Minimalist Years, 1960–1975
September 12, 2002–June 15, 2003

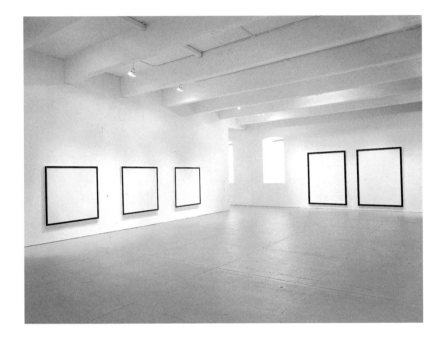

Untitled (Black Star), 1960–61

ROBERT WHITMAN
Playback
March 5, 2003–January 11, 2004

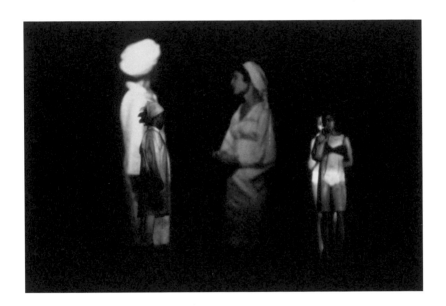

Prune Flat, 1965, performed at Dia in 2003

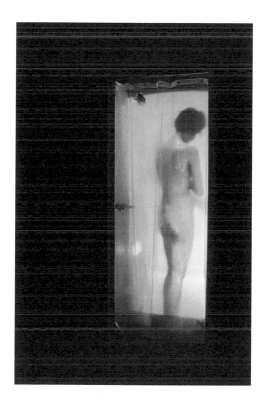

Shower, c. 1964

PIERRE HUYGHE
Streamside Day Follies
October 31, 2003—January 11, 2004

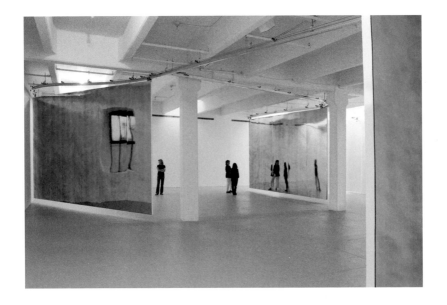

Streamside Day Follies, 2003, video still

VERA LUTTER
Nabisco Factory, Beacon
May 15, 2005–September 4, 2006

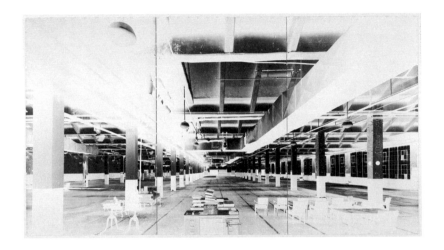

Nabisco Factory, Beacon, I: July 19–22, 1999, 1999

VERA LUTTER
Rodney Graham and Vera Lutter: Time Traced
November 17, 1999–June 18, 2000

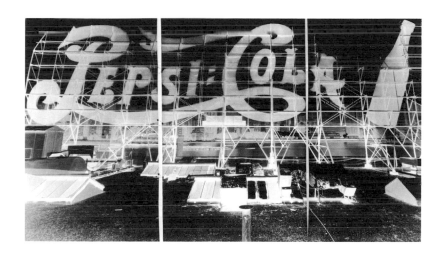

Pepsi Cola, Long Island City, X: July 7, 1998, 1998

Gerhard Richter's *Eight Gray*: Between *Vorschein* and *Glanz*

BENJAMIN H. D. BUCHLOH

For Rosalind Krauss

What, you have no colored glass, no pink, no red, no blue? No magic panes, no panes of Paradise? Scoundrel, what do you mean by going into poor neighborhoods without a single [piece of] glass to make life beautiful?
—Charles Baudelaire, "The Bad Glazier," *Paris Spleen*, 1869

One cannot say in general whether somebody who excises all expression is a mouthpiece of reification. He may also be a spokesman for a genuine, non-linguistic, expressionless expression, a kind of crying without tears.
—Theodor W. Adorno, *Aesthetic Theory*, 1969

Paul Strand's *Wall Street, New York* (1915), with its five black monochrome rectangles deeply embedded in the photographic gray scale, represents a series of elongated vertical windows, awe-inspiring rectangular zones of architectural shadow. These seem to organize

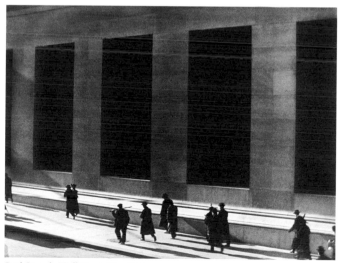

Paul Strand, *Wall Street, New York*, 1915

29

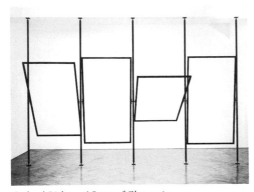

Gerhard Richter, *4 Panes of Glass*, 1967

our spatial perception with a previously unseen authority, announcing an emerging order with menacing certainty. One reason why this image has become a canonical photograph is that it articulates some of the most fundamental oppositions confronting artistic production in the twentieth century with almost prophetic emphasis.

That these oppositions would continue to haunt the century's cultural constructions until its bitter end—and would extend even into the beginning of the next—is manifest in Gerhard Richter's elegiac *Acht Grau* (*Eight Gray,* 2002), a work that acts simultaneously within the registers of painting and photography, sculpture and architecture. Within Richter's larger painterly oeuvre, *Eight Gray* is the culmination of a pursuit that began in 1965 with *4 Glasscheiben* (*4 Panes of Glass*),[1] the artist's first work to programmatically bracket the age-old painterly episteme of the window with the paradigm of the monochrome.

What distinguishes Richter's *4 Panes of Glass*, his subsequent works on glass and mirrors, and *Eight Gray* from other monochrome paintings and Minimalist sculptures produced by his American contemporaries around 1967 is first of all the fact that Richter's works have always attempted to integrate *all of the aspects* that most other artists of the Minimalist generation had been approaching as isolated inquiries. Generally, if a painting from that time dealt with the monochrome (e.g., those of Ellsworth Kelly or Barnett Newman), it was not inclined to address the conditions of opacity and its opposites, transparency and reflection, all of which are inherently present in the monochrome and its tendency to become an architectural divider or merely a perceptual membrane. By contrast, if an artist had actually dealt with painting's evolution

toward such a membrane (e.g., Eva Hesse), toward translucency and transparency (e.g., Larry Bell and Donald Judd) and mirror reflection (e.g., Larry Bell and Robert Morris), the newfound material radicality of the resulting works seemed to dismiss once and for all any connection to the traditionally fabricated formats and surfaces of painting. And finally, if a work eventually engaged with the architectural dimensions of glass and mirror panels (e.g., Dan Graham and Robert Smithson), it would foreground its relationship to modernist architecture alone, repressing any reflection on the pictorial episteme of the window and the paradigm of chromatic reduction that had determined Minimalist practices.

Since the inception of *4 Panes of Glass* all of Richter's monochrome works with mirror and glass—identified by the artist as "colored mirrors"—have engaged the spectator in the dialectic of reflection and transparency and translucency and opacity, suggesting the radical proposal that these are the logical conclusions within the paradigm of the monochrome. These works have also questioned the fate of painting were it to become a merely reflective or transparent spatial divider, dissolving the traditionally private space of pictorial contemplation and opening up visual experience to a wide range of perceptual, phenomenological, tactile, and social interactions. One of Richter's most troubling proposals concerning his earlier monochromes addresses painting's darkest possible future. In a series of drawings from 1975, the artist envisages the construction of a military barracks/administrative building as a museum for a thousand monochrome paintings, a space to house this serially produced, cultural industrial complex.

Thus Richter already offers at that time, if only in a "visionary" drawing, a historical spectrum in which to situate his predilection for gray and a glimpse of his understanding of the historical origins and the social destination of serialized cultural production. Yet it is not until *Eight Gray* that any of his glass or mirror works actually shift in size and scale from painterly surface to architectural plane, investing monochrome painting with an architectural dimension. Thus *Eight Gray* opens up a series of striking oppositions (some of which we first encountered in the reading of Strand's photograph).

The first opposition is that between the public dimension of the glass panels and the paradoxical privacy of contemplative experience that this painterly structure solicits (reversing, as it seems, the classical predictions of Benjaminian aesthetics). Viewing *Eight Gray*, we recognize that the work confronts first of all the extreme difficulties of creating conditions for simultaneous collective perception with painterly, sculptural, or architectural means in the present.

The second of these oppositions results from the improbable synthesis of seriality and monumentality. Traditionally it had been assumed that any conception of the monumental would only celebrate unique achievement (e.g., the master subject) or abstract unifying concepts (e.g., the nation-state) and that monumentality would be anchored most successfully within a rigorously structured hierarchical display. By contrast, it had been taken for granted that *seriality* (in all its forms of production and reproduction) had only come about to cheapen the world. In an incessant process of industrialization and secularization, the order of production and the representation of the commodity had the last word in annihilating the sublime, the unique, and the transcendental in favor of a mere mass ornament to democratize experience at the price of a total loss of the auratic and the hieratic.

A third opposition we face in *Eight Gray* is one inherent to the monochrome as a painterly paradigm. After all, it had once been perceived as a radical intervention, either mystical in its purity or critical in its self-reflexivity, but in Richter's *Eight Gray* the monochrome seems to have become an affectless record of loss. In this regard, what Jeff Wall once wrote in his essay about Conceptual art could apply just as well to Richter's gray monochrome projects from the late 1960s onward:

> The gray volumes of conceptualism are filled with somber ciphers which express primarily the inexpressibility of socially critical thought in the form of art. They embody a terrible contradiction. These artists attempted to break out of the prison house of the art

business, its bureaucracy and architecture, and to turn toward social life. But in that process they reassumed the very emptiness they wished to put behind them.[2]

The fourth opposition in Richter's *Eight Gray* is the improbable synthesis of void and transcendence. When does the process of voiding and erasure in painting give access to a higher transcendental experience? And when does it lead to mere boredom or even atrophy of the senses? Or, by contrast, when does entropic experience turn into a radical aesthetic and when does it simply reiterate the internalized melancholia of a closed system of cultural administration?

It seems that these oppositions could be resolved with a relative degree of certainty when looking at Strand's photograph: those windows and spaces are clearly not opening up towards liberation and transcendence, religious or otherwise. Yet in *Eight Gray*—in spite of the absence of affect—the glass panes might still retain a residual dimension of those aspirations. In Strand's image, the walls are clearly not those of a space of ritual whose massive openings promise access to transcendentality mediated by colored glass and an infinity of fractured light, but in *Eight Gray* a glance is cast backwards, it seems, to that tradition.

Strand was perhaps the first artist in the twentieth century to have photographed an architecture where classical form organizes industrial confinement. In looking at the massiveness of the architectural voids he recorded, we would expect a corresponding presence of urban masses. Instead, the photograph shows only a handful of nervously scurrying subjects, all running in one direction as though they already recognized that amid the regulated definition of these monumental spaces the days of their subjecthood were numbered. By contrast, it appears impossible to answer any of these questions when viewing Richter's *Eight Gray*. In order to respond adequately, we will have to unravel the work's immense range of implications and the oppositions concealed by its treacherous simplicity, first by situating these glass panels in a variety of specific historical contexts.

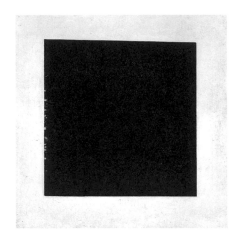

Kazimir Malevich, *Black Square*, c. 1923

The Monochrome

In the same year that Strand's photograph recorded the serial repetition of architectural voids, Kazimir Malevich exhibited arguably the first monochrome painting, *Black Square*, in the famous *0.10* exhibition in Petrograd. This painting undoubtedly established more than any other work the preconditions for a Modernist pictorial dialectic of purification and elimination. But of course, the historically overdetermined desire to erase all linguistic and aesthetic conventions in favor of a new beginning, be it the white of carte blanche or the black of tabula rasa, would be fraught with ideological origins and consequences.

Malevich still felt compelled to demarcate the difference between the zones of pictorial and spatial experience by situating his *Black Square* within a white field that functioned simultaneously as the figure's ground and its frame. Alexandr Rodchenko, in his radical answer to Malevich, was more decisive: his triptych *Red Yellow Blue* (1921) opened up the boundaries of the monochrome to the seemingly uncontrollable influx of actual space; they transformed the painterly plane into a purely chromatic spatial relief.

Malevich and Rodchenko both deployed those strategies to extract painting once and for all from the episteme of the window and from the seemingly eternal pictorial obedience of the construction of perspectival space. Either deciding, as Malevich did, to "simply" geometricize the figure-ground relationship and to transform the painting into a perceptual tautology (the inscription of a square figure within a square ground that serves simultaneously as frame), or opting, as Rodchenko did, to "simply" abolish that

opposition altogether, shifting it from an epistemological distinction between *window/frame* and *figure/ground* into an opposition between the *relief/object* and *architectural/social* space.

Both Malevich's and Rodchenko's monochrome panels remain the predecessors of all subsequent monochrome painting and their programmatic or vicarious attempts to clarify the treacherous suspensions of painting brought about by the new paradigm: to hover between painting and object, pictorial surface and material relief, between framed painterly perception and unbound architectural vision, between virtual space and actual space. The new architectural scale of Richter's monumental *Eight Gray* makes these contradictions all the more apparent. All monochrome painting had claimed to achieve an erasure of the past in preparation for future purity; once all representational conventions had been abolished, anything appeared to be possible. Almost thirty years later, describing the continuation of the same phenomenon with more precision than anyone else at that time or afterwards, though failing to understand the causes or envision solutions, Clement Greenburg reignited this same type of reflection:

> There is a persistent urge, as persistent as it is largely unconscious, to go beyond the cabinet (or easel) picture . . . to a kind of picture that without actually becoming identified with the wall like a mural, would spread over it and acknowledge its physical reality. I do not know whether there is anything in modern architecture itself that explicitly invites this tendency. . . . Abstract painting being flat needs a greater extension of surface on which to develop its ideas than does the old three dimensional easel painting, and it seems to become trivial when confined within anything measuring less than two feet by two. Thus, while the painter's relation to his art has become more private than ever because of a shrinking appreciation on the public's part, the architectural and, presumably, social location for which he destines his product has become, in inverse ratio, more public. . . . Perhaps the contradiction between the architectural destination of abstract art and the very private atmosphere in which it is produced will kill ambitious painting in the end. As it is, this contradiction

whose ultimate cause lies outside the autonomy of art, defines specifically the crisis in which painting now finds itself.[3]

This is a dialectic that would be played out *in extremis* throughout the 1950s and 1960s in monochrome works as irreconcilable in their ambitions as those of Ad Reinhardt and Yves Klein, or Kelly and Newman, legacies with which Richter's first gray monochrome paintings of the mid-1960s were explicitly engaged.[4] In response to these various receptions of the monochrome, Richter's projects with glass and mirror, in their prohibition on drawing, on figuration, on contrast, on tonality, on perspective, on modeling, on iconography, on metaphoricity and ultimately—in the painter's insistent commitment to the noncolor gray from the mid-1960s onward—on chroma itself, were based on a radical project: to void the conventions of pictorial representation and of all privileged forms of experience. Yet, as the artist himself wrote, commenting on a major series of large-scale gray monochrome paintings from 1975 that could be considered one precursor to the current *Eight Gray* paintings, the voiding was inevitably also a beginning. Richter has written, "In the *Gray* pictures it's lack of differentiation, nothing, nil, the beginning and the end, in the panes of glass it's the analogy with attitudes and possibilities, in the color charts it's chance, anything is correct, or rather, form is nonsense."[5]

Thus Richter's monochromes and glass and mirror works are not only erasures, probing the purity of negation and the sobriety of withdrawal. Richter's *Eight Gray* also asks what kind of spectatorial subject would be inscribed within this architecture of effacement and elimination. Could *Eight Gray* generate the same type of spatiality that determined the monochrome voids of the architecture in Strand's photograph, a tectonics of oppression, melancholia, and silence? Or would it generate the opposite, a space of mirror inscriptions where the new subject would suture itself in the architectural dimension of reflective glass, but a painterly construction that would at the same time preserve the memory of its Modernist self-reflexivity and empirical skepticism?

Chroma and Chrome

It is particularly productive to study the various instances where the carefully drawn territorial demarcations of monochrome color break down, either by deliberate artistic acts of destabilization, or by a failure to fully control the entwining of registers in which the monochrome operates: between a hieratic and diaphanous transcendental space on the one hand and a neo-positivist field of empirical verification on the other. Or it shifts continuously between a spectacular *blague* and industrial design's streamlining of color to its opposite extreme, the melancholic despair about the evaporation of the painterly plenitude.

In Richter's glass paintings,[6] color is now sealed beneath the reflective surface while drawing occurs only in the space of reflections and shadows of the spectators. With the spectator's departure, all visual incident disappears as well, leaving behind an unmarked, monochromatic field. One of the problems that this fusion of chroma and support had already brought out in the context of Minimalism was the fact that baked enamel and colored Plexiglas (the materials favored by Judd, for example) all carried connotations of industrial *design culture*. This register offered itself in lieu of a revolutionary architectural project of collective simultaneous perception still accessible to the artists of the Russian avant-garde. Monochrome painting's unconscious lodging in industrial design culture seemed to anchor what Greenberg had rightly called the historical condition of "homeless abstraction." This condition applied just as much, if not more, to the German artists of that generation, in particular to the monochrome work of Richter and Blinky Palermo, Richter's closest friend throughout the 1960s and into the 1970s. Yet both Richter's and Palermo's works within the monochrome around 1965 shift from the sphere of industrial design to the social spaces of consumption and domesticity and to a sphere of administrative self-reflexivity.[7]

Paradoxically, Richter's first experiments with a monochrome mirrored surface were executed on the occasion of a rather precarious juxtaposition of his work with that of Neo-Expressionist painter Georg Baselitz in 1981.[8] These mirror paintings foregrounded the

immediate functionality of a neutral reflective device much more explicitly than the subsequent "colored mirrors" of which *Eight Gray* undoubtedly constitutes a culminating moment. Deploying the cold and skeptical tool of the mirror that Richter himself often inserts into the inspection of his own paintings during the final stages of their execution in order to verify their spatial, gestural, and compositional cohesion, his mirror paintings reflected the spectacular display of Baselitz's painterly traces. Ironically, these appeared reversed in the mirror's image, thus—perhaps inadvertently—enacting a subtle travesty of Baselitz's own desperate maneuver to save his obsolete project by an apparently scandalous spatial rotation of the reading order of his paintings by 180 degrees. The function of pure mirror reflection—while integral to all of Richter's subsequent deployments of mirrored or highly reflective colored-glass surfaces—consisted, on this occasion, in reflecting the conditions of painterly facture in the present. Thus, against Baselitz's rather ostentatious assertion that painting could still claim facture as gesture, as psychic inscription, as unconscious record, as bravura performance, and finally, as proof of a historical continuity with Expressionism as the untroubled painterly idiom of the German nation-state, Richter positioned the spectator in the space of a sudden withdrawal of any authorial inscription. The promises of painterly facture revealed themselves in these reflective monochrome voids as so many falsities, as empty claims for a presence of the author, an achievement of the virtuoso, a mastery of the painterly craft, conditions that all lacked credibility in the historical context and the experience of their spectators.

Clearly then, the mirror and the highly reflective monochromatic glass pane intensify the purging of all indexical mark-making processes and situate the production of inscription entirely within the range of the reader/spectator. Now it is in fact the spectators' movement alone, the reflection of their random acts performed in front of these mirrors or in the ambient spaces that surround them, that is *temporarily* and *temporally*—as in a photograph or in a cinematic image—recorded as "marks" within the mirrors' immaculate surfaces.

Richter's mirror paintings suggest that the monochrome surface, in its total eradication of the indexical inscription of any mark-making process, inevitably *has* to become a mirror, or a spatial and architectural membrane in which spectatorial movement inscribes itself as the sole source of perceptual activity. Thus it establishes a dialectic between aesthetic device and spectatorial participation that can adequately reflect the necessary conditions of radical equality and equivalence between aesthetic experience of the spectator and aesthetic conception of the artist.

The Window

In exact correspondence to the monochrome's attempt at purifying painting's planarity, another Modernist episteme emerged in 1912: the compositional structure of the grid. The spatial vectors of horizontality and verticality that had traditionally served to map the scheme of illusionistic perspectival depth now became themselves the principle markers of the painterly surface.

The most important early example of this Modernist episteme is the series of *Windows*, begun by the French Orphist painter Robert Delaunay in 1912, when he attempted to integrate the legacies of Paul Cézanne and Georges Seurat and to transcend what he believed to be the limitations of Cubism. Delaunay's project, conservative when compared to the development of Cubist reliefs (also around 1912), attempted to sublate the episteme of the window into the new pictorial maps. Rosalind Krauss was the first to delineate the full range of aesthetic and theoretical oppositions that were articulated in the pictorial matrix of the window from Romanticism to Symbolism in her landmark essay "Grids":

> The Symbolist interest in windows clearly reaches back into the early nineteenth century and romanticism. But in the hands of the Symbolist painters and poets this image is turned in an explicitly Modernist direction. For the window is experienced as simultaneously transparent and opaque. As a transparent vehicle the window is that which admits light—or spirit—into the initial darkness of the room. But if glass admits, it also reflects. And so the window

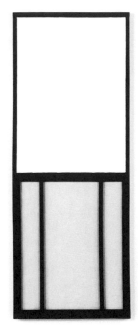

Ellsworth Kelly, *Window, Museum of Modern Art, Paris*, 1949

is experienced by the Symbolists as a mirror as well—something that freezes and locks the self into the space of its own reduplicated being. Flowing and freezing: *glace* in French means glass, mirror, and ice; transparency, opacity, and water.[9]

Delaunay recognized, as had Seurat before him, that it would become increasingly problematic to contain vision—once it had been considered in scientific terms—and its painterly representations within the spatial parameters of the picture frame. His decision to conceive of a painting as an actual window within its frame signaled the inevitable dialectic of a simultaneous containment and expansion of the virtual pictorial field into actual spectatorial space. Thus Delaunay's incorporation of the frame within the pictorial field answers a question that the monochrome would face shortly thereafter with greater urgency: how could one justify painterly containment in the frame given the evident necessity of painting's unlimited expansion into actual space?

This duplicity (or historical ambiguity) that hesitates to abolish the memory of the painterly episteme within the very act of its radical deconstruction (an episteme that had, after all, determined European painting's functions for centuries) would become the starting point for a series of key Modernist works that have engaged painting's containment within that episteme, from Delaunay's *Windows* to Marcel Duchamp's *Fresh Widow* (1920), from Josef Albers's glass assemblages such as his *Park* (c. 1924), made from industrial glass, to Kelly's *Window, Museum of Modern Art, Paris* (1949), to Palermo's wall painting *Window 1* for the Kabinett für Aktuelle Kunst in Bremerhaven in 1970–71. It is within this lineage, as much as within the history of monochrome painting, that Richter's *Eight Gray* and his earlier works on glass must be situated.

Glass

Inevitably, the episteme of the window not only opens up a whole range of historical references that are particularly charged in the context of German Romanticism, it also shifts our attention to Richter's use of actual glass in the production of *Eight Gray* (and in his work since 1967). After all, glass is defined by perceptual, technical, historical, and ideological investments that range across an extremely contradictory spectrum.

The Modern mythemes of glass originate in the nineteenth century, ranging from the cult of glass and crystal as a mystical substance in German Romanticism (as in the work of the mine inspector Friedrich von Hardenberg, known as Novalis), to its industrial celebration in Joseph Paxton's Crystal Palace of 1851, an example of secular architecture that opened up new spaces for the commodity, its circulation, display, and consumption. In the twentieth century, the material would be recoded once again in diametrically opposed terms. For German Expressionism, glass would become the transmitter of a radiant new world in the poetry and the writings of Paul Scheerbart (e.g., his essay "Glass Architecture" of 1914), and it would become the matter of utopian visions in the architectural designs of Bruno Taut and the young Walter Gropius. In 1919, art historian and critic Adolf Behne imagined that glass architecture promised to purify and transform the European bourgeois subject:

> Glass architecture. . . . No material overcomes matter as much as glass. Glass is a completely new, pure material, into which matter is melted and transformed. Of all the substances at our disposal, it achieves the most elemental effect. It reflects the sky and the sun; it is like luminous water, and it possesses a wealth of possibilities in the way of color, shape, and character that is truly inexhaustible and can leave no one indifferent. . . . Its most profound effect, however, will be that it breaks the European of his rigidity along with his hardness. . . . Glass will transform him.[10]

Glass, generating light and sudden transparency, promised to liberate the subject from the impenetrable orders of domination, the unfathomable structures of mythical and religious thought. But the cultic veneration of the material also provided a new mythic imagery to propagate the emancipatory powers of industrial rationality. Transferred from the natural to the social realm, the crystal and glass now served as an analogue in which geological forms of growth were correlated to the sphere of a future transparent social collective.[11]

Thus, *vision* in the definition of the avant-garde artists and architects of the first two decades in Germany was inextricably intertwined with *utopian* vision, with what Ernst Bloch called *Vorschein* (best translated as "promising appearance," or "prophetic semblance"). Paradoxically, in spite of their secular aspirations, visions of utopian architecture such as Taut's *Die Stadtkrone* (*Crown of the City*, 1919), as well as Gropius's early conceptions of the Bauhaus, all circulate around the idea and image of a secular *cathedral*, one of the traditional sites of Western European collectivity bound by myth and religion. It seems then that the new cult of glass and transparency had to enact its secularization first at the very site of the cathedral—in the very material of stained glass—where religious transcendence had been traditionally transmitted. Christoph Asendorf quotes the German architect A. G. Meyer as making this link explicit as early as 1907:

> A. G. Meyer, in his study, *Eisenbauten*, discovers a further analogy in the history of design. The glass wall, which, as membrane and solid body in one, allows interior and exterior space to blend into one another, has a prototype in the Gothic church window. Believers and their God are connected by light. According to the symbolism of the church building, "the glass windows correspond to the precious gems in the walls of the heavenly Jerusalem."[12]

It is not surprising that even an artist as central to painterly purification as Albers, one of the Bauhaus masters devoted to a new scientific register of perceptual experience, remained entangled

in those legacies at least until the mid-1920s, and executed a series of stained glass assemblages and "stained" glass windows. In secularizing this pictorial-architectural idiom once foundational to religious cult however, Albers systematically dismantled its hierarchical color schemes by opposing the traditional primacy of blue in favor of a randomly ordered constellation of square particles, manifestly made out of industrially produced wire mesh security glass. Sixty years later, Richter engaged with the material of stained glass in one of his lesser-known works. Unknowingly—we presume—Richter echoed Albers's attempt to emancipate the material of glass and the format of the stained-glass window from its religious and cultic as much as from its Romantic and Symbolist legacies when he produced a window as a commission in 1989 for a private home in Berlin originally designed by Gropius. Richter's window reiterated and intensified Albers's emphatic coloristic de-hierarchicization in its programmatically aleatory combination of color squares arranged according to the very same chance procedures that Richter had already applied earlier in the color combinations of his various *1024 Colors* (1973).

Yet the conception of light as the embodiment of transcendental experience, and of glass as its transmitter, would inevitably undergo the same changes, slow and radical, as the conception of vision itself. Barely twenty years after Scheerbart's Expressionist-utopian pamphlet "Glass Architecture" was published, Walter Benjamin would discuss that very essay and the philosophical implications of glass in distinctly anti-Expressionist and anti-utopian terms in his "Experience and Poverty." Benjamin writes, "It is no coincidence that glass is such a hard, smooth material to which nothing can be fixed. A cold and sober material into the bargain. Objects made of glass have no 'aura.' Glass is in general the enemy of secrets. It is also the enemy of possession. . . . Do people like Scheerbart dream of glass buildings because they are the spokesmen of a new poverty?"[13]

If "transparency" remained at all integral to the promises invested in the new glass architecture of the 1920s and 1930s, the concept was now altogether different from the Expressionists'

definition. Their binaries of mystical versus secular luminosity, of transcendentality versus enlightenment, would now be displaced by a new set of ideals: sobriety, clarity, and functionality. These new promises responded to the general cultural calls to integrate inside and outside, private and public, to redefine matter as energy and to fuse spatial and temporal modes of perception.

Thus, already in the context of his architecture in the late 1920s, Ludwig Mies van der Rohe stated for example that he was primarily interested in glass because it generated an infinite play of light and reflection on its surfaces: "my experiments with a glass model showed me that the use of glass depended, not on the effect of lights and shadows, but on the rich play of reflection."[14] What followed the cult of *transparency* was a cult of *reflections*, of mirror effects that would reflect audience behavior and movement in the manner of a recording camera. Or, as we will argue, in the manner of a technologically evolving system of narcissistic containment, one which could provide technological loops, recording and replaying the activities of the perceiving subject back onto itself. And soon enough, the space of radiance and reflection would become a new space of total confinement, as Wall has analyzed:

> Mies's response to the historical catastrophe of the 1920–50 period is to renounce the implicit utopian critique of the city contained within Modernism and to relinquish the city to its Caesars: the speculators, bureaucrats and real-estate developers. His gesture of withdrawal is deliberate and his architecture, in its perfected empti-ness, expresses his submission to the modern forms of power which have apparently vanquished all opposition and rule over a chaotic estranged mass. His buildings reflect the atomization suffered by that mass at the hands of the institutions the building symbolizes. In their perfection of technique and proportion, these buildings relinquish the Modernist utopia in an act of silent, stoic purity, and come to exist, as has been said, "by means of their own death." . . . The combination of puristic resignation and spectacularized exper-tise of Miesian building becomes of course the prototype for the post-1945 corporate skyscraper style.[15]

It becomes apparent then that some of the difficulties posed by Richter's *Eight Gray* result from the fact that the large-scale gray glass panes can neither be fully mapped onto the historical formation of the monochrome nor can they be exclusively seen through the episteme of painting as a window. It is just as difficult to situate the work within the utopian architectural traditions that invested glass with those extraordinary historical aspirations sketched out above. We will therefore have to turn to subsequent and, eventually, to more recent developments in both architecture and sculpture in the second half of the twentieth century where glass and vision have been associated with a different set of perceptual and psychosexual functions.

Radiance, Reflection, and Polish

What we have left behind then is the historical era of Bloch's concept of *Vorschein* in which the glance and the shine—the reflection of light and its radiance—could still be perceived as the promise of fulfillment and gratification. What we have also vacated is Scheerbart and Benjamin's glass house, whose clarity and new sobriety corresponded to actual, existing poverty, yet also to an authentic experience. What we have entered instead is a phase of the deployment and investment of glass in which the regime of consumption has taken total control of the sphere of perceptual phenomena. This qualitative shift alone would explain why any attempt to situate Richter's works on glass within an unbroken continuity of the history of utopian avant-garde thought would be profoundly problematic. As problematic in fact, as it was for John Cage—admittedly one of Richter's central figures of aesthetic reference—to situate the cult of transparency and reflections in the work of Mies in an unbroken continuity. As for example in his famous lecture in 1957 where Cage explicitly refers to Mies as model: "This openness exists in the fields of modern sculpture and architecture. The glass houses of Mies van der Rohe reflect their environment, presenting to the eye images of clouds, trees, or grass, according to the situation."[16]

The most problematic aspect of this argument is its unconditional trust in an abstract—that is, *dehistoricized* concept of nature as a foundational correlative of aesthetic experience. What was actually at stake—Mies himself had been the first to understand in the immediate postwar period—was to recognize the irreversible destruction of both utopian and naturalist associations of the myths of glass, transparency, and reflection. After all, the postwar period begins the phase of experience of transparency and reflection when even the slightest radiance is skimmed off and instantly deployed to transform hope and desire into their smallest possible quantifiable units. We are moving therefore from Bloch's *Vorschein* into the realm of *Glanz auf der Nase* ("the shine on the nose"), Sigmund Freud's initial definition of the experience of the fetishizing gaze and its deflection from the encounter with the site of loss and absence and its displacement onto substitutional body parts, and eventually, the shifting over to the substitutional objects of consumption, whether products of mass or "high" culture.

The painterly, more frequently sculptural, concern with immaculate surfaces in the twentieth century ranges from the desire for sublime perfection in artisanal production to fetishistic subjection under the new precision of the industrial object. Constantin Brancusi seems to have been the first to articulate this dilemma: he achieved infinitesimal refinement in an endless application of artisanal skills, attempting to match, if not to supercede, the supreme finishes of industrial objects (for example, ball bearings). Brancusi's admirer Duchamp responded by having the readymade guarantee the work's appearance as "immaculate" production. It is certainly not accidental that one of the works by Richter, evolving in tandem with the monochrome glass panels, is a group of perfectly milled stainless-steel spheres whose status as readymade or as sculpture remains ambiguous.

The transition from an artisanal to an industrial mode clearly shifts the means of painting's manufacture, but this shift also forces it to confront unexpected (and at times, it seems, unwanted) registers of perception. While industrial painting might have initially aimed at annihilating the fetishization of the virtuoso

application of paint, it might have already entered the treacherous domain of industrial brand—and commodity design (call it Stella's and Judd's problem). Certainly, Richter's first glass panes from 1965, and works that emerged simultaneously, such as Bell's glass cubes and Morris's *Untitled (Mirrored Cubes)* (1965), would seem to come closest to the neutrality of the perceptual tool or an aesthetic device of experimental vision.

As Minimalism has involuntarily proven (and Richter's works on glass and mirror most certainly have *one* of their origins in the history of Minimalism), at this moment in time it is very difficult to invent aesthetic models that operate as merely perceptual or cognitive devices that could convincingly claim to analyze or alter the governing conditions of perception and conventions of language without simultaneously, if involuntarily, partaking in numerous other formations of "vision." Paradoxically, it was precisely their intended *lack of aesthetic qualities* that triggered Greenberg's notorious attack on Minimalist works in 1967:

> Minimal works are readable as art, as almost anything is today, including a door, a table, or a blank sheet of paper. (That almost any nonfigurative object can approach the condition of architecture or of an architectural member is, on the other hand, beside the point; so is the fact that some of the Minimal works are mounted on the wall in the attitude of bas-relief. Likeness of condition or attitude is not necessary in order to experience a seemingly arbitrary object as art.) Yet it would seem that a kind of art nearer the condition of non-art could not be envisaged or ideated at this moment.[17]

Even in these instances, the deployment of glass and mirror and the industrial quality of the finish, the steel and chromium frames and, in the case of Bell's and Morris's boxes, the peculiar fusion of the most classical planar and volumetric trope of Modernism—the square and the cube—could not protect any of these works from immediately acquiring references that opposed and surpassed the presumed purity of the perceptual model, ranging from the

shop window's display case to the design of gadgets for garnering narcissistic attraction.

Obviously, the industrial material and production of *Eight Gray* (and of the "colored mirrors" that precede it) partially originates in the desire to change painting from a surface of belabored inscription into one of polished perfection. The monochrome's passion for erasure, its pursuit of a fusion of pigment and process, its desire to totalize texture and surface, leads to the paradoxical project of a *pittura immaculata*—a stainless painting.

What Richter's stainless paintings reflect first of all then are these questions: When does erasure achieve perfection and when does it end up merely as polish? When would the perfection of erasure signal a sealed repression and when would the shiny surface merely entrap the gaze in a fetishistic exchange? Once the immaculate surfaces of Minimalism cross over into a spatial, or even an architectural structure, these contradictions necessarily intensify, since it is no longer the fetishistic object that captures spectators. Instead, the environment in its entirety entangles them within a phenomenological process of mirror reflection, inevitably expanding the subject's narcissistic object relations to those of a spatial confinement of suturing and surveillance.

Notable among the large-scale architectural and site-specific installations of Post-Minimalism are those by Dan Graham from 1974 onward, his *Public Space/Two Audiences* (1976) being among the most exemplary works to use glass and/or mirror. In these works, Graham was not aiming to continue the conditions of simultaneous collective perception conceived by the avant-garde artists of the 1920s and 1930s (from El Lissitzky to Mies and—with increasingly affirmative and opportunistic intentions—from László Moholy-Nagy to Frederick Kiesler). De facto, these artists found themselves compelled to articulate the conditions of a highly isolated, almost cellular perception. Atomized individual capacities to perceive an aesthetic object are, if at all, alerted only on the condition of a guaranteed experience of narcissistic mirroring: after all, the only conditions of simultaneous collective perception that are accessible are those in which the design of commodities

contains its consumers. As Wall succinctly phrased it: "[In] these performance works (i.e., Graham's), the 'environmental functional behavioral' models use window, mirror, and video control systems to construct dramas of spectatorship and surveillance in the abstracted containers of gallery architecture."[18]

Dan Graham, *Public Space/Two Audiences*, 1976

Exhibition Value

Thus, in a way, *Eight Gray* is an installation whose range of historical references—and references of a considerable magnitude, as we have attempted to sketch out—is surpassed by its temporal and spatial specificity. There is a quiet grandeur in this work that is, however, immediately contradicted by its hidden yet manifestly present mechanical dimension. Like an object straight out of a novella by E. T. A. Hoffman, Richter's painting can be mechanically adjusted—like that of a vanity mirror—according to the spectator's needs. The austere rigor and stasis of Richter's wall-size gates, whose direction of openings are hermetic, find an instant counterpoint in their mechanicity, which generates a perceptual-perspectival disorder that troubles both the hieratic and traditional orders of perspectival vision as much as the perception of a sacred ambience of the memorial hall that the paintings might otherwise induce. They achieve this instability through their structural support: these large-scale glass panels are mounted on metal frames with fastenings that can be loosened, allowing the artist or the curator (and, by implication, the spectator) to manipulate the angles of the panels by tilting them slightly, reorienting their reflections enough to alter the overall spatial orientation, creating the peculiar conditions of a mirror cabinet. Thus the mechanisms introduce

a sudden dimension of domesticity or even vaudeville into an otherwise extremely serene and austere project. To get a sense of the profoundly disturbing qualities of the potentially participatory mobility of these panels, one might imagine for a moment the large paintings of Mark Rothko's chapel in Houston installed on movable hinges to allow them to be tilted according to unknown criteria, willful or programmed, by artist, curator, or spectator.

It should by now be evident that *Eight Gray* responds in a very particular way to the location of the museum where it will first be exhibited, to the city that is home to this museum, and to the particular historical circumstances of the newly found cult of the monument in that city, becoming, in the end, a kind of antimonument. When first considering the project, Richter was uncertain; but then he had the idea of removing all the architectural paneling that the museum often deploys in order to close its large-scale vertical windows that open to the street as part of its mission of "exhibiting," of producing exhibition value.

By contrast, the work itself, in juxtaposition with the open windows, acquires an almost austere muteness, withholding rather than exhibiting itself, *relativizing* rather than *foregrounding* its aesthetic ambitions and its status in direct juxtaposition to the architectural reality of a newly established interpenetration of inside and outside spaces, of daylight and noise, that now intrude into the artificially created spaces of pure exhibition value. The work diffuses that condition in favor of a more real constellation of actual givens: daylight and street noise, the grandiloquent claims of sponsorship, the cultural pretense for a newly found national identity, the self-congratulatory celebration of the newly found capital and the cultural and political delegation of the task of commemorating to the artist as specialist.

The problem of public commemoration in Berlin had posed itself only a few years ago when Richter was commissioned (along with several other artists) to produce a work to adorn the new German Reichstag in Berlin. The result should be recognized as a rather important predecessor to *Eight Gray*, especially in the way that both works perform the complicated dialectic of revelation and

concealment, of subversive affirmation and critical refusal typical of Richter's work at large. In particular the preparatory studies for the Reichstag project reveal the complicated process that eventually led to the large-scale installation of three glass panels in black, red, and gold (almost inevitably to be read as a representation of the German flag defined at the moment of the foundation of the Weimar Republic).

As the preparatory sketches and drawings indicate in great detail, Richter had initially planned a project in which images of the victims of concentration camps in Nazi Germany would have constituted the iconic information in the public mural installation for the Berlin parliament building, supposedly corresponding (and conforming) exactly to the demands of the commissions and the patron: to fulfill the duty of commemoration, now executed by the artist as specialist in such matters. Step by step in the preparatory drawings, all representation is effaced. At first, a polychromatic work on chance constellations takes over, eventually leaving room only for the self-negating and restrictive framework of the national emblem itself: thus Richter's painting abdicates its false expertise as much as it insists on critically reflecting on the services that it actually supplies and then makes those services part of the restrictive tautology.

Thus *Eight Gray*, certainly as a result of its hue as much as of its size and scale, acquires the condition of a curtain or a veil that conceals, while its radiant reflections position the spectator in a set of equivalent relationships. As is constitutive of Richter's work at large, the extreme contradictions that operate inside the pictorial structure remain unreconciled: The window, the frame, the glass pane here operate at least to the same degree as works of a radical critique of ocularcentrism (as had been the case in Duchamp's *Fresh Widow* and in Kelly's *Window*).

As a work about the conditions of vision, Richter's *Eight Gray* assumes then a rather different attitude from the works about transparency and mirror reflection discussed above. The coloration of each panel (also its tension between opacity and reflection) point to Richter's extreme ambivalence with regard to the desirability

(or rather, the prohibition) of an ever-expanding regime of exhibition value and its associated spaces and objects.

Richter's *Eight Gray* shares these premises of a critique of ocularcentrism. It is a work in which the institutional restriction of art and its ensuing condemnation to a tautology have been formulated with a clarity that programmatically *deprivileges* vision rather than celebrating it. In this work, the promise of seeing as an act of transcendental experience is manifestly denied. Instead we encounter a definition of a visuality that seems to suggest that it is far from liberating and transcendental, that it is in fact deeply inscribed in or causally connected to other formations, the regulations of institutional interests and control or the processes of systematic fetishization. Or going further, *Eight Gray* might outright identify "vision," the specular desire in its present forms of socialization, as the compulsion, the site, and the sense of a fraudulently obtained gratification, if not even as the practice of deceit.

And it seems that this conflict acquires a real urgency for Richter when the spectacularization and institutionalization of memory itself is at stake. That is, when the contemporary cult of exhibition value is transferred onto the necessity of constructing spectacular sites and images of commemoration. Thus the withholding of the spectacularized acts of memory serves as a reminder that the individual has to perform acts of commemoration on his or her own terms, in continuity, outside of the officially administered and advocated locations of delegated mnemonic representations.

November 14, 2002

Notes

1 There are extensive studies for a variety of glass installations and wall dividers as well as preparatory drawings for the *4 Panes of Glass* dating from 1965 and 1966, although the actual sculptural work was executed in 1967.

2 Jeff Wall, *Dan Graham's Kammerspiel* (Toronto: Art Metropole, 1991), p. 19.

3 Clement Greenberg, "The Situation at the Moment," *Partisan Review* (January 1948), pp. 83–84.

4 The first properly gray monochrome paintings would be numbers 143/1, 143/2, and 143/3 in Richter's catalogue raisonné, where the artist combines two or three different tones of gray and stacks them as squares or rectangles one above the other. See Jürgen Harten, ed., *Gerhard Richter: Paintings 1962–1985*, 3 vols., catalogue raisonné and exh. cat., vol. 1 (Cologne: DuMont, 1986), p. 60.

5 In a letter to the author, May 23, 1977; published in Hans Ulrich Obrist, ed., *Gerhard Richter: The Daily Practice of Painting: Writings and Interviews 1962–1993* (Cambridge, Mass.: MIT Press; London: Anthony d'Offay Gallery, 1995), pp. 84–85.

6 All of Richter's glass paintings are produced the same way: pure pigment is dispersed on the backside of a glass pane and subsequently fused with the surface at considerable heat. These monochrome glass panels make it evident that even hue and tint are influenced by and dependent upon the texture of painterly application (or its absence). For example, in a series of square glass panels conceived by Richter for the lobby of a German bank, he chose to match the square format with unlikely bright hues bordering on light versions of the primaries. Inevitably—as it appears to the spectator in hindsight and as it might well have been intended by the artist the fusion of glass and bright color gave the work a purely decorative, almost vapid appearance. By contrast, it is perfectly possible to imagine a heavily factured or textured bright red or yellow painted monochrome that would escape that fate.

7 Throughout the late 1960s and early 1970s, Palermo devised a procedure for fusing painterly support and chroma within a single surface in his fabric paintings (the *Stoffbilder*, 1967–72). In 1976, Palermo produced his first major work using baked enamel on glass panels, which must be considered one of the precursors to Richter's subsequent work with colored glass panes. Palermo produced *Himmelsrichtungen* for the groundbreaking exhibition *Ambiente Arte* organized by Germano Celant for the 1976 Venice Biennale, the same exhibition that showed one of Dan Graham's most crucial works using glass and mirrors, *Public Space/Two Audiences* (see

Spleen de Cologne: Rosemarie Trockel's Disenchantments

REBECCA COMAY

"Ja, dies ist spleen . . ."

By all accounts, the English word *spleen* seems to have entered the German language in 1771. This was the year that Sophie von La Roche—Germany's first critically acclaimed and commercially successful woman novelist—published her best seller *Geschichte des Fräuleins von Sternheim* (The History of Lady Sophia Sternheim). Considered today to be the first bildungsroman written both by and about a woman, the book managed almost overnight to generate a female reading public. Its success would outlast by several decades the fulsome but short-lived praise accorded by Johann Wolfgang von Goethe and Friedrich Schiller. The novel's ill-fated, eponymous heroine came to be known as the "female Werther," and partly inspired the crying epidemic that was to sweep through German youth culture by the mid-1770s.

Written in an acquired German by La Roche, whose mother tongue was French but whose passion was for all things English, the novel imported from England not only a genre but an entire vocabulary of sentiment and affect, and was partly responsible for introducing into Germany the "English national character"—bilious melancholia—as an object both of emulation and of fascinated repudiation. Early on in the novel, the recently orphaned heroine, who has just been cast into the glittering viper pit of court society, has her fateful first encounter with British traveler and cultural ambassador Lord Seymour. Marveling at the delicate air of melancholy wafting from the traveler as he sits pensively by the window, she whispers to her hostess, "Is he always like this?" to which the latter, equally wonderstruck, murmurs back, "Ja, dies ist spleen . . ."

Disasters of course await the star-crossed lovers. But this is nothing compared to the trials awaiting the little word *spleen*. Within a year of the novel's publication, the word will be repudiated by the standard dictionaries as a *Lieblingswort*, a kind of linguistic bastard and foreign interloper with no "citizen's rights," *Bürgerrecht*, in the German tongue. By 1808, the enlightenment philosopher Joachim Heinrich Campe, campaigning against the incursion of foreign words into the transparency of the mother tongue, will categorically delete the word from the lexicon, remarking that the "unpleasant sound" of the English loanword not only suits its atrabilious meaning but marks its perfect dissonance within the German language.[1] The exclusion is both predictable and strange. By the eighteenth century there had been much discussion of an elective affinity between Germany and England, usually centering around a common proclivity for a sublimely tinged melancholia. It is striking, then, that the very word that might have crystallized this phantasmagoric merger would be immediately banished as an intrusion. *Spleen* would inhabit the uncomfortable linguistic border zone between the two cultures—at once too foreign and a little too close to home.

Resurfacing soon enough as a German colloquialism, the word acquired a range of connotations radically different from its standard English sense. To this day it continues to haunt the pages of dictionaries and handbooks of German *Fremdwörter*; in a recent lexicon of "Amideutsch" it can be found sandwiched between *splatter-movie* and *split-run-test*.[2] Stripped of its morbid associations, eventually detached from high literary culture, *spleen* in spoken German has ceased to evoke lugubrious melancholia. It rather points to the play of whimsy, caprice, or impulsive folly or eccentricity—"crankiness" in the colloquial sense. "Sie hat einen spleen" translates roughly into "She has some kind of crazy notion."

While the original meaning of *spleen* was perhaps broad enough to capture a range of associations—from saturnine tenacity to unpredictable manic exuberance—the eventual divergence between English and German usage marks both a stubborn barrier and a secret contamination between the two languages. What is lost

in one idiom is retained in the other; spoken German captures a sense now obsolete in English, and vice versa. It is as if a secret filter is channeling circulation—perhaps like the organ itself, through which blood and lymphatic fluid are secreted. Neither fully buried nor revived, neither metabolized nor ejected, the word itself displays an uncanny resilience. If *spleen* lacks the auratic pathos of a ghost or revenant, it has the unmistakeable élan of a survivor.

Fremdwörter

And so it was that I was not entirely sure in what language I was to read the title of Rosemarie Trockel's exhibition at Dia in 2002. *Spleen*: was it a translation, a transliteration, a repatriation, a citation? The word oscillated irresolutely between languages, between epochs, between idioms, between high literary culture and the vernacular. It presented at once a pressure to translate and the essential impossibility of translation. Its vicissitudes seemed appropriate to the hybrid work of Trockel. Multinational in scope and orientation, polyphonous in its literary and cultural references, the oeuvre is rife with allusion to the international art scene, to the film industry, to the global network of commodity capitalism, even while remaining stubbornly local and even occasional in its references.

The centrality of language to Trockel's work might easily be underestimated, if only because of the maddening prevalence of *Untitled* as the preferred title for so many of her works. As one walked through and around the freestanding panel walls of the exhibition, the strangeness of her linguistic practice became quite striking. The material aspects of the installation, with its peculiar concatenation of sculpture, architecture, film, and video, raise a series of formal, conceptual, and historical issues. The video loops were projected simultaneously onto freestanding screen-walls, the back of each wall sheathed with a different color of interlocking aluminum plates. The whole ensemble evoked a complex history of divergent media, art forms, and movements—cinema, photography, sculpture, installation as processed through the various art-historical moments of Minimalism, Conceptual art, Pop art, and beyond.

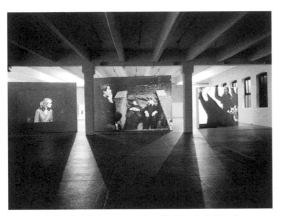

Rosemarie Trockel, *Spleen*, 2002, installation view, Dia Center for the Arts, New York

Numerous tensions divided the front and back of each panel: cinema on one side, sculpture on the other; figurative image on one side, Minimalist monochrome on the other; temporal movement on one side, spatialized repetition on the other. The contrast points to an enigmatic tension in language as such. Something like the arbitrariness of the sign is at stake.

Recto: on the front of each screen-wall, we are presented with a series of virtually identical titles, each pointing to an extreme diversity of cinematic references. Only a numerical difference distinguishes the names of the five different renditions of *Manu's Spleen*. And since the numbering system corresponds neither to the dates of composition nor to the spatial arrangement of the films in the exhibition space, even this numerical distinction has no obvious pertinence beyond the printed catalogue. Verso: on the back, we are given a series of intensely specific titles, each drawn seemingly at random from Hollywood cinema, each with its own overdetermined history and connotations, and attached apparently indifferently to the textured metal surface. On the one side, then, we are presented with an excess of the signified over the signifier: language is reduced to the arbitrariness of sheer enumeration or identification without contributing any qualitative information to the designated object. On the other side, we confront an excess of signifier over signified: floating freely in a monochromatic void, language is here untethered from any determinate referent and meaning. The uncoupling of word from work seems almost perfect.

Is there, then, no motivation in the title *Spleen*? And if so, in what language should one read it? In English? Certainly there were graveyards, widows, cannon fodder, corpses, mausolean vitrines full of book covers and maquettes for exquisitely unrealized projects, a little monitor in the

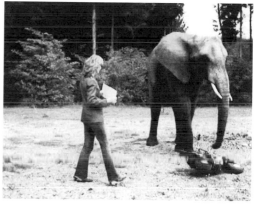

Rosemarie Trockel, *Manu's Spleen 5*, 2002

corner emitting ghostly images of abandoned appliances in a silent warehouse. Ample justification, I figured, to begin to weave the project into the current idiom, by now somewhat oversaturated, of mourning, melancholia, archive fever, ethics of trauma, memory-immemory, and so on—our own familiar contemporary hypermnesic culture. But a few loose ends dangled annoyingly. An elephant was plodding about in *Manu's Spleen 5*. A madcap party scene kept bursting out in *Manu's Spleen 3*. The grave lacked all gravitas. Mother Courage danced. Jackie K., in black, was smiling, if only in a kind of vague and deadpan way. The balloon popped. No one took any notice. The woman died, but only for a while. Once more, no one seemed to notice. I lost my bearings.

Perhaps in German? There were certainly enough quirks and ticks and whimsy to go around. And if the artist's intentions meant anything—the curators, gallery people, and journalists were in consensus—the German word had simply been transliterated for the American gallery circuit: *spleen* meant a crazy or eccentric habit, an idée fixe. Trockel, who almost never talks, had said so repeatedly. Sure enough, there was a crazy energy at the birthday party in *Manu's Spleen 3*—the slapstick staging, the popping pregnancy, the surging sound waves. The encounter with the elephant in *Manu's Spleen 5* had the improvised casualness of a 1960s-style Happening.

And throughout *Manu's Spleen 4* there was that strange, ongoing obsession with Brigitte Bardot, a figure who had been haunting Trockel's work for over two decades under the rubric of BB. In this piece, the doubled initials of the actress are redoubled: Brigitte Bardot meets Bertolt Brecht.[3] Blondely cloned, twinned, or stereoed like the two initials, the actresses in the video lip-synched in tandem to an early recording of Bardot singing, her voice in turn woven into the sound collage accompanying Trockel's reprise of the legendary 1949 Berliner Ensemble production of *Mutter Courage und ihre Kinder* (Mother Courage and Her Children).

But there was an inescapable plangency pervading this last work. Trockel's Brecht rendition retains a political edginess that even the MTV-like sound mix cannot quite muffle. Breaking through the compacted wall of music, intermittently audible, the recorded voices of Brecht and Helene Weigel could be heard testifying before the House Un-American Activities Committee, or announcing that "communism is good for you"; Brecht's voice could also be heard at times giving a parodic rendering of the Nazi party anthem, "Horst Wessel Lied." The soundtrack was also intermittently punctuated by the crackling airwaves of a Dallas radio station, from 1963, with the shattering announcement of Kennedy's assassination.

Should we read *spleen* in French? By the mid-nineteenth century the English word had also migrated to France, where it was to pick up its most persistent and influential resonance. A poem cycle in *Les fleurs du mal* explores the vertiginous negativity of a time fissured into the infinite accumulation of empty moments, a self vaporized through the accretion of empty experience. Repetition, addiction, ennui, inertia, fog, smoke; *spleen* signifies the irreversibility of exile—from God, from meaning, from the plenitude of presence and lyric self-production. It reveals time itself to be the repetition born of irreparable loss. In its doubling and duplicity, *spleen* marks both the limit and the strange possibility of poetry itself as ex nihilo creation.

For Charles Baudelaire, *spleen* had named the specific repetition compulsion of the modern age—the jarring anonymity of the city,

the proliferation of mass-produced things and images—a repetition that by 1848 would have become linked to the seemingly unending cycle of revolution and counterrevolutionary repression. The aesthetics of *spleen* would become inseparable from the political challenge posed by the eternal return of the missed revolution and the repeated dying and resurgence of the republican ideal. Genius would be redefined as the capacity for recycling—*créer un poncif*, to create a cliché, an originary copy—and to be modern would be to register the chronic anachronism of the present day.

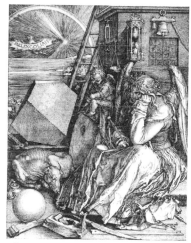

Albrecht Dürer, *Melencolia I*, 1514

But to think this through we will need to cross yet another linguistic frontier. The French word *spleen* must be pronounced in some kind of German: it is through Walter Benjamin's Baudelaire exegesis that this concept has entered the collective consciousness.

Death Heads

This last articulation points to a mortuary dimension that has been running through Trockel's work since the beginning of her career. The scope of this goes well beyond iconography, although her work abounds with emblems from the melancholic canon. In an earlier piece, for example, Trockel had taken an image of Albrecht Dürer's magic square, from *Melencolia I* (1514), silkscreened it onto Masonite, and mounted it on an open cube; the effect is a strange amalgam of Andy Warhol and Sol LeWitt. And throughout Trockel's corpus we repeatedly confront heaps of dead matter in all shapes and sizes. There are bones, skulls, relics, body parts, corpses. There are jawbones locked up in museal vitrines, dead animals cast in bronze, fingers cast in silver reliquaries, books clad in black leather. There are close-up images of death's-head moths, rows

Hans Holbein the Younger, *The Body of the Dead Christ in the Tomb*, 1521

Grave Scenes

The cemetery scene *Manu's Spleen 1* is exemplary. Both deposition
and resurrection are staged with the casualness of a weekend stroll.
A double grave—a marriage bed?—yawns open, a young man lying
there motionless, as if already dead. A group of men and women
walk by and shove the corpse over without ceremony to make
room for a young woman, the eponymous Manu. She climbs in
and lies still for several minutes while her companions wait, smoke
a cigarette, chat on the cell phone, have a snack. After a while she
climbs out, dusts herself off matter-of-factly, and the group moves
on. We hear throughout this scene the vague, ambient sound of
muffled conversation, distant music—not quite audible enough to
create an atmosphere, but noisy enough to disturb the silence of
the tomb.

On one level, the work begs to be inserted into the history of
modernism: the progressive disenchantment of death as the source
of metaphysical transcendence. The standard version of this story
starts at least as early as the Reformation, and a few highlights can
be quickly noted: death humanized as a putrid carcass (Holbein's
The Body of the Dead Christ in the Tomb, 1521); death secularized as
the scene of a country gathering (Courbet's *A Burial at Ornans*,
1849–50); death made painterly as a streak of color (Manet's *The
Dead Toreador*, c. 1864), or as a shadow-stain on a landscape
(Manet's *The Funeral*, 1867). Trockel presents an epilogue to this
well-rehearsed tale. Video camera in hand, the artist disenchants the
very project of disenchantment and draws modernism's story to a
close. Manu's sojourn in the grave recalls the sleep sessions Trockel
had staged several years earlier in *Sleeping Pill* (1999). For this earlier
work she had constructed a temporary space on the outskirts of
Cologne, equipped with fold-out beds and hanging pill-shaped

capsules, which passersby were invited to sleep in while being filmed. Projected on the walls of the German pavilion at the Venice Biennale the same year, these images of sleeping bodies had

Edouard Manet, *The Dead Toreador,* c. 1864

the affectless impersonality of John Giorno sleeping, recorded in real time by Warhol in his film *Sleep* (1963), which Trockel's flattened style of filming also recalls.

The temporary tomb also evokes the temporary womb in *Manu's Spleen 3*, in which, for an enormously distended two minutes, the handheld camera weaves and bobs around Manu's hugely pregnant belly. The balloon then explodes, the belly shrinks, the event repeats—and then repeats again. A close-up of a flickering birthday candle in the opening scene momentarily evokes the pathos of a vanitas. But instead of pointing to transcendence, the life cycle is here enclosed within the claustrophobic repetition of a film loop. Grafted onto the chaotic party noise is Madonna's song "Don't Tell Me," played backwards. In normal forward mode, the song's refrain insistently and repeatedly assimilates sexuality and death, womb and tomb. "Please don't / Please don't / Please don't tell me to stop / Don't you ever / Don't you ever / Don't ever tell me to stop / Tell the rain not to drop / Tell the bed not to lay / Like a open mouth of a grave, yeah / Not to stare up at me / Like a calf down on its knees." In reverse mode, Madonna's preterition is itself put under erasure: the negative is reversed while being repeatedly reasserted. To *not* tell someone, backwards and repeatedly—to negate in reverse— is to submit to the uncertainty of a living death.

This double negation presents sexuality itself as a trauma fated to go unmarked. The bursting of the balloon does nothing to puncture the noisy celebration of the partygoers, who take no notice of the crisis, and yet whose very jollity has a curiously flat and deadpan tone. Fecundity is demystified as yet another semblance—

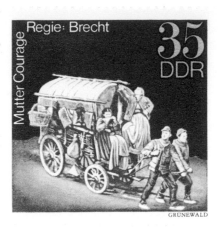

Regie: Brecht
Mutter Courage
35
DDR

GRUNEWALD

German Democratic Republic Stamp (1973) commemorating the 1949 Berliner Ensemble performance of *Mother Courage*

a demystification that is in turn demystified, by being stripped of pathos, and knitted back within the eternal recurrence of the same. Compare the glossy infertility crisis parodied in *Living Means I Tried Everything* (2001). Every whiff of traumatic sexuality is extinguished: the paradigmatic female loss (of pregnancy, of new creation, of futures) is eradicated with the push of the rewind button. The catch, of course, is that in life there is no real rewind in the sense of a second chance or new beginning. Living means to have to take it again and yet one more time within the endless circuit of empty time.[5]

In *Manu's Spleen 4*, this repetitive erasure takes on an overtly political dimension, as layers of traumatic history collide, contract, and mesh within a complex weave of sound and image, word and song. It is not only the recent past that Trockel is disinterring; the divergent histories of cinema, journalism, fashion, music, and visual art are also being exhumed. The canonical 1949 Berliner Ensemble production of *Mother Courage*—by now fastidiously well-documented and preserved in the embalming fluid of bourgeois theater—is recycled through the prism of the 1960s. Mother Courage is outfitted in a Courrèges A-line; Yvette, the prostitute, is decked out in Jackie Kennedy's widow black and pearls; two lip-synching prompters perform an androgynous parody of Brigitte Bardot; Eilif and Swiss Cheese (Mother Courage's sons) parade in flesh-colored bodysuits, like dancers in a modernist ballet. This visual compilation is accompanied by a tightly sutured but dissonant soundtrack that zaps through the iconic sound bites of Cold War culture with the ease of a radio dial turning. In the

hands of the knight-
costumed Joan of Arc,
this technology appears
at once timely, futuristic,
and curiously outdated.
The soundtrack jumps
rapidly from John Lennon
to Bob Dylan, from the
radio announcement of
Kennedy's assassination to
Brecht's testimony before
the HUAC. The dissonant

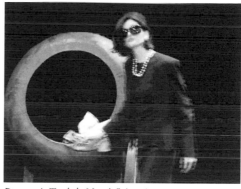

Rosemarie Trockel, *Manu's Spleen 4*, 2002.

effect of this montage does not quite have the startling impact
of the Brechtian *V-effekt*—that surprise is over. Marilyn, Jackie,
and BB do not quite have the gleam of Warhol's celebrities—that
allure is over. And the monochrome-backed panels on which the
videos are projected are not quite the Minimalist architectural
constructions of a bygone age—that moment of intervention
is past.

At the level of the soundtrack, if not at a visual level, Trockel's
collage has affinities with classic cinematic montage. But the
acoustic dissonance is alleviated by the structural symmetry of the
whole. The soundtrack is framed at both ends by music drawn from
a very different register: Joan of Arc's famous aria, "Holy Father
help me, I am afraid," from the final act of *The Maid of Orleans*,
Pyotr Ilyich Tchaikovsky's 1881 hybrid of French and Russian
musical idioms, with a Russian libretto based on a polyglot mélange
of texts by Schiller, Barbier, and Auguste Mermet. This acoustic
framing formally mirrors the visual symmetry created by the video's
opening and closing shots of Mother Courage's carriage entering
and leaving the stage with Jackie Kennedy in the background
pulling the cannon in the opposite direction.

This operatic framing places the soundtrack under a kind
of acoustic glass—the auditory equivalent of Trockel's earlier
ethnographic-style vitrines. This neutralizes the specificity of the
individual sound bites—the fragments are contained within the

enclosure of a collection—but it also highlights the structural unfinishedness of the work itself: every collection is incomplete and open to revision. The museum reifies every element as indifferent material within a homogeneous continuum even as it hints at an unpredictable afterlife in another context. Citation is in this sense like a woman rising unbidden from the grave. Is the quotation buried alive or mechanically reanimated? A living death or a deadened life?

Requiem for Modernism

The question is not purely formal. It pertains to the possibility of a resurrected political aesthetic. Trockel's citation of Brecht operates at a variety of levels: as theatrical mise-en-scène; as acoustic element; as intertextual archive;[6] as epitaphic homage (BB/BB); and finally as dramaturgical principle (laying bare the device, separation of elements, and so on). Brecht thus provides both the work's horizon and several of its key components—a set that contains itself as one of its own members. Is Brecht himself being knitted into the work as one more element within the indifferent continuum of consumer goods? Another logo to add to the Playboy bunny, the Marlboro cowboy, the hammer and sickle, the Minimalist patch, the Expressionist blob, the swastika, the skull? Has alienation become so commonplace that it has become a fetishistic surrogate for itself—the negation of a vanished critical negativity?

The question of revival—both aesthetic and political—can turn into a question of survival. This is the explicit subject of *Manu's Spleen 2*, the last of the videos to be produced, but the first to be encountered upon entering the exhibition—it can function as a kind of frame or introduction to the whole series. It is the most overtly political of the pieces. Shot in black and white, it is also the most disarmingly neutral in its style of filming, and the only video with clearly audible speaking parts.[7] The work records a speech delivered at a protest demonstration captured in real time, in Cologne, in 2002, just weeks before the opening of the New York exhibition. The speaker is Udo Kier, an actor best known for his roles in raunchy sex and horror movies before being taken up

by Gus Van Sant in the 1980s. Featured in full-frontal nudity in Madonna's best-selling book *Sex* (1992), Kier was also the star of Warhol's films *Blood for Dracula* (1974) and *Flesh for Frankenstein* (1973); he has had more than passing experience of the living dead.

In contrast to Trockel's other video pieces, which typically use nonprofessionals acting out their assigned roles before the camera, this film features an actor playing the role of a civilian. The event is both improvised and yet choreographed with utmost care. Kier is seen reading a speech, written by Trockel herself, for an agitprop demonstration, in which it is impossible to distinguish the extras from the passersby. The demonstration had been organized to protest the "death sentence" of the Cologne Kunsthalle. Home of avant-garde exhibitions and events and a cultural magnet since the 1960s, the Kunsthalle had been slated for demolition as part of a millennial urban renewal project that was to include the construction of a museum-mile complex of the type so familiar in European cities today. Promoted officially as the site of an urban cultural renaissance, a phoenix rising, the projected art center is described by Kier as a mini-Hollywood for the global entertainment industry, a place where the culture industry can dish out its "sensual encounters of the third kind."[8] The speech is delivered as a funeral oration for a death already in the past. Emphasizing the essential belatedness of every protest, the speaker "protests against the very impossibility of protest"; the absorption of art's critical negativity by consumer capitalism entails the recuperation of any dissidence that might have opposed this. Even this formulation, however, has the slightly formulaic ring of rehashed Adorno and displays this weariness with the same impassiveness as the boredom spreading over the faces of the actors throughout all the other films in the *Spleen* cycle, even as they dance, or laugh, or walk along.

This requiem for a lost utopian project thus includes a requiem for the possibility of requiem: it is not only loss, but the loss of loss—the loss of any symbolic or collective response to loss— that Trockel is commemorating. The spiraling reflexivity recalls the loopings of Trockel's early knitted works, to which the aluminum panels also bear a slight resemblance. The nonfuneral staged in

Rosemarie Trockel, *Spleen*, installation view, 2002

Manu's Spleen 1 can thus be read as the allegory of the entire *Spleen* series, in relation to which *Manu's Spleen 2* must be read as political exegesis.

And here the tension of the project comes sharply into relief. Baudelaire's gamble was to bet on *spleen* itself as self-transcending repetition. This would become the condition of writing after the traumatic abortion of the republic. To create a stereotype was to find in repetition itself the condition of innovation—the alchemical transformation of black bile into ink. This conceit was, however, firmly rooted in the heroic tradition of melancholia: it unfailingly evoked the sublime pathos of the loser's win. Such rewriting of defeat as triumph is historically gendered: the genius who finds power in impotence is invariably the male creator, for whom the figures of female impotence—in Baudelaire the infertile woman, the statue-woman, the lesbian—serve as silent muse and mirror. This is perhaps why *spleen*, in Trockel, is not quite a French word, although the disenchanted mourning that she is so obsessively tracking is almost Baudelairean in its intensity.

It is in this sense, finally, that we can begin to interpret the work's physical installation—the slightly mortuary slabs on which the videos are projected, with their evocations of so many missed opportunities of the recent and not-recent past. Among the lost utopian possibilities commemorated by these tombstones are the revolutionary potentials of cinema itself as a vehicle of collective demystification. Projected onto the monochromatic flatness of the screen-walls—rather than being screened on monitors or projected into little side rooms in the gallery—the videos have an unmistakeably filmic quality. They cannot fail to recall video's own prehistory in cinema, an association underscored by the Hollywood

titles randomly assigned to the aluminum panels on the monochrome back side of each screen.

With their grid-like variations of repeated geometrical shapes, these panels also evoke the experiments of Minimalism. As free-standing walls bits of architectural structure—they also recall the effort of Conceptual art to escape the coils of administration by turning to architecture as a form of social praxis.[9] These layers of art history form an archaeological deposit on the back side of the projection; they incorporate both the repressed prehistory of the present and its indispensable support. In their opacity, the panels also function as the tain of a mirror. They reveal the condition and limit of all narcissistic identification and produce a shattering of the spectatorial imaginary. This raises an ineluctable question about video itself: Does the medium spell the death of cinema through its incessant rechanneling and atomized consumption, or might it harbor possibilities still unthinkable?

December 12, 2002

Notes

1. Joachim Heinrich Campe, *Wörterbuch der deutschen Sprache* (Brunswick: In der Schulbuchhandlung, 1807).

2. Cf. Alfred Probst, *Amideutsch: ein kritisch-polemisches Wörterbuch der anglodeutschen Sprache* (Frankfurt am Main: Fischer Taschenbuch, 1988).

3. The joke in turn recycles Jean-Luc Godard's pun in *Contempt* (1963).

4. Silkscreened onto a panel whose proportions and design resemble a tea towel, the skulls might also evoke the deadly boredom of domestic work and point to the absorption of the household economy within the regime of commodity production.

5. In yet another rendering of the fertility crisis, Trockel films a woman dropping an egg, which smashes on the ground, leaving a kind of inky blotch (in fact a photographic reversal of positive into negative).

6. The casting of Kattrin as Joan of Arc involves a grafting of *Mother Courage* onto *St. Joan of the Stockyards*. Snippets of this latter play are also quoted in the soundtrack.

7. The striking stylistic differences between the various videos are worth noting: home-movie jerkiness for the party scene, haphazard framing for the cemetery scene, cinematic precision for the Brecht montage, casual contingency for the elephant sequence. The history of the past forty years of video-making can be excavated here—from artist's medium to family toy, from journalism to MTV, from advertising to cinema. I owe this observation to Lynne Cooke.

8. All citations are taken from the speech, published in the book accompanying the video, *Pro Test: Manus Spleen 2* (Cologne: Buchhandlung Walther König, 2002).

9. I'm thinking of Benjamin H. D. Buchloh's powerful arguments in the early 1990s, and also of Dan Graham's own architectural interventions.

Programmatics, Poetics, Painting: On Jo Baer

MARK GODFREY

Before encountering Jo Baer's exhibition *The Minimalist Years, 1960–1975*, at Dia Center for the Arts in 2002, I had seen only a few of the artist's paintings. One in particular, *Stations of the Spectrum*, stayed in my mind. The title of this work—painted in 1967, the year after Barnett Newman exhibited his *Stations of the Cross* (1958–66)—suggests a deliberate attempt to rid painting of the metaphysical content that Baer might have mistrusted in Newman. It seemed like the kind of painting that was inevitable by the mid-1960s. In it, Baer gave orthodox modernist answers to questions of flatness and deductive composition, while demonstrating a post-Frank Stella attitude to expressionism and facture. There were no gestural marks, but also missing was the jubilant color that one would find in contemporaneous Stellas. Peter Schjeldahl once described a show that included Baer's work as theoretically successful, yet depressing; this was, for some time, my impression of Baer.

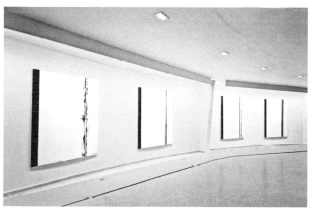

Installation view, *Barnett Newman: The Stations of the Cross: Lema Sabachthani*, Solomon R. Guggenheim Museum, New York, 1966

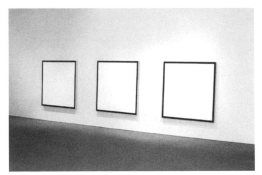
Jo Baer, *Primary Light Group: Red, Green, Blue*, 1964–65

But when I came to the exhibition and saw Baer's *Primary Light Group: Red, Green, Blue* (1964–65), its brightness lifted my gloom. For paintings that seemed art historically predictable, they were, in the viewing encounter, utterly surprising. The work consists of three paintings. Each is sixty inches square, of which the central fifty-inch square is painted a bright white. Around this white area is a very thin band of color, which in turn is surrounded by a considerably thicker band of black. This black almost stretches to the outer border of the canvas, but not quite; a very thin white line surrounds it. There are no immediately visible brush marks on the canvases, but it's also quite apparent that they're hand-painted, with paint applied vertically. The borders of the areas are not perfectly straight, and it does not seem that masking tape was used.

Because the paintings were hung quite low, the tendency was, at first glance, to look at the white center at eye level. I could see the weave of the canvas, the occasional pull of thread, all evenly covered with white paint—a solid, substantial surface. But this hardly sustained attention, so the gaze immediately shifted sideways, arriving at the point where white meets color, which meets black. Perhaps it could be at this point that some kind of relationship between figure and ground could be established. Did the black band seem to lie in front of the color band? Did the color band appear to lie above the white area? No. What I saw was what I saw. A flat surface looked flat. To quote Baer, "There is no hierarchy. There is no ambiguity. There is no illusion."[1] But the absence of spatial illusion hardly meant the work was without its surprise.

Stepping to the right, I attempted to name the color before me. Encouraged by the triptych structure of the work, which the title told me consisted of three distinct lights, naming seemed quite easy.

In the immediate section of the painting before me, the color was a bright turquoise. Rather than the nuanced ultramarine of Newman's *Cathedra* (1951) or the rich, bold blue of Ellsworth Kelly's *Red Blue Green* (1963), this blue reminded me of felt-tipped pens on shiny whiteboards. It was bright, not rich; it was zesty, tangy. It was like the color of David Bowie's makeup against the bright white in the bleached video for *Life on Mars?* But then the canvas's composition pressed me to glance across to the other flank, and I discovered that all was not what it seemed.

Fifty-five inches or so to my side, the turquoise had disappeared. Instead, like a faded memory, the band was a darkened gray, a ruin of color. My immediate reaction was to move to the left to check what my eyes had just seen. As I reached this point, the color before me changed to a bright turquoise, but the band I'd just come from was not spoilt, dirtied. I was locked by perception into a world of distortion. Nothing I could do would stabilize the color.

I moved back to the first viewing position, in the center, but the urge was now to look away from the white and up to the band of color along the top. It was impossible not to follow the band's run around the white square. Though the color was firmly stopped between black and white, it did not contain itself. Inside the band, color zoomed around and around, brightening and darkening with a velocity that was heightened by the stationary feel of the rest of the painting. This velocity was the very inverse of the slow emergence of color contrast in an Ad Reinhardt painting; the circuiting path of color change was utterly different than the directionality of color in Kenneth Noland's work of the time. Where his 1967 paintings suggested speed, because of the rush of color from one side of the painting to the other, here the color flashed around and around. Baer's color did not pulse like color does in Op paintings, however: it did not change in the same place, but between one part of the band and another. (That is, unless, as I eventually discovered, you fix your eyes on the vertical color band and move your head side to side without losing your focus, then look out of the sides of your eyes. The color change is dramatic, startling.) The only way to stop the race of color is to get your eyes

they argued that painting was inevitably compromised. In "Specific Objects," from 1965, Judd contended that advanced painters, in their ambition toward wholeness of form, were limited by having to base compositions on the rectangular shape of the support. "A form can be used in only so many ways," he wrote, and, "The rectangular plane is given a life span."[5] The sell-by date, he implied, had passed. Furthermore, paintings were compromised by inevitable illusionism. "Almost all paintings," he said, "are spatial in one way or another."[6] And finally, the materials of painting, oil and canvas, were both overly familiar and limited.

Judd's arguments paved the way for his championing of specific objects, while Morris was more concerned with the possibilities of the sculptural. But Morris also condemned painting as a dead-end practice. In the first part of his "Notes on Sculpture," published in the February before *10*, Morris described modernist painting's investigation of the literal qualities of the support as a dialogue with a limit. Modernist painting was now an endgame, or what he described as the "rather pious, if somewhat contradictory, act of giving up this illusionism and approaching the object."[7]

The horizontal flanking diptych Baer exhibited in *10* looked onto work whose makers by now entirely mistrusted the premises of her practice. Morris would continue to attack painting in the third installment of "Notes on Sculpture," in 1967, when he wrote, "The trouble with painting is not its inescapable illusionism per se. But this inherent illusionism brings with it a nonactual elusiveness or indeterminate allusiveness. The mode has become antique. Specifically, what is antique about it is the divisiveness of experience that marks on a flat surface elicit."[8] For him, Minimalism would be a matter of pragmatic, empirical work. And so painting, even Baer's, could no longer play a part.

In the very same month that Baer's diptych was included in the extremely hostile company of Judd and Morris in *10*, she was also showing uptown at the Guggenheim. Lawrence Alloway's *Systemic Painting* provided a more hospitable context. Here, Baer was positioned among twenty-eight other painters, all working with what Alloway called "one-image art." In a short catalogue text,

Baer indicated that the canvases of *Primary Light Group*, which were shown in this exhibition, were actually part of a larger series of twelve. "There are four colors in the series," she wrote, "blue, green, purple, yellow. There are also four sizes and shapes: large squares, small squares, vertical rectangles, horizontal rectangles. Each particular size and shape needs particular properties of color: intense, or pale, or grayed, or bright. The possibilities for combinations or grouping of the paintings are the permutations of twelve (831,753,600)."[9]

This exhibition and text open up onto the second kind of context for framing Baer's work of the mid-1960s: the notion of seriality. It was Mel Bochner, more than anyone else, who theorized the serial practices that he witnessed around him. For Bochner, the debates of painting versus object that so preoccupied Judd and Morris were not as compelling as those around the planning out and arrangement of the artwork, whatever its medium. He could locate a serial attitude in works as diverse as Flavin's *the nominal three (to William of Ockham)* (1963), Judd's Progressions, and his own photo pieces. Bochner reviewed *Systemic Painting* in *Arts Magazine* in 1966, and given his concerns, it's not surprising that of all the artists in the show, he devoted most attention to Jo Baer.

What fascinated Bochner most about Baer's work were the implications of her catalogue text. Whereas other painters in the show selected the colors for a given painting because of their subject preference, or in an intuitive attempt to balance out other colors, Baer chose hers according to a predetermined order. And whereas other painters composed their paintings part by part, Baer, at least as Bochner represented her ambitions, merely treated paintings as units to be arranged in any one of a huge but calculable number of orders. The arrangements, not the units themselves, were the key thing. After Baer set up the initial schema for her work, "it followed its own logical necessity and not any personalized aesthetic."[10]

Bochner's interest in seriality was certainly motivated by the way that seriality bade the personalized aesthetic good riddance, but Baer's work was not merely, for him, about doing away with subjectivism. The effect of Baer's schema was more compelling.

The extremely high number of possible arrangements for the units was, for Bochner, "mind-cramping . . . an intuition of infinity."[11] This was not the sublime infinity of eternity, but a calculable yet unknowable infinity of blankness. So a cramping, claustrophobic infinity, rather than a free or expansive one. Because he saw blankness in the very meaning of her seriality, Bochner was nicely and neatly able to link Baer's seriality back to the look of any one of her units. "The frame is not a window," he wrote. The paintings do not "delude the viewer into any facile transcendence."[12] Having started with the wonderful line that Baer's works were "the most thought provoking in this exhibition yet the least penetrable by thought," Bochner concluded that "they remain unavailable to the emotions as well as to the intellect. They are a presence as impenetrable as reality itself, an objectification of the nothingness they frame."[13]

After reviewing *Systemic Painting*, Bochner invited Baer to participate in a project that he was organizing for the School of Visual Arts, New York. As is well known, Bochner asked the various participants to submit working drawings and other visible things on paper not necessarily meant to be viewed as art. He photocopied their submissions and placed them in binders arranged on four low plinths. Baer's pages showed plans for dimensions of paintings, and a sketch of the six possible combinations for the three units of a triptych. The latter drawing was just the kind of thing that Bochner was interested in, and the following year, 1967, he included a triptych in the show *Art in Series* at Finch College, New York, where her paintings hung opposite those of Al Jensen and Jasper Johns.

But though Bochner's support for Baer was primarily motivated by her seriality, what his writing draws out best is his understanding of the nothingness of her paintings. Negativity is, after Minimalism and seriality, the third early frame for Baer's work. Negativity and negation, as Meyer has written in an essay on Eva Hesse, were key concerns for Bochner and others at the time.[14] And given the impenetrability of Baer's paintings, it's easy to see why Bochner thought about Baer in this way.

Robert Smithson, Bochner's onetime writing partner, also placed emphasis on what he considered to be Baer's blankness. In his 1968 essay "A Museum of Language in the Vicinity of Art," Smithson described a "cartography of uninhabitable places" that he saw developing in the work of contemporary artists, "complete with decoy diagrams, abstract grid systems made of stone and tape."[15] Works like Carl Andre's *Cuts* (1967)—which Smithson described as "an entire floor with a 'map' that people walked on"[16]—called to mind Lewis Carroll's abstract cartography. Smithson mentioned two of Carroll's maps: the one-to-one map from the book *Sylvie and Bruno Concluded* (1893), and the blank map in *The Hunting of the Snark* (1876), which contains nothing. "The Bellman's map in the *Snark*," Smithson wrote, "reminds one of Jo Baer's paintings."[17] He quoted from Carroll's poem: "He had bought a large map representing the sea, / Without least vestige of land: / And the crew were much pleased when they found it to be / A map they could all understand."[18] Smithson continued, "Jo Baer's surfaces are certainly in keeping with the Captain's map which is not a 'void,' but 'A perfect and absolute blank!'"[19]

OCEAN-CHART.

Henry Holiday, illustration of "The Bellman's Speech" from *The Hunting of the Snark*, 1876

Smithson's account of Baer is intriguing. Characteristically, he was able to join Andre to Baer through the notion of the abstract map. And in so doing, he sidestepped both the Minimalist discourse that served to distance painting from sculpture, and the discussions of seriality, which could serve to bring them together. The brief allusion to Baer helpfully separates the concepts of the void and the blank. Smithson's suggestion that the former term ill served Baer was astute. Like Bochner, he realized that Baer's whites were not spatially recessive, that her work had no sense of the void and its connotations of metaphysics and landscape.

But Smithson's preferred term, *blank*, might be equally problematic. Thinking about Baer's surfaces as perfect and absolute blanks means paying too much attention to their white parts and not nearly enough to their borders, which surely are as full of content as the peripheries of the map from *The Hunting of the Snark*. I find Smithson's idea of Baer's blank troublesome, for the same reason that I disagree with Bochner's insistence that the colors of the *Primary Light Group* "do not do anything . . . spatially, optically or emotionally."[20] Perhaps the colors do not do optical, emotional, or spatial things, in the same way as other paintings of the time; but as might be clear from my account of my experience with *Primary Light Group*, the paintings are not so blank. The phenomenological encounter with them, as, indeed, with all of Baer's early work, amounts to anything but nothing.

There's no telling what Baer might have made of Smithson's reference to the blank map, but she did once complain, in a letter to Morris, of the problem of allusive readings of abstraction, which she argued beset abstract sculpture every bit as much as they beset painting. "Allusion," she wrote, "is everyone's problem. . . . If an unvisual, literary set of non-lookers must 'see' me as a surreal illustrator of clean pages, empty vistas, on that same token, they must see that you and Judd build boxes."[21] Smithson's reading was not really the casual literary one she invoked, though. After all, neither Smithson nor Bochner were thinking of her work through the idea of landscape. While the empty map from *The Hunting of the Snark* was nonetheless a useful trope to comment on Baer's paintings, the map that actually seems to fit best with Baer's own intentions around this time was the other map that Smithson mentioned, from *Sylvie and Bruno Concluded*. That other map, far from being blank, is totally detailed; it's the same size as the land that it charts. The link to Baer has nothing to do with immensity of size, but with exactness of charting.

Jo Baer, in Her Own Words
This exactness emerges in Baer's accounts of her own work. In 1970, Baer published a pamphlet called "Mach Bands," in the same

issue of the journal *Aspen* that, coincidentally, featured Smithson's "Strata." Baer discussed different theories of light and color, before outlining, in scientific detail, the perceptual theories of Ernst Mach and the visual phenomenon known as Mach bands. Mach had discovered that where a black area meets a white or light-colored area, the actual light change between the areas that a light meter can measure is not correctly registered by the eye. The eye sees a band of darkness within the black, and of lightness within the light area. So the contrast is accentuated. The sharper the border between the areas, the more pronounced these Mach bands. Mach bands, then, are optical illusions, but exact and measurable objective ones. In her text, Baer produced a graph that plotted actual and perceived light changes across a surface on which there was a change from a light pigment to a black one. Like Carroll's map from *Sylvie*, this graph exactly plotted the surface it recorded. Baer's graph could be laid over the surface of one of her paintings and exactly chart what the viewer would see when looking at the border between a colored band and a black section. The perceptual change was caused by light contrast. Light was at the heart of Baer's own account of her work.

Though Baer's own voice was not yet featured much, she was anything but a silent painter. Indeed, of all the abstract painters whose work came to notice in the mid-1960s—Ryman, Robert Mangold, Ralph Humphrey, Brice Marden—she was the most articulate spokesperson for painting. Her texts give a great sense of the frustration that a painter must have felt at this time. One can imagine *Artforum* dropping through Baer's studio letterbox each month, Baer reading articles condemning painting as antique, and then looking up from the magazine at her determinedly non-illusionistic, exact, and measurable work.

In a number of letters in *Artforum*, in her *Aspen* essay, and in private correspondence, she put forward a cogent argument for her work. The texts that she wrote were punchy and clever, juxtaposing incredibly detailed technical information with a historical overview of the development of modernism, and rigorous yet witty put-downs of other artists' positions. Baer's theory of painting combined

Greenbergian modernism with perception analysis. In "Mach Bands," she quoted from Clement Greenberg's "Modernist Painting" (1960), reminding readers of Greenberg's account of how painting exhibited and made explicit that which was unique and irreducible in its medium. For Baer, modernist painting could still be a force for effecting change toward a more basic and particular substance of art. "At present, a radical redefinition of current painting," she wrote, "is pertinent and possible."[22]

In their essays of this time, Greenberg and Michael Fried were championing Morris Louis, Noland, Jules Olitski, and, in Fried's case alone, Stella. The key questions for the continuation of modernist painting involved the optical experience of color and the dialectics of internal and enclosing shape. Baer produced what she called a radical redefinition of painting, by arguing that the root of painting was neither flatness nor color nor shape. She placed the emphasis entirely on light. Explaining her point, she distinguished three types of light: emitted light, light as from a bulb; light through a substance, such as a prism or a section of fiberglass; and reflected light, "light reflected back from the surface of an object allowing us to see this object."[23] Painting, she wrote, was concerned fundamentally with the third kind of light. That is, the light that is reflected back to the viewer's eyes from the surface of a painting.

In another text, she summed up her practice: "Painted light: not color, not form, not perspective, or line, not image, or word, or equations, is painting. I make paintings which do not represent light, they are light."[24] In a passage in "Mach Bands" that recalls Fried's description of Minimalist sculptures in darkened rooms, she invited readers to imagine a painting and a sculpture in a room together: "If all the lights in a room are turned out, there isn't much to know about a painting excepting its texture and its shape against the wall."[25] But there is plenty still to be ascertained about the sculpture: its mass, shapes, movements, materials. The essence of painting can be distilled only once the lights are turned back on. In her words, "Bounded, colored surface light is painting's ontological bottom."[26]

By reconceiving painting in this way, Baer was able to offer some progressive ideas about the role of the medium, but her redefinition cut a swath through other practices. As the string of *not*s suggests, she was every bit as concerned with downplaying other work as articulating a theory for her own. Her concentration on reflected light led her to condemn Color Field painting as hedonistic. In the 1970s, she referred to it as "sexual solipsism."[27] Olitski and others were merely providing viewers with lush, fluctuating fields of color that were, to her, decorative. Light was itself to be conceived as definite rather than fragile. Baer's approach was quite distanced from what she must've seen as the romantic, mystical, sublime approach to light espoused, for instance, by Agnes Martin, whose work Baer later called "evanescent." With Baer's image of the painting in darkened rooms, she brushed aside first Stella, whose concern with external shape was, for Baer, merely sculptural, and Ryman, whose textured, impastoed surfaces were also characterized by Baer as the product of sculptural activity. Touch, for Baer, implied a thickening of surface and a confusing play of light. For light to reflect off a surface in as precise a way as possible, surface had to be even, and touch to be banished from the field of painting to the terrain of sculpture.

While her concentration on light enabled her to position her work against other modes of painting, it also provided the means to defend painting against those who distrusted the medium. Despite what Judd and Morris wrote, painting, she pressed, could be as free from spatial illusionism as their objects, and every bit as precise. In a letter she wrote to Morris, she invited him to "Consider paint a film of light reflecting/absorbing material, and a colored paint a material which gives a particular, characteristic transmission of light via differential absorption and reflection. Call this reflected quality 'luminance' and measure it in millilamberts. This measure is as real and present as height, breadth, depth; and I find the phenomenon equally sumptuous and convincing."[28] Baer continued, firing off a preemptive strike against the predicted counterargument that an artist like her, interested in light and set against illusionism,

should use actual lights. "Light," she wrote, "not 'lamps,' which are complicated artifacts . . . qualified by industry and the markets."[29]

Looking at Flavin's ironic commentary on painting, which had been constituted most clearly in his *a primary picture* (1964), Baer could've remarked on the imprecision of its effect, on the residual similarity of the blurry rectangle between the fluorescent tubes to a Mark Rothko painting. But her attack on Flavin instead predicts Hal Foster's analysis of Minimalism.[30] She saw just how his version of the readymade was every bit as tied to contemporary industrial production as was Pop. Baer's comment on lamps suggests a desire to separate painting from the world of capital, but her texts do not suggest that she wanted her work to be autonomous. Instead, she insistently articulated its political implications. At the end of "Mach Bands," she suggests that "perhaps it is now propitious for radical painting's surfaces to mediate new color and value relations between a more closely examined observer and an expanded, more worldly observed."[31] If painters, Baer intimates here, paid more attention to the physiology of perception, their works, though not referring beyond themselves directly to things in the world, could produce visual experiences that speak to the everyday observed world beyond painting.

This model of reference was one of analogy. A particular visual experience could stand, in a concrete way, for an attitude to life. Baer's politics were rearticulated in 1970, in her response to the *Artforum* symposium "The Artist and Politics." Asked, "What is your position regarding the kinds of political action that should be taken by artists?" she divided contemporary practices into three. Figurative work looked to the past; protest art, Pop, color painting, and "concept art," as she called it, all mirrored the present, displaying both the good and bad aspects of the now. Only radical abstract art "aimed at the future."[32] Abstract artworks imply political situations through their forms; works that "picture their own shapes"[33] imply that viewers similarly should determine their destinies. A deductive structure was thus, for Baer, an intimation of self-sufficiency and personal freedom. Going further, she suggested that artworks that explored and echoed their formal boundaries

intimated an approach to territorial boundaries. It was almost as if Baer, highly involved in the Art Workers' Coalition at this point, implied that the tightly bounded painting implied a non-expansive foreign policy.

Later on, Baer articulated a political reading of the processes behind her work: "This act of looking long to the nature of the object and into its specific organization stood for a hard look at integrity and the motions of deceit."[34] Baer suggested that the very kind of inquiry that produced her work "projected a quasi-political visionary stance."[35] For Baer, both the rigorous, focused process leading to paintings and their finished forms stood for political attitudes.

Some of these political models might now seem naïve, others very nuanced. What remains of interest is the fact that the arguments were made in the first place. We should remember, after all, that though Baer's texts indicate how useful modernist theory could be, many artists at the time thought it washed up. No other Americans mobilized Greenberg into arguments for a politicized, progressive abstraction—least of all Dan Graham, Ed Ruscha, or Dennis Oppenheim, whose texts were nestled inside *Aspen* alongside Baer's "Mach Bands."

In the end, Baer's texts are symptoms of the compromised position of painting at this moment more than a diagnosis of her own work. For guiding us around her own oeuvre, Baer's programmatics can seem little more helpful than the blank map in the hands of the hunter of the Snark. Occasionally, though, amid the science and utopian politics, the attacks and defenses, the insistence on measurement and the injunctions on texture, there are suggestive phrases. In the letter to Morris, for instance, there's the word *sumptuous*—an indication that Baer found painted light resplendent, rather than restrained. And in May 1969, bemoaning one reviewer's tired use of the word *minimalism*, she wrote in a letter to *Artforum*, "I believe in a maximal art content, and work for paintings which are as complex as the world I find around me."[36] In these isolated passages, there are clues that the meaning of her work might be found outside, rather than within, the parameters of the art discourse of the period.

Jo Baer, *Untitled (White Star)*, 1960–61

are powerful and recurrent in Baer's practice, helping to describe her works, the viewing experience she creates for the spectator, and her own development from one group of works to the next. These ideas, for instance, could help account for Baer's encounter with Pop. Married to John Wesley at this time in the early 1960s, like him she produced flatly painted canvases based on flags, stamps, heraldry: simplified, crisp, abstracted images. The obvious direction for this kind of work was the one that Wesley took it. Though the framing bounds hardly disappear, the interior gets more and more complex.

Baer's direction was counterintuitive. It wasn't the center that counted, but the border. In her painting *Untitled (White Star)* (1960–61), a black star is bordered by a blue line. This outlines the star, but is not always at its periphery. At the top, it bends down below an equally thick band of black. Black and blue are twisted around each other at the border of the main painted shape. The binary inside and outside is confounded. In her next works, the Korean series, Baer would empty the central painted figure away, while she continued to complicate inside and outside. Using the same palette, Baer painted fifteen canvases, all with black squares. In each, a blue line traveled down the inside edge of the two flanking and bottom black lines, reading as a kind of internal border. But blue also runs along the outside of the edge of the black at the top, complicating any clear sense of inside and outside. The paintings were further differentiated at their tops. Sometimes an additional long horizontal blue line was caught in the middle of the black. In every painting, there were two matching patterns in the top corners. These were collections of short blue horizontal or vertical lines, some more complex than others. Noticing these details, the viewer's attention is diverted from the

center to the top. The periphery becomes the central site of interest. This movement is all the more forceful because of the look of the patterns themselves. On their own, they bring to mind logo designs, Bauhaus typography, and, to the contemporary viewer, the trademarks on Adidas sneakers. But in the context of the composition, they invoke column capitals, curtain rails, or even brackets.

Do the paintings seem to stage events—events that fail to take place? The centers can seem empty. But as soon as one concentrates on their emptiness, the focus is thrown back onto the changing details themselves. Baer first showed these paintings as a group in 1971, almost ten years after they were made. The differences between the Korean paintings could not be described by a schema, and her decision to show this nonserial series might point to her reluctance to embrace the discourse of seriality into which her work by then had been placed. Coincidentally invoking Carroll, Kasha Linville, in her excellent review of the 1971 show, asked, "How does one explain the Alice-in-Wonderland feeling that the pictures could be minute or infinite, a sensation that disconcerts the viewer's perception of his own scale?"[38] The pairs of terms that reverse and twist in these paintings are *inside* and *outside*, *center* and *periphery*, *blankness* and *detail*. Another binary that Linville's account points to is immense and miniscule size.

Of course, there's a fourth pair of terms that twists around in the Koreans: *figure* and *ground*. At one moment, the black frame seems to lie in front of the white, and at the next, the whole surface seems equally frontal. Perhaps under pressure, Baer banished this illusionism from her paintings of the mid-1960s, but that did not mean that the work could no longer offer the sumptuous maximal experience that Linville described. Baer must have sensed that one of the unexpected excitements of the Korean paintings was that blue paint looked different when it was enclosed within the black than when it was situated between the black and white. Seeing this difference and drawing on it, she progressed to the next phase of her work, which includes *Primary Light Group*, where, as I described at the beginning, color zooms around in the bound of each painting,

Jo Baer, *Untitled (Vertical Flanking Diptych–Green)*, 1966–74

where its velocity counters the rest of the painting's stillness.

As Baer's work up until now had hinged on the twisting of two elements in a contemporary binary—primary/secondary, drawing/painting, figure/ground, inside/outside, center/periphery, slowness/speed—it's hardly surprising that she would make good use of the very idea of pairing. With *Untitled (Vertical Flanking Diptych–Green)* (1966–74), Baer's approach to binaries seems to unravel and twist round again. The binary is now a pair: not two opposite terms, but two identical paintings. However, the viewer's knowledge of the pair's identity scuppers in the visual encounter. Just as it's impossible to look into the two eyes of a fellow person, so it's impossible to view the whole composition at once. The pair structure encourages the viewer to look to one side. And as they do, the colors in the other, seen only in the periphery of vision, look totally different.

Baer called these nonserial diptychs, the point being, presumably, that what counted was neither any progression from one to the other, nor repetition as a means of noncomposition, but the extraordinary difference between the identical units that emerges in the viewing process alone. The drama inside the colored bounds of *Primary Light Group* and mid-1960s diptychs occurs in two discrete places on the surface of the double-bar works. The eye no longer chases changing color around and around the white, but scans back and forth across it. In the process, the white section gains more of an identity as a shape in itself. It's a shape that wraps around the two bars, which don't quite reach the edge of the paintings. What happens here is again quite contrary to expectation. Precisely in the course of relinquishing the black band that followed the shape of the canvas, Baer found that the literal boundary of

the painting had become more pronounced. The actual edge, in other words, was more evident when not being echoed by the internal composition. But now, as the white area leeched out of the center to the edges, there was the threat that it would merge with the wall, that the surface would dissipate

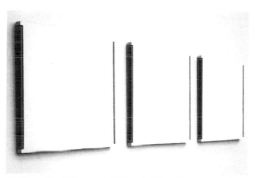

Jo Baer, *Grey Wraparound Triptych (Blue, Green, Lavender)*, 1970

into the space around. The way for painting to avoid assimilation to the space of the wall was mimicking sculpture.

Baer would next acknowledge the literal three-dimensional volume of the support. The Wraparounds can thus be seen as the necessary consequence of the double bars, as a means of protecting the painting. In painting around the edge, however, Baer risked treating the canvas as an object—she risked falling into the very trap that Judd and Morris had claimed lay waiting for the painter. And of course, they leapt into this trap with excitement. But Baer avoids the trap. For though the Wraparounds mobilize the three-dimensionality of the support, its literal bulk, the viewer never experiences this three-dimensionality as verifiable or objective. The new binary, whose terms are *face* and *side*, is posed as the subject of the Wraparounds precisely in order to blur, rather than specify, the difference between the terms. In front of the face of a given painting, the viewer senses strongly that the bars extend around the side of the support. This sense arises not just because of the composition on the canvas, but because of what's happening in the viewer's peripheral vision. Since there are six canvases, wherever the viewer stands facing the front of a painting, she also sees the sides of others. The intervals are carefully wide enough to grant this oblique aspect, but not too wide so as to separate the series.

The composition that wraps around consists of a rectangular loop of bright color that encloses a black rectangle. The colored area

is itself enclosed on both of its short horizontal and one of its long vertical sides by a thin band of the same black. Because of this, it would make sense for the other long side to meet the front-to-side vertical edge of the canvas. However, this is not the case. For the enclosed black rectangle itself wraps around, only just. In terms of the composition, the edge is not where you think it would be. And because the paint on the edge is black and absorbs light rather than reflecting it, there's no way of telling exactly where the edge is. So side and front are not only hard to distinguish because of the canny, counterintuitive nature of the composition, but also because of the way light behaves off a black painted surface. The black paint flattens out the edge, which disappears in a way not dissimilar to the disappearance of the corner of the room in Flavin's Corner Pieces of the same period. But if Flavin's works destroy architecture, Baer's succeed in specifying what for her is the "ontological bottom" of painting, even in the process of acknowledging the literal three-dimensionality of the support.

Though it is difficult to distinguish front from side, there is a way of finding out what is what—but finding out involves inspection. And inspection involves bodily movement. Could it be to record the phenomenological account of Minimalism that Baer wants to make her viewers aware of their physical movement around the work? I hardly think this is the point. What seems to have concerned her was far less the viewer's movement than the desire that prompts it, the desire to find out.

Finding out is the predominant activity that the early to mid-1970s paintings, which she called the Radiator works, require of their viewers. The Radiators include vertical paintings four inches deep, painted on their fronts and their two flanks, and horizontal paintings hung almost touching the floor, also four inches deep and painted on four sides: the top, the two flanks, and the front. Looking at *V. Speculum* (1970), the viewer sees a mainly cream surface, with one gray truncated triangle extending down from the top right corner, and another truncated triangle, black, rimmed with green, extending upwards along the central half of the left side. *V. Eutopicus* (1973) presents two curved shapes just meeting toward

the left. Because of the obvious depth of the
stretchers, and because the shapes extend right
to the edge, the viewer walks to one side. As
the viewer moves, his aspect begins to include
both the front and the flank of the painting;
as a result, the sense of the initial shapes that
he had seen on the front alters.

It's not right to say that new shapes
emerge gradually during movement to the side:
they emerge suddenly, at specific points along
the journey. For instance, at forty-five degrees
to the right of the surface of *V. Speculum*,
the gray truncated triangle becomes a perfect
rectangle. In *V. Eutopicus*, at the same angle
to the right side, the viewer has a sense that
the curved, gray shape on the right hand of
the front now completes a regular oval, which

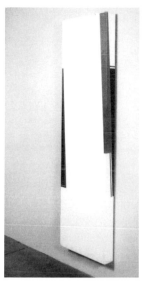

Jo Baer, *V. Speculum*, 1970

extends over the edge from the right flank—or almost completes it,
were it not for a chunk of the oval that is cut out along the flank.
This cut prevents the oval's completion, but results in a shape that is
uncanny, strangely familiar. The viewer remembers her first frontal
aspect, and suddenly realizes that the shape on the flank is the twin
of the shape on the left of the front, which had seemed irregular,
but which now has a new identity as one of a pair.

There is a kind of puzzle here. Inspecting the painting, the
viewer feels that she is making sense of painted shapes in a number
of eureka moments. A truncated triangle is suddenly half of a
rectangle; an unknown shape is one of a pair. Aha! she wants to
exclaim. So that's what it's all about.

The colors of the Radiator paintings are quite different from
the colors of Baer's other works to that date. Gone are the felt-tip
pinks, the buzzing turquoises, and the zesty oranges. The colors
aren't discreet anymore, but are instead tonal—pastels, creams,
yellowed whites, earthy reds and browns, various light olives. There
was no doubt that the pink on the side of a Wraparound was the
same as the pink on the face of the painting. But standing to

the left of *V. Eutopicus*, the viewer can be less sure whether the green is actually the same green that's on the front. It looks darker. But of course it does. The paintings are lit with spots directed to the front, so obviously, there'll be less light on the flanks, and consequently, colors will look slightly different. Sometimes, though, Baer confounds this apparent change of color by making it actual. She will use one color for a shape on the front, and a slightly darker one in a contiguous shape on the flank. This is clearest where, at the top left corner of *H. Arcuata* (1971), a dark red on the front meets a very close brown on the top. If the first puzzle set for the viewer involves shape, the next invitation is to tell apart real and apparent color shifts. This means inspecting the paintings, and for these horizontal ones, it means getting on hands and knees. Baer once wrote about Claes Oldenburg's *Bedroom Ensemble* (1963), which may come to mind in the encounter with the Radiators; the absurd parallelogram bed prompts the viewer to move to one side to make the bed rectangular. But just as they move, everything else begins to blur. One thing resolves, something else warps.

As the viewers of the Radiators go about solving puzzles of shape and color, a third puzzle is set by the paintings. This one combines and complicates the terms of the first two: it has not to do with depicted shapes on the canvas, but the literal volume of the support; not with the colors that light variations cause to seem different, but the actual shadows that the volumes cast. As far back as Baer's mid-1960s diptychs, shadows on the wall had played a part, albeit an uninvited one, in the artist's compositions. Any interval between two stacked paintings would divide into a dark band of wall space shaded by the bulk of the higher painting, and a lower, fully lit band of wall just above the bottom painting. In the aluminum, stacked horizontal diptychs, this is particularly dramatic, as the light and shaded areas of the wall correspond to the light contrast between aluminum paint and white paint on the surface of the two paintings. To acknowledge these shadows risked treating the paintings as objects, though, and this was something that Baer was reluctant to do. But what if real shadows could be taken, as it were, from off the wall and onto the paintings themselves, and

thus be made part of the painted, rather than the object, identity of the work? This is what happens in the Radiators. In the horizontal low paintings, deliberately hung just high enough above the floor to cast a shadow onto it, Baer painted trompe l'oeil shadows onto the support to mimic these actual shadows. On the side flank of *H. Arcuata*, there are two intersecting black painted triangles mimicking a shadow. And along the bottom of *H. Tenebrosa* (1971), there is a very low triangle that's painted. Perhaps the most cunning trick in the series involves a kind of shadow in reverse; in *V. Speculum*, there's a glint along the edge. In *H. Tenebrosa*, Baer replicates this kind of glint with a very thin line of white paint running along the edge. To solve the puzzle and tell the two apart, the viewer must inspect the painting like a detective. In these works, neither shapes nor colors nor shadows are what they seem.

The whole journey of Baer's work into three dimensions is counterintuitive. There are five distinct directions from which to view the vertical paintings, rather than an infinite number of aspects, as around a sculpture. Thus the duration of the viewing encounter is limited. Fried famously described the feeling of endlessness that one experiences walking around Minimalist work, before arguing for the stopped time of presentness with which modernist painting graces its viewer. Baer's Radiator paintings demand time, but only a certain amount of it. The inspection that the viewer performs soon comes to an end, and when that end arrives, he can move on—yet not without a certain nagging feeling.

The Radiator paintings are named after orchids. Baer grew them in the 1960s, frequently writing for the *American Orchid Society Bulletin*. It's likely that she would've known, through her hobby, a book by Norman MacDonald, published in 1939, called *The Orchid Hunters*. It's a tale of two youthful New Yorkers who leave the city in the 1930s to search for a rare species of flower in the jungles of South America. Before their expedition, the adventurers visit an old hunter. Laid low and coughing with pain, he warns the boy of what lies in store.

Your lips will crack, and you'll lick them and taste the salt of your own sweat. The sun will burn you by day, and the cold will shrivel you by night. You'll be wracked by fever and tormented by a hundred discomforts. But you'll go on. For when a man falls in love with orchids, he'll do anything to possess the one he wants. It's like chasing a green-eyed woman or taking cocaine. A sort of madness.[39]

In the description, the orchids, though pursued, are firmly in control. It's the hunters who will be entrapped, their actions a mere effect of the flowers' charm.

Baer's paintings are named after orchids, but not because of their appearance, and surely not just because of Baer's hobby. It's because of the trap, the madness that the paintings create for their viewers. For describing viewing as detective work does not explain the final nagging feeling the viewer has after leaving the paintings, of having been controlled, manipulated. Every move made has been anticipated. As a detective, he is performing a role scripted for him, following clues he's meant to find. To recall Bochner's phrase, this is a mind-cramping feeling, a claustrophobic one. But even after a viewer is in possession of all the clues—that is, after having inspected the paintings from all viewpoints—the paintings as wholes remain unknowable, since not all views can be available at once. Like orchid hunters, the viewer of the Radiators chases after an elusive prize.

Recall that the viewer of *Primary Light Group* is unable to fix colors from flashing and changing. Here, too, with these later works, the viewer never stops feeling locked into a world of distortion. But this time, the world seems less playful, more unnerving. For strangely, the viewer is also locked out of the world of the paintings, excluded, like the inhabitants of Oldenburg's *Bedroom Ensemble*. Writing on that work, Baer commented that whereas bedrooms exist as arenas for humankind's most necessary and personal affairs, Oldenburg's bedroom is impersonal, inflated, non-utile, and unanimated. No intimacies, sleep, sex, or nail clippings seem possible in this bedroom. If the occupants are shut out from the tableau, so too is Baer's viewer. For all his movement

and hard work is not affirmed by the paintings, but excluded, cast by them as a kind of irrelevance.

In the last works in this show, the symbols that had been important for Baer early on return. Baer's viewer is no longer made to pursue puzzles of shape and color, but of symbol and meaning, deciphering the dots

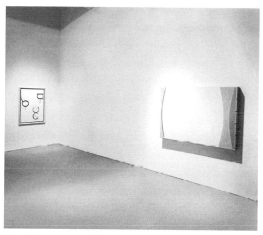

Installation view, including *Cadmos' Thicket*, 1973, and *M. Refractarius*, 1974–75

and dashes on *M. Refractarius* (1974–75), the ancient scripts on *Cadmos' Thicket* (1973). After her 1975 Whitney retrospective, turning away from the work discussed here, Baer embarked on radical figuration, where images would be juxtaposed and meanings could be decoded. Clearly, for her, it was still important to work in painting, but abstraction was no longer feasible.

New Coordinates

Though Baer and others have characterized the shift as one from abstraction to figuration, this examination has hopefully implied the inadequacy of such an account. For if Baer's program at this stage meant declaring "I am no longer an abstract artist," that would privilege the term *abstract*, as if the only two words that could describe her oeuvre were first *abstraction* and then *figuration*. Isn't it necessary to change the coordinates for locating Baer's early work? Despite Baer's insistence on abstraction, the Radiators share very little with the work of other painters like David Reed or Mary Heilmann, both then rethinking gesture. Yes, some of the shapes on the Radiators look speedy and gestural; they even look like drips. But the important term here is look *like*. The shapes only evoke speed and spontaneity; there's never a sense that they're made

quickly—quite the opposite. The viewer never forgets that they are meticulously preplanned.

The artists whose works share the most with the poetic structures of Baer's mid-1970s paintings were hardly those concerned with distinctions between media. One might think, for instance, of artists whose work set in train viewing encounters that are similar: some of Douglas Huebler's Variable Pieces which set absurd games for their viewers, or Bochner's *Axiom of Indifference* (1973), which requires its viewers to move around from one side of a wall to another, remembering what they see and read as they move. Peter Campus's installations demand oblique viewpoints, and destabilize the viewer's sense of her own identity.

It's not as if these similarities to nonpainters only emerged in the 1970s, though; Baer's counterintuitive compositions and strategies had always shared less with the deductive structures of Stella than with Smithson's concepts of displacement and site/Nonsite. Just as Baer would empty the literal center to make the periphery centrally important, so Smithson conceived a Nonsite as "the center of the system," and the site itself as the fringe or the edge. For all the shortcomings of Smithson's account of Baer's blankness, there is more than a visual link between her work and his 1968 *Mono Lake Non-Site*. Smithson said that his map tells you how to get nowhere. If the coordinates of a map to locate Baer remain only painting and sculpture or abstraction and figuration, those responding to her work will only ever reach the same place, fast.

February 20, 2003

Notes

1 Jo Baer, letter to Robert Morris, July 29, 1967, in *Jo Baer: Broadsides & Belles Lettres: Selected Writings and Interviews 1965–2010* (Amsterdam: Roma Publications, 2010), pp. 41–42.

2 Walter Benjamin, "A Child's View of Color" (1914–15), in *Walter Benjamin: Selected Writings, Volume 1: 1913–1926*, ed. Marcus Bullock and Michael W. Jennings (Cambridge, Mass.: Belknap Press, 1996), p. 51.

3 See James Meyer, *Minimalism: Art and Polemics in the Sixties* (New Haven: Yale University Press, 2001).

4 Brian O'Doherty, "Art: Avant-Garde Deadpans on Move," *The New York Times*, April 11, 1964.

5 Donald Judd, "Specific Objects," in *Donald Judd: Complete Writings 1959–1975* (Halifax: Press of Nova Scotia College of Art and Design; New York: New York University Press, 1975), p. 182.

6 Ibid.

7 Robert Morris, "Notes on Sculpture, Part 1" (1966), in *Minimal Art: A Critical Anthology*, ed. Gregory Battcock (Berkeley: University of California Press, 1995), p. 223.

8 Morris, "Notes on Sculpture, Part 3: Notes and Non Sequiturs," in *Continuous Project Altered Daily: The Writings of Robert Morris* (Cambridge, Mass.: MIT Press, 1993), p. 25.

9 Baer, statement in *Systemic Painting* (New York: Solomon R. Guggenheim Museum, 1966), p. 23.

10 Mel Bochner, "Systemic Painting," in *Solar System and Rest Rooms: Writings and Interviews, 1965–2007* (Cambridge, Mass.: MIT Press, 2008), p. 15.

11 Ibid.

12 Ibid.

13 Ibid.

14 See James Meyer, "Non, Nothing, Everything: Hesse's 'Abstraction,'" in *Eva Hesse* (San Francisco: San Francisco Museum of Art; New Haven: Yale University Press, 2002).

15 Robert Smithson, "A Museum of Language in the Vicinity of Art," in *Robert Smithson: The Collected Writings*, ed. Jack Flam (Berkeley: University of California Press, 1996), p. 92.

16 Ibid.

17 Ibid.

18 Ibid., p. 93.

19 Ibid.

20 Bochner, "Systemic Painting," p. 15.

21 Baer, letter to Robert Morris, July 29, 1967, in *Jo Baer: Broadsides & Belles Lettres*, pp. 41–42.

22 Baer, "Art and Vision: Mach Bands," *Aspen* 8 (Fall–Winter 1970–71), n.p.

23 Ibid.

24 Baer, letter to Robert Morris, July 29, 1967, in *Jo Baer: Broadsides & Belles Lettres*, p. 42.

25 Jo Baer, "Art and Vision: Mach Bands," n.p.

26 Ibid.

27 Baer, "The Artist and Politics: A Symposium," *Artforum* 9, no. 1 (September 1970), p. 35.

28 Baer, letter to Robert Morris, July 29, 1967, *Jo Baer: Broadsides & Belles Lettres*, p. 42.

29 Ibid.

30 Hal Foster, "The Crux of Minimalism," in *The Return of the Real: The Avant-Garde at the End of the Century* (Cambridge, Mass.: MIT Press, 1996), pp. 35–70.

31 Baer, "Art and Vision: Mach Bands," n.p.

32 Baer, "The Artist and Politics: A Symposium," p. 35.

33 Ibid.

34 Baer, "I am no longer an abstract artist," in "The '60s in Abstract: 13 statements and an essay," *Art in America* 71, no. 9 (October 1983), p. 137.

35 Ibid.

36 Baer, letter to the editor, *Artforum* 7, no. 8 (April 1969), pp. 4–5.

37 Sara Rich, "Jo Baer," *Artforum* 41, no. 6 (February 2003), pp. 133–34.

38 Kasha Linville, "Jo Baer at the School of Visual Arts," *Artforum* 9, no. 9 (May 1971), pp. 77–78.

39 Norman MacDonald, *The Orchid Hunters: A Jungle Adventure* (New York: Farrar & Rinehart, 1939), p. 1.

Robert Whitman's *American Moon*: A Reading in Four Phases

TOM MCDONOUGH

In the early 1960s, when Harriet Janis and Rudi Blesh were writing their influential account of the collage aesthetic in the twentieth century, they turned to Allan Kaprow for information and advice while composing the final chapter. It was to address the recent development of environments and Happenings in New York, and Kaprow was a natural spokesperson for the group of artists assembled around the downtown Reuben Gallery, where much of this innovative work was taking place. He was intelligent and well-spoken, with a professorial cast that appealed to his rather uptown interlocutors, who made sure to note in their text his position in the art department at Rutgers. His respectability belied what was seen as the shocking nature of his work. In his interview, he gave Janis and Blesh brief sketches of the main personalities in the genre.

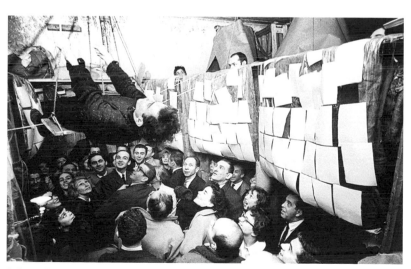

Robert Whitman, *American Moon*, 1960

Claes Oldenburg was described as "very literary, a social critic using archetypal situations, with a warm feeling for people and a strong sense of moral purpose." Jim Dine was "an artist of magical, mysterious, Gauguinesque symbolism yet using immediate actions." Red Grooms appeared as "a Charlie Chaplin forever dreaming about fire." George Brecht, too, was mentioned, his work seen as "an abstract *arcane* suspended in feeling and very pure." And then there was Robert Whitman. Kaprow simply characterized him as "the most adventurous and intuitive of all of us."[1]

This was no mere homage to a star pupil on the part of his onetime teacher. (Whitman had studied with Kaprow while an undergraduate at Rutgers in the mid-1950s.) The former had recently presented his most ambitious work to date, a Happening titled *American Moon*, at Reuben, over the course of several evenings in late November and early December 1960. Kaprow would describe it as "a strange, dark masterpiece."[2] And indeed, it marked a crucial turning point in the artist's trajectory. *American Moon* signaled the beginning of Whitman's increasing commitment to an "abstract theater," as he described it, and his ever-growing distance from the production of discrete objects. He would become "the most adventurous" of those exploring theatrical forms, and one of the only artists among the circle around Kaprow to devote his full energies to that exploration. Whitman's Happening completely transformed the space of the Reuben, then in its second incarnation, at 44 East Third Street. Whitman created a central elliptical performance area, from which six crudely constructed tunnels radiated. Audience members were seated in these tunnels, able to see only fragments of the overall action of the production, and unaware of the full extent of the environment in which they were immersed. What they witnessed was an ambitious procession of enigmatic images that made use of filmic as well as human action, and an array of props that transformed the most banal of materials into almost otherworldly apparitions.[3]

Yet while the significance of *American Moon* is widely acknowledged, and while we have clear written and photographic accounts of its performance, there have been remarkably few attempts at

reading the work.[4] Whitman has noted this curious gap, protesting that "people tend to overlook the literary value of the kind of theater we've been doing. Nobody seems to be very interested in talking about it, partly because it is a little more difficult."[5] Certainly, this has something to do with its rather hermetic character, a trait shared with the genre of the Happening as a whole. Michael Kirby once described their structure as insular. In the vaguely cybernetic language in favor at the moment he wrote, he noted that they were "based on the arrangement and contiguity of theatrical units that are completely self-contained."[6] Such fragmentation seems intended to resist the solicitation of synthetic or totalizing meanings, and presents any commentator with a conundrum: how to approach this work without simply imposing, through interpretation, a closure alien to its open-ended structure? Perhaps just as *American Moon* refused the classical narrative continuities of beginning, middle, and end, we might abjure the inevitabilities of complete explanations in favor of more humble syntheses. Such an approach—taking the form of four phases, in accord with the lunar character of Whitman's performance—seeks to solicit the latter's various resonances across the artistic and social landscape of its time.

Waxing

We might begin, appropriately, with a section titled "Waxing," not only in reference to my hope of increasing our illumination of Whitman's work, but also in reference to "waxing poetic"—in particular, to nursery rhyme. For the title *American Moon* immediately recalls what is probably the best-known nonsense verse in the English language:

> Hey diddle diddle,
> The cat and the fiddle,
> The cow jumped over the moon.
> The little dog laughed
> To see such sport,
> And the dish ran away with the spoon.[7]

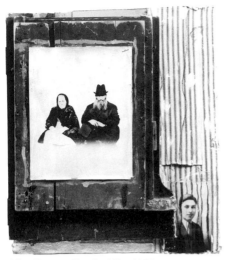

Allan Kaprow, *Grandma's Boy*, 1957

Robert R. McElroy's most famous photograph of the performance—of Lucas Samaras stretched out to his full length on a trapeze, just over the heads of a laughing audience—inevitably evokes this favorite childhood doggerel. The scene occurred toward the end of the piece, and began with the house lights coming on and Whitman himself standing in the central space, asking the audience to leave their seats in the tunnels and to join him. After everyone had gathered, the lights were shut off. When they were restored, a startled audience found, just a few feet above their heads, the rigid body of a man sitting on a swing. He was accompanied, at either end of the oval space, by balls of colored cloth, which, in contrast to his immobility, danced at the end of ropes. After a few moments of this vision, the lights went out again. And in a final movement, lit only by flashbulbs and flashlights, the heads of the performers gradually rose into view around the catwalks erected around the room, and then sunk back down. Not to say that *American Moon* is a literal transcription of the nursery rhyme. But it does seem to partake of the latter's grounding in the experience of everyday objects. It also seems to partake of its delight in the absurd, in the manner in which it brings those objects together, and in its insistent physicality, its jumping, laughing, and running away.

Childhood memories, like that of "Hey diddle diddle," seem to have played an important role in the culture of Happenings.[8] Kaprow's work of the time, for example, is replete with references to his youth, in the 1930s. *Grandma's Boy*, a much-reproduced assemblage of 1957, is a canvas onto which a piece of broken furniture, perhaps part of a cabinet, has been hinged. While the hinge is

closed, the viewer is faced with a yellowing photograph of a seated elderly Jewish couple; while opened, the viewer finds a collage that includes a mirror and mattress ticking, the striped pattern of which extends down, in drawn lines, over the photograph of a formally posed young man, imprisoning him, perhaps, in this rather stifling world of domestic memorabilia. The influence of Robert Rauschenberg's combines of the mid-1950s is evident here, although Kaprow's work is notably smaller, quite literally a "cabinet" picture, intended to hang on the wall. The overall tone is redolent of ambivalent nostalgia for a Depression-era childhood, that moment of crisis lived not, as for an older generation, as a moment of radicalization and commitment, but, rather more cryptically, as a time before the all-pervasive spread of the commodity into every sphere of private life, as an ideal that was simultaneously attractive and suffocating.[9] However, such a reading, which understands *Grandma's Boy* as a reflection by the artist on his youth, must be tempered by our knowledge that these are not photographs of Kaprow or his family. As he has recently explained, they were found in a rented farmhouse.[10] Perhaps something of this dissembling is signaled in the work itself. When the object is closed, the facing mirrors of the panel and the hinged door repeat each other into infinity—a *mise en abyme* of reference and signification, of the self as theatrical construction.

But childhood did not only evoke a nostalgic reaction among these artists. At the least, we may assert that it was not the dominant emotional tenor of *American Moon*. Rather, the recollection of childhood and its play provided in several instances a concrete model for the kind of movement Whitman would enact, for what we might call his meaningfully repetitive gestures. In particular, one of the few segments in which the human body appears "as itself" unadorned—is distinctly evocative of the world of play: two bodies, those of a man and a woman, roll toward each other from either end of the oval arena, bumping against one another and rolling back. This is repeated several times, until one body rolls over the other—"like two logs might roll across each other," one performer remembered—and continues across the space.[11] This

occurs once again, and after the sequence, both figures return to the arena, now engaged in an insect-like, prone hopping. Each hops toward the center of the oval, circling the other until the lights go out. The man in this scene was Whitman himself, and his partner, significantly, was Simone Forti, at that time married to Robert Morris. She had met Whitman earlier in 1960, after a performance of his *E.G.* at the Reuben, where she had been struck by the affinity between her own developing aesthetic ideas and those found in Whitman's theater pieces. At the time, she was teaching at a nursery school, where she was observing attentively the games and movements of her charges. Her own sense of movement was close, as she later described it, "to the holistic and generalized response of infants."[12] Their shared sense of the unity of performer and environment, of a breakdown of rigid subject-object relations as articulated through play, made them natural collaborators.

Forti had arrived in New York from San Francisco the previous year, where she had studied for some time with Anna Halprin's Dancers' Workshop. The latter's emphasis on improvisation and on natural movements was formative; it can be seen not only in the rolling and hopping segments of *American Moon*, but also in two works Forti presented herself at the Reuben Gallery in December 1960, just after Whitman's Happening. This was, in fact, upon Whitman's invitation. Her *See-Saw* and *Rollers* shared billing with works by Dine and Oldenburg. As described by dance historian Sally Banes:

> Both of Forti's pieces were games for adults, based, with very few changes, on children's playground equipment. The structure of each piece showed the operations of the adult body in a situation that is ordinary for children, but rare for adults. Skills of balancing and adapting to momentum were tested in a systematic examination of the processes of equilibrium.[13]

Performed by Morris and Yvonne Rainer, *See-Saw* and *Rollers* were, one could equally say, "performed" by the accessory objects that played an absolutely determinant role in the production of

trajectories, gestures, and bodily states. Initiative here lay not with the human subjects, but with the concrete, material elements with which they interacted: the unbalanced plank and the box on little wheels, pulled about by members of the audience.[14] A similar reversal of subject and object was planned

Simone Forti, *Rollers*, 1960

for *American Moon*—in the so-called "Big Wheel" that was never realized, for purely technical reasons: a standing person would be centered in it, with the wheel able to tilt from the vertical to the horizontal, a Renaissance Vitruvian man merging with a Space-Age gyroscope. Here, too, the human was subsumed under the logic of the mechanical, in an image that was both one of play, with its recollections of the exhilarating loss of motor control, and one of the farthest points in technological rationality. Just as Samaras had posed frozen on his trapeze while cloth-draped globes animatedly cavorted around him, Whitman's work consistently inverted the terms of the active body and its inanimate accoutrements in an absurdist vision worthy of the world of nonsense rhyme.

Full

American Moon does not only evoke childhood, its nursery rhymes and its games. It also evokes the full moon, as in the segment during which Forti and Samaras crawled under a giant inflated plastic balloon that filled the central performance space. Whitman then came out and stood over them, staring into the balloon with his hands resting on its shiny surface, an enigmatic man-in-the-moon looking down on the earth and its inhabitants. *American Moon* also recalls the full moon of Georges Méliès's early-cinema classic of 1902, *Le voyage dans la lune* (*A Trip to the Moon*). There, too, one could find

a figure sitting on a crescent moon suspended from a guyline—a moon-maiden now, but a clear enough echo of Samaras on his swing to allow us to posit the connection. Indeed, such early films were well known to Whitman's larger downtown circle, and were appreciated for their so-called "primitive" quality. Méliès's *Voyage* was particularly popular, so much so that in 1962, photographer and filmmaker Rudy Burckhardt along with Grooms would make their own version, titled *Shoot the Moon*, which, at twenty-four minutes long, was almost twice the length of the original. These echoes raise the larger question of the place of film in Whitman's work, and of the particular role it plays in *American Moon*. He certainly was not alone in that interest. Several colleagues also explored the use of projections as an element in performance: Kaprow showed a series of slide projections in his seminal 1959 *18 Happenings in 6 Parts*, and Grooms utilized shadows thrown onto a scrim in 1960's *The Magic Train Ride*—both of them Reuben Happenings that Whitman had seen prior to *American Moon*.[15] But his use of the medium was unique, and not only for the significance of the role he gave it in his work, but also for his particular formal strategies of the doubling of live and recorded actions.

In *American Moon*, the filmic segment constituted what we might consider its second "act." From the rear of each of the six tunnels in which the audience sat, a projector beamed copies of the same film onto a screen composed of a clear plastic curtain with white paper rectangles fixed to it in a loose grid, which was hung at the opposite end of each tunnel, where it met the central performance space. The film, which took place in an autumnal wood, consisted of the antics of several abstract, cloth-covered "figures," variously shaped like haystacks or helmets. These were seen rising from and sinking behind shrubbery, or alternately suspended like puppets among the tree branches. Occasionally a form would approach the camera, sometimes hesitantly, sometimes threateningly. As the patchwork screens—which one commentator described as being like "multiple-paned windows," but ones in which the frames were transparent and the panes opaque—would suggest, no attempt was made to mimic the normative space of the cinema.[16] During the

projection, lights would occasionally be turned on in the tunnels, whiting out the image; the screens were made to move, distorting the picture; while at other times, the light illuminating the central space would be shut off, so that the viewers in each tunnel could look through their screens to see what was being projected elsewhere. As each of the six films ended, the screen at the end of that tunnel would be raised, until the white lights of all the projectors were shining into the central area onto a huge cloth-covered ball, similar to those just seen in the film. At that point, the ball rose up and shuffled offstage.

There are several observations to be made regarding this passage. First, we may wish to signal the continuity between this cinematic aspect of *American Moon* and Whitman's earlier work, for the plastic-and-gridded-paper screens clearly recall the central work presented almost two years earlier at his first solo exhibition, held at the Hansa Gallery in January 1959. That show was dominated by an untitled construction of 1958, since destroyed, that took the form of a six-foot-square cube framed in wood and sheathed in clear plastic, suspended by guylines from the gallery's ceiling. Onto, into, and around this geometric form were appended sheets of paper and aluminum foil that not only gave it a greater physical presence, but also presumably reflected the red and blue blinking lights found in other works included in the exhibition. The references here are multiple: most clearly, back to his mentor Kaprow, and specifically to the works exhibited in Kaprow's March 1958 show at Hansa Gallery. *Newsweek* had quoted Kaprow as saying his show was "like Cinerama . . . all enveloping," and went on to describe how

> visitors step *into* Kaprow's creation, for it hangs, like a back-yard wash, from ceiling wires. The "work" is made up of different size panels of such assorted materials as carbon paper, tinfoil, linen, and transparent plastic vigorously daubed with black and Japanese red.[17]

Yet Whitman seems to reach back beyond Kaprow, whatever his debt to the latter's conception and use of materials, to Marcel Duchamp and *The Bride Stripped Bare by Her Bachelors, Even*

(The Large Glass) (1915–23). Whitman's 1958 construction in some ways resembles a three-dimensional version of the latter, with the results of chance procedures now frozen not on glass, but polyethylene sheets. Kaprow's residual expressionism has been shed in favor of a clear box ready to receive the ephemeral, abstract impressions of its environment, what we might call, after the French term for camera, a *chambre claire.*

American Moon transformed that independent construction into a proto-cinematic environment, with the tunnels serving as theaters for the screening of his movie. The physical arrangement of the space, the disruptions of the diegetic unfolding of the film, even the uncanny doubling of the real and the recorded, all worked to question the norms of spectatorship of classic Hollywood cinema, most especially the assumption of passivity. One reviewer of the event remarked that "the audience, instead of being a spectator to the action, is a subject of the action."[18] This is, of course, generally true for the Happenings genre, which sought not so much to replace the passive spectator with a new, active participant— whatever the rhetoric to the contrary—as to embody, even objectify that spectator. Whitman, like many of his colleagues, had typically accomplished this through techniques of physical shock, as in the rather athletic performances of *E.G.*, or in the planned bursting of large balloons at the mouths of *American Moon*'s tunnels.[19] But the latter sequence was rethought before the first performance, becoming more restrained. In general, *American Moon* represented a turn away from these extremes of agitation by Whitman, toward more subtle means of disrupting the audience's complacency. Even frustration had a role to play here, with the restricted view of the action that many viewers suffered reminding them of the contingent, embodied experience of looking.[20] We might say that the work is posed halfway between the historical avant-garde's anticipation of a new space for film—as in Theo van Doesburg's prediction that "the spectator will no longer observe the film, like a theatrical presentation, but will participate in it optically and acoustically"— and the "expanded cinema" of the 1960s.[21]

The film itself transposes the urban detritus of the Happening, its vaguely anthropomorphic clumps of old cloth, to a rural setting, where it continues its uncanny performances. There is a faint echo in these scenes of classic avant-garde cinema, and of Fernand Léger and Dudley Murphy's *Ballet Mécanique*, of 1924, in particular. In an interview from the 1960s, Whitman recalled having seen it, and the impression it made on him. "Good movies I remember have been things like *Ballet Mécanique*, which I thought was interesting the first time I saw it because I'd never seen anything like it."[22] The attraction is understandable. Both Léger and Whitman developed their filmic aesthetic from advanced trends in painting—Cubism for the former, Abstract Expressionism via Kaprow for the latter—and both produced an almost abstract drama from a rhythmic flow of imagery, sharing a sense of what Léger had called "the poetry of the *transformed object*."[23] Yet there are crucial differences. For if Léger's objects were always the mass-produced commodities, the "type-objects" of the Fordist assembly line, that under the camera's gaze revealed their metaphysical subtleties, Whitman's sensibility could not admit the contemporary "cellophane world" into his work so readily. Léger's typewriters, fountain pens, wine bottles, straw boaters, and the like—all strikingly new, as if from publicity images—have been replaced by castoffs and the worthless scraps of a society of plenty. These rather shapeless forms become the enigmatic, vaguely pathetic monsters of *American Moon*.

Waning

But what was distinctly "American" about this moon? What might the title *American Moon* have evoked in 1960? Such a phrase may well have recalled the front page of the newspaper and the lead stories of the evening news, for in the context of the Cold War of the early 1960s, claiming ownership of outer space was considered of vital national importance. The so called "space race" had begun only three years earlier, in 1957, when the USSR had launched *Sputnik*, an accomplishment to which the United States responded the following year with the launching of its own *Explorer*. Yet in late 1960, it must have seemed that the moon was slipping out of the

US's grasp. It was a Soviet spacecraft that had first photographed the far side of the moon and at the time Whitman was preparing his performance, Yuri Gagarin was preparing to become the first human in space. There seems little doubt that these current events were on Whitman's mind during the choreographing of *American Moon*, for his work of this time is replete with references to space exploration. Earlier that June, for example, he had included in Martha Jackson's important *New Forms—New Media I* exhibition a work titled *Cape Canaveral*. The Space Age, as it was known, and its entanglement with contemporary struggles for hegemony between the two superpowers, certainly provided one immediate backdrop to Whitman's 1960 performance.

But some commentators saw this exploration of space as having to do not only with the international rivalries of the Cold War, but equally with the peculiar transformations occurring in the domestic landscape in these years, with what we might call the waning of experience. In 1961, historian Daniel J. Boorstin noted:

> We call ours the "Space Age," but to us space has less meaning than ever before. Perhaps we should call ours the "spaceless age." Having lost the art of travel on this earth, having homogenized earthly space, we take refuge in the homogeneity (or in the hope for variety) of outer space. To travel through outer space can hardly give us less landscape experience than we find on our new American superhighways.[24]

The probing of outer space could be construed, then, less as an attempt at an imperialist annexing of new territory than as a desperate quest to escape the banality of contemporary society, as the vain hope for release from a homogenized world. Boorstin's *The Image: A Guide to Pseudo-Events in America* constituted a vast and damning compendium of that world, one that was characterized at all levels by what he called "secondhandness." "We make, we seek, and finally we enjoy, the contrivance of all experience," he wrote. "We fill our lives not with experience, but with the images of experience."[25] Where Boorstin sees only "an unfortunate and quasi-serendipitous coming together of too vast a technology of image-diffusion on the

one hand, and, on the other, too great an appetite for sensationalism on the part of today's public," we might more accurately detect the cultural manifestation of late capitalism's definitive subordination of all forms of production to the market economy.[26] However, if this 1961 book fails to rise above the level of a description of a set of societal symptoms without ever being able to speak a convincing diagnosis, it nevertheless traces a telling portrait of the context in which Happenings such as *American Moon* took place.

For Boorstin, the contrivance and artificiality of the contemporary American cultural landscape entailed the disappearance of spontaneous reality, "of happenings," he wrote, "not brought into being especially for our benefit."[27] The eradication of such "Happenings"—and his use of this term in 1961 should be noted—elicited a reciprocal effect among the public, "a desperate hunger," as he called it, for what was unrehearsed and unplanned, for what resisted the logic of postindustrial capitalism. As the pseudo-event came to predominate social life, people searched ever more eagerly for what was left of an uncontrived reality in the impulsive, the natural, and the childlike. One might find these in the spatially distant—hence the hopes pinned on lunar exploration—or in the ever more rare sectors of society that had not yet been submitted to the homogenizing forces of the marketplace: the run-down urban core, the obsolete or unwanted commodity, the unmotivated play of youth, or nature itself. These were domains, however, with little power to withstand, as Boorstin noted,

> a revolutionary change in our attitude toward what happens in the world, how much of it is new, and surprising, and important. Toward how life can be enlivened, toward our power and the power of those who inform and educate and guide us, *to provide synthetic happenings to make up for the lack of spontaneous events.*[28]

The culture of Happenings, and of the combine and the environment as well, seem like varied attempts to produce or discover an alternative to the cellophane paradise of the American culture of secondhandness. Mass-media coverage of these developments,

though generally condescending when not simply dismissive, acknowledged this aim, often by aligning the artists in question with the contemporary bohemian culture of the "beatnik."[29] As inaccurate as this may have been, it did capture the shared desire to find an elusive "outside" to an increasingly stifling market culture.

Yet as Boorstin's arguments suggest, Happenings were caught in an inextricable paradox. They responded to this age of contrivance, of the pseudo-event, with quasi-theatrical spectacles of spontaneity. Attempting to discover a space outside the market, they created a newly commodified art form.[30] Whitman's *American Moon* might evoke nature, childhood, even the distant lunar orb as sites of alterity, but their effectiveness was tenuous at best. Although the enigmatic character of the action, its non-narrative format, and the insistently fragmentary mode of viewing produced the effect of a spontaneous event "not brought into being especially for our benefit," this was, after all, *only* an effect, a carefully staged quality that belied the synthetic character of the action. And despite the remarkable transformation of the space of the gallery itself, its complete if temporary annulment as a space of exchange, this first and crucial step in the delegitimation of the space of the institution would not ultimately entail the cancellation of the artistic commodity, as the later trajectories of Oldenburg, Dine, and Grooms amply demonstrate. In fact, the Happenings genre's very resistance to commodifying the work of art, through recourse to the ephemeral and transient, would soon become one of the most valuable myths used to rejuvenate the traditional institutional framework. Yet these failures—the artists' inability to recognize the naïveté of their strategy of spectacular refusal and the synthetic event—did provide a path for those who, at the end of the decade, would develop the most sophisticated models of site specificity and institutional critique. There is a direct line that we may trace from the young Michael Asher, who witnessed a rehearsal of Whitman's *Water*, produced in Los Angeles in the summer of 1963, to the Asher who produced an intervention in the San Francisco Art Institute six years later, in 1969, consisting solely of a thirty-six-foot-long partition built into the gallery space as a modular wall. From the metamorphosis

of the gallery —in the case of *Water*, actually a garage—into a total environment for dramatic action, we pass to a very different practice of situational aesthetics, one predicated on what Benjamin H. D. Buchloh has described as "a critical refusal to provide an existing apparatus with legitimating aesthetic information, while at the same time revealing, if not changing, the existing conditions of the apparatus."[31]

New

Finally, *American Moon* evokes most broadly the nighttime sky and all that takes place under cover of the new moon's darkness. It evokes sleep and the fantasies that haunt it. The performance was explicitly described as a sort of theater of reverie by its contemporary spectators:

> After the audience entered through dark narrow tunnels the curtains forming the tunnels were raised and in the central semidarkness a mysterious rustling began; then images of cloth and paper, featureless and shrouded and moving in eerie counterpoint; a pink image (object? person?) arching overhead as if on the irrelevant swing of a summer holiday; paper rustling in the dark and then looming in semihuman shapes out of the shadows . . . It was mysterious out of all proportion, a kind of dream with meanings around its corners.[32]

Another recalled

> half a weighted mummified form, half a swinging penis, or mushroom cloud, or stuffed paper sack, half a sexual duet (a misdemeanor). There began an odyssey of things, great and small, sounds, motions, signals, signs, symbols, shapes, films, many happenings, fast and furious.[33]

It matters little whether these are "accurate" accounts of the performance. Their value lies instead in the testimony they provide of what at least some visitors remembered of its choreography. For them, it was a scene that recalled disjointed memories and uncanny

apparitions, ghostlike figures neither living nor dead, forms that existed between the human and the inanimate, suggesting both sexual fantasy and the nightmare of annihilation in death, while remaining obdurately, even prosaically material.

Kirby has noted this concrete quality of materials as they appear in Happenings, the way that performers, objects, even mechanical effects are all "taken from and related to the experiential world of everyday life," rather than the metaphorical world of theatrical representation.[34] Whitman seems to have partaken of this shared aesthetic preference, attempting to forestall interpretation on the part of his collaborators by refusing to explain the "meanings" of actions they were to perform. Nevertheless, as the accounts quoted previously confirm, it is impossible not to read symbolic meanings into *American Moon*—although they will be of an opaque, personal nature, rather than a social one. As Kirby writes, even the concrete components of the Happening may function as symbols "of a private, nonrational, polyvalent character. Although they may . . . be interpreted," he claimed, "they are intended to stir the observer on an unconscious, alogical level."[35] Perhaps Whitman himself stated the problem most clearly. In a much-quoted 1965 interview, he asserted:

> At a certain point, fantasy is an object in the physical world. It is like a street or rain. It is a product of physical events. It is a part of nature that can be described. The fantasy exists as an object, as a central physical entity, and as part of the story that you tell about other objects.[36]

This is a remarkable statement, striking not least in its refusal of psychoanalytical depth, of the unconscious itself, in favor of an almost mechanistic conception of the psyche's workings—"it is a product of physical events."

The most immediate question it raises, however, is that of the historical conditions for the appearance of "fantasy" as an object. How does this most profound component of the human condition become reified to such an extent that it might appear as simply another tangible element to be manipulated in the performative

matrix? What is significant in this question is precisely the distance it indicates existed between the "painter's theater" of the late 1950s and one of its primary antecedents, namely, interwar Surrealism. The connection between the two has often been postulated, most notably through the figure of Antonin Artaud and his "Theater of Cruelty," work that was just becoming well known in advanced cultural circles in the US at this time. Yet what could be further from Surrealism's vision of desire and fantasy as disruptive, transgressive forces within the collective realities of monopoly capitalism than these domesticated, objectified phantasms that appeared on the Happening's stage? Indeed, what becomes apparent are the very different conditions in which the Surrealists and artists like Whitman were operating, and the ways that those conditions impacted the possibilities for representing fantasy. The Surrealists had worked in a social context notable for its retrograde and archaic elements, for the fact that the economy had not yet eradicated the space for individual action or scruple. The found objects that they invested with their psychic energy, those mysterious finds from the small workshops and store counters of old neighborhoods and the stalls of the *marché aux puces*, were the products, as Fredric Jameson has noted, "of a not yet fully industrialized and systematized economy." They were objects that might still bear traces of their human origin, of the artisanal labor that produced them. "Thus what prepares these products to receive the investment of psychic energy characteristic of their use by Surrealism," he continues,

> is precisely the half-sketched, uneffaced mark of human labor, of the human gesture, on them; they are still frozen gesture, not yet completely separated from subjectivity, and remain therefore potentially as mysterious and as expressive as the human body itself.[37]

The "postindustrial" world of late capitalism in which Whitman and his colleagues would work, the world of "secondhandness" and depthlessness, allowed for no such projection of fantasy onto the object. It no longer resided as an enigmatic promise radiating from inexplicable objects in the junk shop, from the shop window

> Nowadays the movements and counter-movements that are hatched in downtown lofts are quickly promoted to posh uptown galleries and then on to the museum. It is ironical that a movement that professes to thumb its nose at tradition is so rapidly incorporated into tradition.[40]

But there is no irony here. There is only the inability to recognize the new cultural condition of late capitalist society, in which the possible space for autonomous activity on the part of the individual has been practically annihilated. We may be comforted viewing the Happening as a beatnik or bohemian form "recuperated," as they used to say, by an institutional apparatus. But in doing so, we blind ourselves to the commodity logic within the formula. *American Moon* negotiates that logic with perhaps the most elegance and subtlety of any of its contemporaries, but it does not escape it.

April 17, 2003

Notes

1 Allan Kaprow, quoted in Harriet Janis and Rudi Blesh, *Collage: Personalities, Concepts, Techniques* (Philadelphia and New York: Chilton, 1962), p. 274.

2 Kaprow, quoted in Janis and Blesh, *Collage*, p. 276.

3 The most complete account of the performance may be found in Robert Whitman, "*The American Moon*," in *Happenings: An Illustrated Anthology*, ed. Michael Kirby (New York: E. P. Dutton, 1965), pp. 137–47.

4 Typical is Joseph Jacobs's resignation before the work, in his otherwise excellent essay on John Cage and the culture of performance in New York: *American Moon*, he writes, "evoked a variety of associations and emotions, none of which was very clear or definite. Ultimately, Whitman's work . . . defied interpretation and had to be read as a formalist arrangement of abstract images and sound occurring in time." The utterly unsatisfactory imprecision of such formulations only relegates Whitman to a sort of interpretive limbo. See Jacobs, "Crashing New York à la John Cage," in *Off Limits: Rutgers University and the Avant-Garde, 1957–1963*, ed. Joan Marter (Newark, N.J.: The Newark Museum; New Brunswick, N.J.: Rutgers University Press, 1999), p. 88.

5 Whitman interviewed by Richard Kostelanetz, in Kostelanetz, *The Theatre of Mixed Means* (New York: The Dial Press, 1968), p. 235.

6 Kirby, "Introduction," in *Happenings*, p. 13.

7 This canonical version of the rhyme is quoted from *The Oxford Dictionary of Nursery Rhymes*, rev. ed., ed. Iona Opie and Peter Opie (London: Oxford University Press, 1973), p. 273.

8 On the "retreat to the experience of childhood" in American art of the 1950s and early 1960s, see Thomas Crow, "The Simple Life: Pastoralism and the Persistence of Genre in Recent Art," in his *Modern Art in the Common Culture* (New Haven: Yale University Press, 1996), p. 181–82.

9 Barbara Rose briefly touched on the generational difference in attitude toward the 1930s; see her "Dada Then and Now," *Art International* 7, no. 1 (January 25, 1963), p. 25.

10 As reported by Marter, "The Forgotten Legacy: Happenings, Pop Art, and Fluxus and Rutgers University," in *Off Limits*, p. 5.

11 Simone Forti, *Handbook in Motion* (Halifax: The Press of the Nova Scotia College of Art and Design; New York: New York University Press, 1974), p. 35.

12 Forti, *Handbook*, p. 34.

13 Sally Banes, *Terpsichore in Sneakers* (Middleton, Conn.: Wesleyan University Press, 1987), p. 25.

14 Perhaps the most insightful reading of these performances may be found in Laurence Louppe, *Poétique de la danse contemporaine*, 2nd rev. ed. (Paris: Librairie de la danse; Brussels: Contredanse, 2000), pp. 233–35 and 296–97.

15 As Kirby has pointed out, a precedent for all three may be found in Cage's 1952 Black Mountain College presentation, which combined a film projected on the ceiling and walls with readings, music, and dance. See Kirby, *The Art of Time: Essays on the Avant-Garde* (New York: E. P. Dutton, 1969), p. 120.

16 Whitman, "*The American Moon*," p. 141.

17 "Trend to the 'Anti-Art,'" *Newsweek*, March 31, 1958, p. 94.

18 S.S., "Theatre: American Moon," *The Village Voice*, December 15, 1960, p. 10.

19 This sort of attack on the audience was considered one of the defining elements of the Happening as a genre, and one of the factors that linked it to Antonin Artaud's "theater of cruelty." See Susan Sontag, "Happenings: an art of radical juxtaposition" (1962), in her *Against Interpretation* (New York: Farrar, Straus & Giroux, 1966), p. 265; and also Rosalind E. Krauss, *Passages in Modern Sculpture* (Cambridge, Mass.: MIT Press, 1977), pp. 232–33.

20 For example, one reviewer remarked that "the sight, at least in the last seat of the first tunnel, was greatly restricted. Whatever I saw, though obviously intentionally fragmentary, was more so." V[alerie] P[etersen], "Reviews and Previews: Robert Whitman [Reuben]," *Art News* 59, no. 9 (January 1961), p. 13.

21 Theo van Doesburg, quoted in Peter Wollen, "The Two Avant-Gardes," *Studio International* 190, no. 978 (November/December 1975), p. 172.

22 Whitman interviewed by Kostelanetz, in Kostelanetz, *The Theatre of Mixed Means*, p. 234.

23 Fernand Léger, quoted in Robert L. Delevoy, *Léger*, trans. Stuart Gilbert (Lausanne: Skira, 1962), p. 108.

24 Daniel J. Boorstin, *The Image: A Guide to Pseudo-Events in America* (1961; repr., New York: Atheneum, 1975), p. 115.

25 Ibid., p. 252.

26 This is the core of Guy Debord's critique of Boorstin's account. He continues: "Boorstin cannot see that the proliferation of prefabricated 'pseudo-events'—which he deplores—flows from the simple fact that, in face of the massive realities of

present-day social existence, individuals do not actually experience events." See Debord, *The Society of the Spectacle*, trans. Donald Nicholson-Smith (New York: Zone Books, 1994), p. 141.

27 Boorstin, *The Image*, p. 255.

28 Ibid.

29 See, for example, "Up-Beat," *Time*, March 14, 1960, p. 80; or "The Emperor's Combine," *Time*, April 18, 1960, p. 92.

30 For an account of the absorption of Happenings into the art market, see Al Hansen, *A Primer of Happenings & Time / Space Art* (New York: Something Else Press, 1965).

31 Benjamin H. D. Buchloh, "Editor's Note," in Michael Asher, *Writings 1973–1983 on Works 1969–1979*, ed. Buchloh (Halifax: The Press of the Nova Scotia College of Art and Design; Los Angeles: The Museum of Contemporary Art, 1983), p. vii.

32 Janis and Blesh, *Collage*, p. 276.

33 P[etersen], "Reviews and Previews," p. 13.

34 Kirby, "Introduction," p. 20.

35 Ibid.

36 Whitman, "A Statement," in *Happenings*, p. 136.

37 Fredric Jameson, *Marxism and Form* (Princeton, N.J.: Princeton University Press, 1971), p. 104.

38 Kirby, "Introduction," p. 19.

39 Manfredo Tafuri, *The Sphere and the Labyrinth*, trans. Pellegrino d'Acierno and Robert Connolly (Cambridge, Mass.: MIT Press, 1987), p. 110.

40 Dorothy Gees Seckler, "Gallery Notes: The Start of the Season—New York," *Art in America* 49, no. 3 (1961), p. 86. See also n.29.

Pierre Huyghe: Vacant Possession

MARINA WARNER

"Is there a narrative for the 'ghost' coming from the future?"
— Jan Verwoert, "Copyright, Ghosts and Commodity Fetishism"[1]

In the closing section of *Elizabeth Costello* by J. M. Coetzee, the heroine is waiting in an antechamber to eternity, although she doesn't understand that she is dead. She thinks she might be in a detention center of some kind—a Nazi camp, even—but she finds play money in her purse and falls to wondering if the people around her are actors, and if the setting is in fact some kind of set. She observes her surroundings:

> The couple at the next table have their little fingers hooked together. Laughingly they tug at each other; they bump foreheads, whisper . . . But perhaps they are not actors, full actors . . . perhaps they are just extras, instructed to do what they do every day of their lives in order to fill out the bustle of the square, to give it verisimilitude, the reality effect. It must be a nice life, the life of an extra. . . . How beautiful it is, this world, even if it is only a simulacrum![2]

The features of Coetzee's eschatology are banal rather than apocalyptic, but they are also eerie. This eeriness arises from their

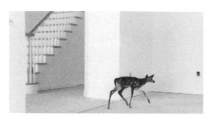
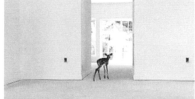

Pierre Huyghe, *Streamside Day Follies*, 2003

unreality, their quality of semblance in place of substance—they double the real, as in the most familiar Freudian theory of the uncanny. The specific character of these features, as depicted by Coetzee, belongs to photography and to the movies. Even the language Costello hears spoken is a universal language that she speculates might be Esperanto. Like the extras, like the scene setting, this language is an effect of global cinema, where film characters can be beamed anywhere and understood. Dubbing carries a trace of doubling in English, but in French it is simply *doubler*, while *doublure* means "lining," as in Chris Marker's inspired formulation that memory is "the lining of forgetting." While the global world of mass communications multiplies, reproduces, and brings things closer, faster, it simultaneously saturates them in a sense of something missing, of their ghostly doubles. In French, extras are called *figurants*, which perhaps translates more exactly as "stand-ins"—a different kind of performer, whose presence vanishes under another's. Many contemporary writers are also entering this terrain to determine the depths of modern counterfeit experiences and test their implications. For example, the Spanish novelist Javier Marías, younger than Coetzee but equally prolific, has traversed and retraversed the coincidence of act and appearance, of reality and fantasy. In *Dark Back of Time* (1988), *All Souls* (1989), and *A Heart So White* (1992), he splices together a number of episodes and love affairs taking place in different locations and periods, and reveals that made-up stories have the power to generate consequences in the lives of individuals, moving the original invented event into a dimension of actual, lived experience. His novels are witty, often cynical ruminations, but their unstable ontology regarding the truth status of his characters and their lives produces an effect that is absurd, comic, and deeply disquieting.

Artists are enmeshed in similar concerns, and the direct manipulation of digital media can give them control of counterfeit actuality in ways that elude the novelist. Tony Oursler's early work with dummies and automata explores the margins where spooks and specters overlap with the phantoms of film, LEDs, and other digital media. He displaces the artist as observer and beams himself

up into the realm of earth-angels, inhabiting the elsewhere of virtual reality systems. Similarly, Italian artist Sarah Ciracì blurs the separation between film, science fiction, fantasy, and documentary in various online reports on outer space. Her work focuses on alien abduction stories and more benign visitations of

Man Ray, *Dust Breeding*, 1920, printed c. 1967

the third kind; on parallel universes close by but inapprehensible; on channeling planetary and galactic energies; on time bands moving at different speeds; on what the critic Ato Quayson has called "volatile proximities," and on the pleasures he has termed "the fecundities of the unexpected." Ciracì communicates these tingling, weird skewings of knowledge through material to hand, introducing these familiar elements so that they lose their instant recognizability.

In a 2001 video animation called *Duchamp*, for example, she unfurls a science-fiction landscape through which a giant flying saucer is descending; the wilderness stretching to the horizon is taken from Man Ray's famous photograph *Dust Breeding* (1920), his picture of the dust-strewn surface of Marcel Duchamp's *The Bride Stripped Bare by Her Bachelors, Even (The Large Glass)* (1915–23). The title in French, *La mariée mise à nu par ses célibataires, même*, can mean, in Duchampian double entendre, "The bride raised to the clouds by celestial threshers." And it was this allusion to celestial threshers that inspired Ciracì's simulation of crop-circle markings, which themselves hark back consciously to Incan and Mayan civilizations.

Doomsday predictions based on interpretations of Mayan calendrical calculations and surmises regarding the collapse of their civilization inspired the title of Ciracì's most elaborate artwork to date, *2012* (2003). The video shows a staged report on the events

Sarah Ciracì, *2012*, 2003

of that year, when our planet was rescued by aliens. Delivered in the manner of a scientific lecture, it is couched perfectly in the high discourse of the paranormal currents of the Web. Ciracì openly comments on the deceptive relations of truth-telling and film in this piece: "We are living in a time when, thanks to new technologies, it is extremely easy to falsify reality, and I'm making a critical statement about documentary media."[3] But she also admits to a fascination with Futurist perspectives, as captured in architecture of the last century; with the scene-painting and fictive scenarios of movies from *Metropolis* (1927) to *Blade Runner* (1982); and with the way "third memory" stirs experience and imagination, representations, and projections into phantasms that have the power to guide sensory data and persuade minds.

Such artists' films and works enact the same processes that they probe—a loop that constitutes the loops of perception that are entwining us all. Ciracì's mimicry of paranormal paranoia discloses the use of documentary stratagems to create plausible realities. Pierre Huyghe's work wanders this same antechamber created by the visual moving media of representation. He searches out the duplicities of their doubling effects and reenacts the deceptions of storytelling devices that are so habitual in cinema and its cognate forms that they have become truly invisible. He makes such conventions visible. His operations do not hollow out the objects of his inquiry in a spirit of irony and iconoclasm, but instead have the unsettling effect of deepening their mysterious independence. By seeing into the contrivance of film conventions, by opening up their workings, Huyghe's work helps us to grasp the way the medium has opened new dimensions of experience and how it has

established a relationship to space-time that is sui generis and, while apparently seamlessly acceptable, intrinsically unsettling and weird. Huyghe shares concerns with many writers and other artists who, rather than creating a unified aesthetic zone, have instead identified a shared zone of anxiety. This zone involves reorientations of personal identity at the most fundamental level—ideas about what a person is over time, about what is constituted by mind, memory, imagination, or other faculties of consciousness. Personhood shifts from the stable mind-body union that, broadly speaking, held for the post-Cartesian world. The replicant figure, for example, is a preeminent emblem of our time: furnished with the memories of another, which he or she cannot recognize to be such. This paranoid model of techno-possession, brilliantly invented by Philip K. Dick in the novel that inspired *Blade Runner*, also governs the plot of the *Matrix* films. In many ways, the newly conceived personal subject operates as an extension of contemporary media and of the potential and virtual universes they have opened. In other words, the faculties of this new kind of protagonist—fantasy, memory, sensory responses, emotions—exist in symbiosis with televisual communications, the laws that organize them, and the loops and warps in the manifold planes and volumes of space-time that they have brought into play.

Zygmunt Bauman coined the suggestive term *liquid modernity* to describe the vertiginous flux and speed of contemporary existence; it catches the nightmare lack of moorings as well as the potential for consoling, even exhilarating, freedoms.[4] Huyghe enters this condition: the warps of memory and perception, the proleptic influence of fantasy, forms of disembodiment such as celebrity images and virtual reality figments, and, above all, the bewildering intersheaving of actuality and imaginings, of dream and reality. He focuses his inquiry into new liquid identities through audiovisual technologies, adopting them in order to act as a fifth columnist and expose them. Like many such spies, however, his camouflage runs so deep that it becomes his skin: the double turns into the self, the lining surfaces, and he, too, then authors the very illusions that his art set out to interrogate and expose.

Pierre Huyghe, *Streamside Day Follies*, 2003

Streamside Day Follies, a film and installation shown at Dia in 2003–04, illuminates the pasteboard character of a new housing estate going up in Fishkill, near Beacon, New York, in previously undeveloped woodland. It offers an elegy for the costs of a new settlement and simultaneously tries to bandage the wounds the clearing and building inflicted on the rural surroundings. The exhibited artwork records the daylong pageant-cum-village fête that the artist staged at the housing estate on the day of its official opening. "Celebrate the birthday of a new community!" said the invitation.

The name Streamside Knolls, dreamed up by the estate agents, is intended to stir associations with Arcadia, and the whole business venture has clear designs on its clients' hopes and dreams: Huyghe's project to film the events of the official opening day gave rise to mixed feelings, to say the least. I wasn't alone in feeling uncomfortable in the role of city visitor to the new inhabitants' hopeful ceremonies. Taking the beautiful train ride from Manhattan along the Hudson River to join the partying made several of us feel like voyeurs and interlopers. We were taking a ringside seat while keeping our hands clean, observing the carryings-on from a knowing position of art-world sophistication. The housing project itself is grandiose in appearance, made up of a set of identical clapboard houses with traditional pitched roofs. Many lots were still empty, waiting for purchasers, who order a residence to suit their needs—four bedrooms, four-car garage, or something more modest. Still, all the new homes aim at grandeur: there were different choices, between a colonial portico with classical columns, for example, or a London front door with a fanlight porch. The

buildings arrive in flat-packs and are raised quickly, the clapboard and stonework being vinyl, the doors and windows in prefabricated kits. None of the allusions to past craftsmanship and master builders' skills are loyally grounded in historical materials: this antebellum paradise is a stage set, but one that will be a home to real people who have paid to own their part of it. I felt disdain for the plastic dwellings and their aspirational snobbery bubbling up in me, coupled with embarrassment for feeling so superior and snobby.

Huyghe wanted to introduce solidarity, community, and identity—soul—into this soulless place. He devised an elaborate series of communal rites along the lines of a *festa* for the saint's day of an Italian hill town. Meals were out in the open, with colorfully dyed doughnuts and green cotton candy, children's games, fancy dress in the costumes of furry woodland creatures (raccoons, rabbits, deer), singing and processing and tree planting—each of these activities aimed at bonding and naming the new site.

Huyghe's project is ultimately neither ironical nor mocking in spirit; there is a sense in his earnestness that irony has had its day. As Coetzee writes in *Elizabeth Costello*, we cannot afford unbelief. If we give credence to something that proves synthetic, made up, fictive, then with our surrender to belief the object of our faith will come into being and be remade as fact. This is what filmed spectacle can achieve, and, for better or for worse, it is time to recognize its power in this regard. Huyghe's *Streamside Day Follies* attempts to take charge of this potential and run with it.

The critic James Wood, while praising the Coetzee novel, commented that when the protagonist Elizabeth Costello finally writes a credo and is then admitted past the gates into eternity, her statement of belief amounts to a declaration of trust in the life of a fiction. Costello has written that she believes because a certain species of frog will do anything to survive, whatever the odds. She identifies unconsciously with this life spark, and with the frog that is motivated by it. Wood continues, "To enter the frog's life is like entering a fictional character's life. And this is a kind of religion, akin to the worship of a God who gives us nothing back. If it represents the paganization of belief in God, it also represents the

sacralization of belief in fiction. Because, like suffering and death, fiction, too, is not an idea."[5]

This is not only a wrong interpretation of Coetzee; more importantly, it does not answer the problem posed by digital and virtual representations, which Huyghe and others are tackling. Coetzee allows his alter ego, the writer Costello, to leave the ersatz, pasteboard antechamber to the afterlife only after she has declared her belief in the frogs and declared that they are real, not invented. She honors them—and wins her passage across the threshold to the afterlife—because they hang on to life without understanding anything about it. This is a noble existential position, precisely because it is not underpinned by ironic consciousness—because it is not fictional. Fiction is an idea composed of figments. Huyghe's film work and his art are about fiction's ideational status and complexity, which involve its nearly irresistible power to seep into life and shape its course; that life is the kind of life that human beings suffer or enjoy—and that frogs do not (as far as we can tell)—precisely because we have the kind of minds that make things up and then believe in them.

In 1996, Huyghe's film *Doublures* turned the camera on translators who erase a film's specific linguistic attachments and origins. For more than two hours we watch dubbers at work. We watch their faces, flickering with projected light from the screen, as they react and translate, noting and mouthing the dialogue. We can't see the film they're watching, can only glean from fragments of the dialogue what it's about. Not by accident, the film is *Poltergeist* (1982), a film about haunted houses, about the specifically acoustic possession of a home and its occupants. In this founding video of Huyghe's concerns, the film itself becomes a haunted house, a subject that can be possessed, doubled, and usurped by another, off-stage presence. The dubber is of no consequence to the future viewer, but the actors who later speak in the dubbed version are in effect ventriloquizing the projected beings on the screen, most of them already phantoms of one sort or another.

Gillian Wearing, the British video artist, has also worked in this seam between the outward appearance and the voice and made

powerfully unsettling tapes in which she mixes and matches one character's speech with another's body and face. As her subjects are confessing intimate memories, often of sexual experiences, the effect of this contradiction (an old man piping like a child) is hilarious in a very disturbing way. The device was swiftly adopted by advertisers—for a soft drink, to begin with, but others followed—and the campaigns captured attention because they created a similar jolt.

After *Doublures*, Huyghe continued to explore the phantasmic entity that a film presents to the viewer, chiefly by analyzing cinematic time and its relationship to other temporalities. For part of the ghostliness that casts its eerie light on mass media involves relations of duration and of distance between one time and another. Challenges such as Huyghe's ask us not to see artifacts in visual or literary media in terms of oppositions: true versus false, reality versus artifice, documentary versus invention, memory versus imagination, subject versus object. Instead, they ask us to imagine these elements touching one another at angles or, better still, folded into one another—thus the viewer's space-time folds into the space time of the artifact, which took place in a different time, moves at a different rate, and might even occupy another dimension. The difference in the rate is not simple, since a film lasts a certain amount of time, but represents another lapse of time altogether (unless it is filmed in what is called "real time"; the province of surveillance records, for example).

In *Blanche-Neige Lucie* (*Snow White Lucie*, 1997), Huyghe filmed the singer who had originally dubbed the voice of Snow White for the French version of Disney's 1937 classic. Huyghe tracked her down because she had brought a case against Disney, charging the company had failed to pay her royalties on her rendering of the heroine's theme song. "J'étais complètement Blanche Neige" ("I was completely Snow White"), we hear the middle-aged actress-singer claim with utmost conviction. Face to face with the real person behind the cartoon voice, the viewer comes to several disconcerting realizations: that Lucie exists as a separate being; that this real woman has been growing old all these years since *Snow White and the Seven Dwarfs* was made, whereas the film's

beloved heroine occupies the eternal here-and-now of film time; and that Lucie so successfully expressed the voice of a figment that this figment effectively obliterated her identity and took possession of her. Aristotle considered voice the evidence of soul, saying that all creatures with soul could utter, whereas those without, like fish or stones, could not communicate. In another, more recent Disney film, *The Little Mermaid* (1989), the heroine trades her lovely singing voice for humanity, and it's stolen by the voluptuous sea witch Ursula, who thus is able to usurp the Little Mermaid's place in the prince's heart. In her voice is her identity.

The following year, with the film *L'Ellipse* (1998), Huyghe performed a different operation of resurrection: *ellipse* in French meaning "ellipsis," as in the three dots indicating either a gap (something missing from a quotation) or suspense (something lying in the offing). Huyghe returns here to another film classic, Wim Wenders's *The American Friend* (1977). More than twenty years after it was shot, Huyghe brought back the lead actor, Bruno Ganz, and reinserted him into the film, filling a famous jump cut in the original by showing him walking across a bridge to the assignation at which he would meet his death. But the actor is no longer the age he was then, and so the sequence draws attention to the difference between film-time and time as Ganz—and his audience—have experienced it, as well as to the actor's continuing life beyond his death on film, and thus hollows out the plot and throws the space-time of the film into sharp relief. *L'Ellipse* also incidentally produces a feeling of absurd relief: the later Ganz embodies the life principle cheerfully asserting itself, despite inevitable wear and tear, against the high demands of Art.

The most powerful of Huyghe's surgical operations on cinematic "reality" takes place in *La troisième mémoire* (*The Third Memory*) (2000). For this film Huyghe tracked down a real bank robber, John Wojtowicz, took him to a reconstruction of the crime scene, and asked him to reenact it for the camera. Wojtowicz, an ebullient and likeable personality, had become a reality TV star during the hold-up, which lasted some time. Rather unexpectedly, he'd won popular sympathy, due to his original unselfish motive:

he'd embarked on the robbery in order to get the money needed for his friend to have a sex-change operation.

Wojtowicz's exploit inspired another film classic, *Dog Day Afternoon* (1975), in which Sidney Lumet, the director, cast Al Pacino in the lead role. During his years in jail, Wojtowicz had watched Pacino playing him over and over again and, as his demonstrations to Huyghe show, had lovingly absorbed every detail of the actor's moves and gestures. Pacino—and Lumet—had studied the news footage, as had Wojtowicz. So his reenactment of his own past exploits for Huyghe's camera lays down layer upon layer of memory upon memory, composed of others' variations on his experiences. As we watch him perform himself, he becomes increasingly porous and disunited. This is what Huyghe means by the third memory: the memory introduced by representations and fantasies, which threatens to make each and every one of us into a replicant, furnished with invented recollections that have taken the place of personal experience. It's significant that Wojtowicz's story involves his attachment to someone who believed that his true gendered identity was hidden inside a body he felt did not belong to him. This consciousness of a split in the self, and the resulting desire for physical alteration or metamorphosis, belong squarely in the cluster of psychological possibilities that film personae offer. In cinematic space-time, Nicole Kidman has a thousand faces, and Pacino a protean body; these are then multiplied, dispersed, magnified, miniaturized, and stretched over billboards or captured on miniature airplane monitors or digital screens. They in turn offer a pattern for imitation to their public: we who gaze at them long to slough our own carcasses and adopt their faces, by cosmetic surgery or even more drastic transplants and treatments. The title *The Third Memory* also suggests the way events and representations seep and merge—how a film isn't a record of a happening as it happened, but a refashioning that remodels the action in retrospect and comes to replace it. Again, the theme of occupation—usurpation—comes into play.

The first work by Huyghe I came across in situ was *No Ghost Just a Shell* (1999–2003), made with his collaborator Philippe

Pierre Huyghe, *No Ghost Just a Shell, Two Minutes Out of Time*, 2000

Parreno, when it was installed in the Institute of Visual Culture, a tiny gallery in Cambridge, England. I had wandered in because the title intrigued me, and there I found Annlee, a low-cost manga character the artists had bought in order to set her free from the trade in such figments. Manga characters are produced in great quantities for sale in the industry, at rising levels of complexity. Annlee belonged to the bottom end: a simple cartoon character of no special distinction. In the short animated sequence that I saw, called *Two Minutes Out of Time* (2000), she speaks of herself in a combination of first person and third person, and her immaterial virtual presence, projected on the wall, is hauntingly and touchingly contradicted by the immediacy of her utterance as she plays with the spectator's belief system.

She begins, "She is a passerby, an extra. She was designed just like that." Then, changing to the first person, she continues: "My name, my name is Annlee. Annlee. I've a common name. I was a frozen picture, an evidence submitted to you. I have become animated however not by a story with a plot, no . . . I'm haunted by your imagination . . . and that's what I want from you . . . See, I am not here for your amusement . . . You are here for mine!"

Several things are happening here. Annlee is provoking the kind of emotions associated with sincerity, that index of truthfulness, and showing up the unsettling disjunction between that truthfulness freighted by affect and truth as the objective fact of her fictive reality. This fissure has gaped wide in contemporary society and psychology, with higher value accorded to the truthfulness of emotional response, as the philosopher Bernard Williams discussed in his last book, *Truth and Truthfulness* (2002).

But she also switches the direction of the flow between perceiver and perceived: she is active; we are entertaining her. She is haunted by us. Without us, she has no existence. But this coming into being in perception of the audience alone, since there is no actuality behind the speaking image, is truly uncanny, and the whole project of Annlee illuminates this new twist on the uncanny with weird cunning. For in the E. T. A. Hoffmann tale of the doll Olympia, which Sigmund Freud analyzed in his famous essay "The Uncanny" (1919), the automaton is an object with substance, even if she only gives an impression of life. She belongs in the material world of actual things. But Annlee is spectral. Like the play money in Coetzee's antechamber to the other world, she has no materiality. Yet in this quality she is also very familiar and resembles much of the population of the world as we experience it in the media. The connection with play money is close, since Huyghe and Parreno copyrighted Annlee in her own name in order to liberate her from the market in which she originated as a commodity that could be purchased. They legally assigned to her the rights over the use of her own image, and thereby effectively ended her participation in further art ventures.

At the close of *Two Minutes Out of Time* Annlee describes her own obliteration: "But how can a mere semblance occupy even a single moment of time? How can such a counterfeit experience death?"

In a subsequent video installation Huyghe made in 2001, called *One Million Kingdoms*, we see Annlee proceeding, again with childlike vulnerability, through a jagged lunar wilderness, reciting a digitally altered version of Neil Armstrong's first message from the moon interwoven with quotations from Jules Verne's *Journey to the Center of the Earth* (1864). Limpidly and touchingly, Annlee conveys the condition of cinematic existence at its purest: no referent in real life or historical fact, no actor impersonating her. The voice in which she speaks and identifies herself in *No Ghost Just a Shell* is manufactured, digital, while in *One Million Kingdoms* she flies out of orbit on the speculative wings of the most prophetic of nineteenth-century writers.

By adding to our perplexities about the truth status of contemporary media representations, Annlee focuses attention on a new kind of ghost who haunts us. In their hundreds of thousands, in their millions, these new ghosts are figments in the sense that Andy Warhol, who was so invested in photographic doubling and specular celebrity, meant when he specified his epitaph to read "figment."

In one sense such phantasms are the intrinsic products of human consciousness. As both Plato and Aristotle discuss, the thinking mind summons pictures in the imagination; *phantasm* is from the Greek word for "mental image," not "ghost." From this perspective, Annlee embodies—or rather assumes—the properties of pictures of the mind's eye, in their vivid immateriality. However, by means of contemporary media technology, she has taken form.

In Huyghe's *Streamside Day Follies*, the walls are mobile and close to create an enclave, demarcating a kind of camera obscura in which the film unfolds, thereby setting up an analogy between the fantasy areas in which films are screened and the internal chamber of the individual imagination of the spectator, which summons up and receives such images, or, as in the Annlee project, supplies the lack that endows them with animate life, that haunts them.

The celebrations—including a solemn muster of the local fire engine and police car, official speeches, a Founders' Day tree-planting ceremony, ice cream, a huge cake, and a special song—assembled with almost pedantic thoroughness the building blocks of community ritual. Huyghe added some distinctive threads to the day: cute furry creatures like Disney's Bambi appeared to signify the desecrated woods and propitiate their inhabitants' angry ghosts; everywhere, large cardboard boxes were provided for children to play with, to fill, to empty. The cheerfulness seemed forced, the pace slow, the crowds a bit thin; it was a long, straggly day, and nobody quite knew what to do or how to behave. Huyghe had rigged up a huge inflatable moon so that it would show up in the sky of the film. Still, he presented himself to be serious, genuinely attempting to make a charm, in the form of a festival, to exorcize the emptiness and to make amends for the destruction

of the woods, for the pastiche mansions, for the ravages to Arcadia.

Magical methods: miniaturization, masquerade, ritual, song, procession, and performance of powers. Huyghe acted as both impresario

Pierre Huyghe, *Streamside Day Follies*, 2003

and recorder; the *New York Times* reviewer did not grasp that he had devised the entire proceedings, and that no such party would have happened without him.[6] The mixed tedium and pleasurable idleness of the local events were precisely captured on film, and the successfully launched Founders' Day was intended to return every year from then on. The work can be looked at in the context of relational aesthetics, as discussed by the curator Nicolas Bourriaud, in that Huyghe was making art in the form of a community event in the heart of an ordinary housing estate, providing food and entertainment without defining them as works of art.

Streamside Day Follies is an invented tradition, a planted, replicant's memory. The artwork presents another twist on the idea in *The Third Memory*. Whereas that film illustrates the intersheaving of act and representation to produce, with the lapse of time, a third order of memory in which the original and Pacino have fused and the fiction has seeped into reality, in *Streamside Day Follies*, Huyghe discards the primary event altogether, and institutes a fabrication of his own, a kind of Annlee figment event of his own devising. The day's *figurants*, the costumed woodland creatures, and the cardboard boxes emerge as fragments of an originary myth the artist has supplied to the new settlement, about the previous indigenous inhabitants whom they needed to expel and, at the same time, incorporate as totems (hence the soft and cuddly costumes). The cardboard box represents home and the American frontier tradition of packing up and moving on, unpacking and moving in; it stands for shelter and its dark double, homelessness, and the cardboard

cities of the *sans-abri*, the "shelterless." And also for the enclave, perhaps, that encloses us as we watch—the mindset whose walls are the limits of perception and the contours of imagination.

Jules Verne, Bambi, *Close Encounters of the Third Kind*, *Poltergeist*: the lineage of fantasy that connects Huyghe's installation to past inventions itself proposes alternative realities. The walls that move in to enclose his work recall the walls that appear in current science fiction concerned with parallel worlds: they are called "distrans" in French editions of the cult novel *Hyperion* (1989), by Dan Simmons.[7] Distrans move humans from one galaxy to another, and "allow them to warp instantly through space-time without moving." This is, of course, exactly what occurs when we watch television—in our consciousness and imagination, if not in our embodied selves. *Streamside Day Follies* plants memories deliberately in the lives of the inhabitants of the new community; Huyghe's film openly grasps the possibility of generating history, of counterfeiting reality.

December 10, 2003

Notes

1 Jan Verwoert, "Copyright, Ghosts and Commodity Fetishism," in Pierre Huyghe
 and Philippe Parreno, *No Ghost Just a Shell* (Cologne: Walther König, 2003),
 pp. 184–92.

2 J.M. Coetzee, *Elizabeth Costello* (Harmondsworth: Penguin Books, 2004),
 pp. 212–13.

3 Sarah Ciracì, interview with the author, New York, 2003.

4 Zygmunt Bauman, *Liquid Modernity* (Cambridge: Polity Press, 2000).

5 James Wood, "A Frog's Life," *London Review of Books* 24, no. 20 (October 23, 2003),
 p. 16.

6 Roberta Smith, "Waltzing Walls and Nature Denatured," *New York Times*,
 November 7, 2003.

7 See the discussion of the concept of "distrans" in Huyghe and Parreno, *No Ghost Just
 a Shell*, pp. 25–26.

Plastic Empathy: The Ghost of Robert Whitman

BRANDEN W. JOSEPH

On September 20, 1966, at the New York Film Festival at Lincoln Center, Robert Whitman participated in a panel discussion devoted to the newly emergent art form, expanded cinema. Moderated by the ubiquitous Henry Geldzahler, the symposium consisted of Whitman, John Gruen, Ken Dewey, and Stan VanDerBeek.[1] Although Whitman had previously been considered one of "the Happenings Boys," the debut of *Prune Flat* and the Expanded Cinema Film Festival moved him prominently into this new field.[2] Central to it was the interaction between performers and their images, and *Prune Flat* was repeatedly cited as exemplary of this phenomenon. Richard Kostelanetz's description of the work was typical. "Whitman's masterpiece," as he called *Prune Flat*, was "an exercise in the ambiguous identity of film image and reality. . . .

Robert Whitman, *Prune Flat,* 1965, performed in 1976

His structure and theme are the same—the possible confusion between image and reality."[3]

That afternoon, VanDerBeek—host of a festival-sponsored visit to his recently completed *Movie-Drome*—proved the most enthusiastic participant, frequently speaking on behalf of the entire "movement." As a means of succinctly explaining his viewpoint, VanDerBeek proclaimed that painting, and, by implication, its medium-specific boundaries, was "dead." And dead along with it were all the aesthetic separations and negations by which the arts had been theorized in three decades of formalist criticism. Unconditionally renouncing artistic distance or autonomy, VanDerBeek affirmed, "To simplify the issues here I would say something to the extreme that, for instance, painting is dead and that just recently we've grown out of our kind of industrial puritan background and our romantic aspects and are now quite seriously and enthusiastically embracing our technology. . . . I would say that probably artists working in uniting themselves with their culture and technology is the most important cultural step that we are about to take."[4]

For VanDerBeek, the expansion beyond medium boundaries was part of a much larger expansion of art, as a mode of communication, throughout the globe. Technology opened a virtually unlimited sphere of instantly transmittable imagery, "an expanded cinema that quite literally circles . . . the world." "The most important medium we have right now," he contended, "is light and the transfer and storage of images by light," or, as he put it, "basically television."[5]

VanDerBeek's rhetoric was clearly beholden to Marshall McLuhan's celebration of the capacity of electronics to effect a global village. VanDerBeek's term was "culture intercom," and the *Movie-Drome* was to be a prototype of an image communication system that would "reach for the emotional denominator of all men, the non-verbal basis of human life, thought, and understanding, and . . . inspire all men to goodwill and inter-and-intro-realization."[6] Rather than see electronic technology's capacity to outer the central nervous system (as McLuhan put it) as a means of articulating the human subject with forces of the outside, VanDerBeek's

characterizations resembled a vast, narcissistic inflation of the ego. The individual's prosthetic cathexes were folded back to create a new, expanded unity where those communicated with were internalized—first within the *Movie-Drome* and then within consciousness—as images. As he stated one year before, in 1965, "We are on the verge of a new world—a new sense of art, life, and technology— when artists shall deal with the 'world' as a work of art, and art and life shall again become the same process. When man's senses shall expand, reach out, and in so doing shall touch all men in the

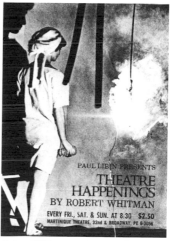

Robert Whitman, 1966 poster for *Prune Flat*, 1965

world."[7] The twentieth-century global village was thus to be a vast subjectivization, "the metaphor of man who is really multi-man," more dynamic but every bit as solid and self-present as the unified bourgeois subject of the nineteenth century.[8]

While VanDerBeek's high-speed image overload, or "visual velocity," seems distinct from Whitman's more deliberate theater events, the culmination of Whitman's aesthetic was a similar "integrati[on] of image material . . . with live actors and performers," a multimedia art encompassing "drama and experimental cinema-theater."[9] Although Whitman, as George Baker has argued, would not ultimately embrace the complete dissolution of medium specifics, he nonetheless endorsed and extended VanDerBeek's blanket dismissal of traditional mediums, declaring to an amused audience at Lincoln Center, "I also think along with paintings that movies (laughter) are dead."[10] Elsewhere, Whitman similarly promoted the instantaneous communicative capacities of electronics. "I am after a work around the stability of a film image and the immediacy of newsflash," he stated about his performance *Two Holes of Water No. 3* of 1966. "Television is a great way to collect stuff; besides what's on the air, a camera on anything

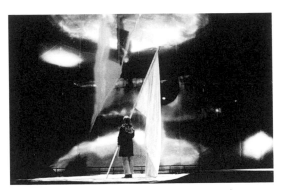

Performance in the mirror dome inside the Pepsi Pavilion,
Expo '70 in Osaka, Japan, 1970

brings it in live—a local newsflash."[11] VanDerBeek, in other words, did not entirely misrecognize affinities with his colleague.

The rhetoric of expanded cinema would culminate four years later in the discourse surrounding the Experiments in Art and Technology (EAT) Pepsi Pavilion at the 1970 Osaka World Exposition. By all accounts, Whitman proposed the mirror dome that filled the pavilion's interior.[12] Its parabolic surface produced not only normal reflections, but also apparently three-dimensional "real images" that seemed to hover freely in space. Echoing earlier descriptions of *Prune Flat*, *Architectural Design* reported that in the dome, "it is often impossible to interpret what is 'object' and what is 'image.'"[13] Because it continued the goals of connecting real and image, even (or especially) while apparently eliminating projective technology, the pavilion was cast by Gene Youngblood as the apotheosis and "future of expanded cinema." "The mirror," he said, "indeed 'exposed' a world of expanded cinema in its widest and most profound significance."[14]

It was not by chance that the pavilion provoked such a response among those, like VanDerBeek and Youngblood, who understood expanded cinema in terms of subjective amplification. For, as reported by Elsa Garmire, "a unique experience occurs at the center of the spherical Mirror [sic]; no matter where you look into the Mirror, you see only yourself. . . . You see all your own images and, in fact, no one else can see them but you. Your image world is filled solely with yourself."[15] It was this that led Barbara Rose, in a passionately McLuhanesque defense of the pavilion, to characterize it as "a secular temple of the self," its "fluid and protein character an analog of contemporary consciousness."[16]

No doubt it was the centrality of Whitman's work to the emergence of such a discourse that led Annette Michelson, three days before the Lincoln Center panel, to single him out for ad hominem critique in "Film and the Radical Aspiration." "The emergence of new 'intermedia,' the revival of the old dream of synesthesia, the cross-fertilization of dance, theatre, and film, as in the theatre pieces of Robert Whitman," she argued, "constitute a syndrome of that radicalism's crisis, both formal and social." "In a country whose power and affluence are maintained by the dialectic of a war economy, in a country whose dream of revolution has been sublimated in reformism and frustrated by an equivocal prosperity, cinematic radicalism is condemned to a politics and strategy of social and aesthetic subversion"—by which she meant, specifically, "an attempted dissolution of distinctions or barriers between media" rather than an actual negation of the "social and economic hierarchies and distinctions" imposed by capitalism.[17]

Michelson was not alone in noting the proximity of expanded cinema, and Whitman's work in particular, to advanced forms of capital. Indeed, an anxiety about expanded cinema's relation to contemporary corporate spectacle resounded among some of the artform's most outspoken supporters, particularly in the aftermath of the 1964 New York World's Fair. The fair's state- and corporate-sponsored multimedia pavilions received such a reaction that Jonas Mekas felt it incumbent on him to review them in the *Village Voice*.

Starting with the New York Pavilion, Mekas moved through the IBM "Information Machine," KLM's "To the Moon and Beyond," United Airlines' "From Here to There," and Kodak's "The Seeing Eye," before ending with a particularly deadpan and sardonic account of Du Pont's "Wonderful World of Chemistry." "The story of Du Pont products," he began,

> combines live actors (fashion models and announcer) and actors
> on screen (perfect timing); projectors used; also slides and lighting
> effects (brilliant job). Live actors conversing with actors on screen
> (perfect timing); a rose is passed by one of the live models on stage

to a model on screen who in turn passes it to another live model and who in turn passes it to the third model on the third screen. A perfectly timed, slick advertisement, the most perfect from the six I have seen so far, with no art pretentions, pure Madison Avenue.[18]

The term *slick* was particularly loaded for Mekas, connoting all of corporate, mainstream culture—whether Madison Avenue or Hollywood—that he, as spokesperson of underground cinema, tirelessly opposed. It is therefore not insignificant that the word appeared the next year in Mekas's review of *Prune Flat*. "Robert Whitman's show," he wrote,

> combined live action with the filmed image. He played his performers against the images, for humor and for surprise (the same performers appeared in the film and on stage). Like any good magician, he had a good bag of tricks ready; as an artist, he let the tricks fail, sort of, and used their imperfections as a formal quality. Still, Whitman's show very often came close to being just a display of virtuosity; it was more on the slick side than any other of his shows I have seen.[19]

Whitman's proximity to corporate spectacle was also noted by Michael Kirby, who spent much of his 1966 article, "The Uses of Film in the New Theatre" attempting to ward off comparison of expanded cinema with the work at the World's Fair. Like Mekas, Kirby also paid particular attention to the Du Pont corporation's combination of "a short history of plastics . . . and a fashion show (in song-and-dance format)," which he described at length:

> Live actors played scenes with films . . . : the master of ceremonies "blew out" a projected candle, an actress ordered food from a film grocer, etc. At one point the screen units were separated, the life-size image of a dancing girl was projected on each, and two real men danced the same steps in the intervals between the screens. Then the filmed girl at stage left handed a rose to the real man on her right, and the rose, alternately real and on film, passed down the line of

dancers. (As the live dancer reached behind the screen box to pick up or deposit a real rose, the image of 'his' hand reached into the film image at exactly the same point to take or deliver the rose.)[20]

Whereas Mekas contrasted art and industry on the basis of finish, Kirby attempted to distinguish them through an ideal of interiority. "There is a primary difference between the performances given at the World's Fair and those which I have called part of the New Theatre," he contended. "The New Theatre is made up of individuals pursuing more or less personal and subjective aesthetic goals. . . . Theatrical creativity is possible at almost the same level of privacy as that enjoyed by the painter, sculptor, or writer." As opposed to the World's Fair, "the 'target'" of which, Kirby maintained, "was a mass audience," "the artists of the New Theatre are working for a relatively small audience that is well aware of the traditions on which the work is based."[21] "As more sculptures and paintings use film," he concluded, "more theatre people and filmmakers will find in their own studio-theatres the privacy of the sculptor and the painter."[22]

Kirby's (only seemingly paradoxical) characterization of *expanded* cinema as an *enclosure* against corporate technologies had in fact been anticipated by members of the Frankfurt School. "Nonconformists," wrote Walter Benjamin in his study of nineteenth-century Paris, "rebel against consigning art to the marketplace. They rally round the banner of *l'art pour l'art*. From this watchword derives the conception of the 'total work of art' the *Gesamtkunstwerk*—which would seal art off from the developments of technology. The solemn rite with which it is celebrated is the pendant to the distraction that transfigures the commodity"—a distraction that, as Benjamin made clear, culminated in the realm of World Expositions.[23]

Just as Kirby's New Theatre presented to the world the individual artist's atelier, the *Gesamtkunstwerk*, for Benjamin and Theodor Adorno, formed the public expression of its private, dialectical counterpart, the bourgeoisie interior.[24] In both, the commodity's removal from either use or exchange led it to assume

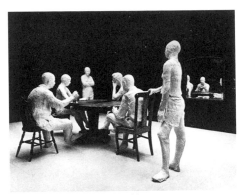

George Segal, *The Dinner Table*, 1962

animate, phantasmagoric form. Adorno described such imagistic evocations of the interior: lamps transform into flowers, and rugs become landscapes of exotic foreign lands or "evoke ideas about a ship . . . sail[ing] out into the middle of the great ocean."[25] "Here in the image," he explained,

lost objects are conjured. The self is overwhelmed in its own domain by commodities and their historical essence. Their illusory quality is historically-economically produced by the alienation of thing from use value. But in the intérieur things do not remain alien. It draws meaning out of them. Foreignness transforms itself from alienated things into expression; mute things speak as 'symbols.' . . . Historically illusory objects are arranged in [the apartment] as the semblance of unchanging nature. In the intérieur archaic images unfold.[26]

Enclosures and everyday objects, archaic imagery and symbolism, illusion and nature: these are the very tropes by which early Happenings were effectively defined. And they were very much in evidence in 1966, the year of Kirby's writing and of Allan Kaprow's voluminous book *Assemblage, Environments and Happenings*.[27] Amid photographs of the cavernous, encrusted interiors of Kaprow's *Eat* (1964) and *An Apple Shrine* (1960), Red Grooms's *The Burning Building* (1959), Jim Dine's *The House* (1960), George Segal's sculpture *The Dinner Table* (1962), and other "Entrances and Enclosures," Whitman is shown on the set of *American Moon* underlined by the designation "Caves." Beneath other photos, Kaprow explicitly relates Happenings to archaic imagery: "The Shrine," "Baptism," "Immolation." Although Happenings' materials were quotidian objects, their symbolism, Kaprow explained to Kirby, was "so general and so archetypyal that actually almost

everyone knows vaguely about these things. . . . I try to keep the symbols universal, simple, and basic."[28]

The invocation of an interior by which the Happening might ward off or transform commercial alienation

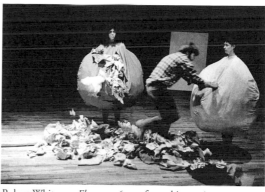

Robert Whitman, *Flower*, 1963, performed in 1976

complements the series of dialectical ruses—subject and object, immediacy and spectacle, the ephemeral and the commodified— that Tom McDonough has recently examined with regard to *American Moon*.[29] The interior's particular capacity to induce phantasmagoria, however, comes more evidently to the fore in the cavernous and enclosed set of Whitman's 1963 *Flower*. There, in a space so small that performers literally brushed audience members' knees, viewers were presented a series of fantastic, animate transformations.[30] These began with a cloth-filled sack that issued forth vine-like tendrils rising to the ceiling on nearly invisible strings. Other sacks were inhabited by female performers who briefly hopped about before the sacks' newspaper stuffing was violently scattered about the room. Formed by the crumpling of the hand, these wads of newspaper were then pressed, glued, and stapled to the walls, encrusting its surface with bodily traces akin, perhaps, to those retained by the velvet drapes and other coverings in nineteenth-century apartments.[31]

Following the tenets put forth in Kaprow's manifesto of Happenings, "The Legacy of Jackson Pollock," *Flower*'s interior was coded as an extension of painting.[32] On two walls were vertical paint stripes, to which—in a scene reminiscent of *18 Happenings in 6 Parts*—more would be added at each performance. Simultaneously, however, Whitman's environment was coded as nature: not only did the colorful paint stripes recall flowers, their long stems

appearing elsewhere in the work, but they resembled the green cloth "vines" that later fell from the ceiling. The stripes were applied by the Happening's four main female characters, who appear— promenading as if at a fashion show—in heels and deceptively simple dresses that they manipulate to reveal colors, like the petals of a flower. With the "flower girls," as they were called, Whitman coupled an archaic (and essentializing) vision of woman to the most ephemeral of commercial transformations, producing a dialectical image reminiscent of Grandville.[33]

Despite continual phantasmagoric metamorphoses, *Flower*'s commercial subtext was revealed in the penultimate scene, where the women pick through cloth remnants and pile them atop another performer. This action was accompanied by a soundtrack consisting of "comments of shoppers, clothes hangers squeaking and squealing as they slid on display racks, the voices and sounds of a department store."[34] Rag picking becomes shopping and (literal) accumulation. Whitman's performance finished with attention focused on the large cloth flowers at each end of the space, most notably on the outside red daisy, which opened and disgorged another mass of colored rags rising upward in a final image of growth.

Prune Flat continued *Flower*'s interrelation of women, fashion, and nature, and also concluded with a single flower. In this case, however, the blossom was a projection that changed, not by physical manipulation, but by subtle alterations in light. If *Prune Flat* marked Whitman's move from Happenings to expanded cinema, however, it was not merely or even primarily through such uses of film—ubiquitous since his earliest performances—but through the dissolution of the metaphorical interior.

In *Flower*, a film of a sleeping woman appeared as a dreamlike projection of the performer's unconscious.[35] It was like a window opening onto an interior world, a subjective projection fully in line with Kirby's expressive paradigm. In *Prune Flat*, by contrast, film takes the place formerly held by painting: performers interact with the screen no longer as a world apart, but as their very environment. Not coincidentally, perhaps, shortly after *Prune Flat*'s production,

Whitman would distance himself from Kaprow's genealogy of Happenings as deriving from painting via three-dimensionality to a physical enclosure. Voicing reservations about the importance of Pollock (another means of distancing himself from Kaprow), Whitman rejected a formal definition of environment—which he dismissed as "really another of those words"—and counterposed an environment defined by media. "We are all trained to look at things that are small and big and let them be the world, like TV for example," said Whitman. "When you look at a television screen, it may be very tiny, but it is a world; everything else is destroyed when you are watching it. A news broadcast is probably as environmental as you can get."[36] In the following decades, Whitman would explore a range of media spaces, first by attaching video projectors to moving cars in *Two Holes of Water No. 3*, and later through more territorially dispersed pieces involving television, telephone, telex, fax, and radio.

Within *Prune Flat*'s literal screen environment, the projected image is primary, while the actors appear as emanations of it. This is clear from the very first moment, as two women in white enter, pressed against the screen, absorbed as though in camouflage. Whitman's notes instruct them to mimic the film; cued by the "shimmering picture" of glitter spilling from a tomato, they are to "shake"; with spilled feathers, to "flail arms" as though buffeted by the depicted wind; with the "oozing picture," to "ooze." Later, they are explicitly told to "disappear into [the] movie."[37] Even when a performer moves upstage, she appears two-dimensional, like a pop-up figure from a children's book, depthless, decorporialized as though part of the movie had detached itself and stepped forward. There is, in other words, a generalized spectacularization at work, which dissolves the performers into the projection, disembodies them such that they carry no particular weight in contradistinction to it.

Only afterward is a certain phenomenality restored: in the infamous appearance of the "movie girl," who poses in different projected outfits (not unlike a model) before seeming to undress and wash herself. Hers is a paradoxical phenomenality, produced not

solely by means of her real body, but by means of a supplementary spectacularization, a return of the body or an incorporation, which occurs only by layering a ghostlike prosthetic body onto the body that has already been absorbed into the image on the screen. Kostelanetz failed to notice that this effect resulted from a second projection until he had seen it four times.[38] Even then, he wanted the performer and her image to match precisely, effacing the disjunction Mekas wanted to augment. He lamented that the "image is quite often off-center" and was disturbed at Whitman's disinclination to correct it. "Even though Whitman himself told me in conversation that he didn't care how precise the visual match was," he noted, "the difference in effectiveness is enormous. Sometimes I wonder how well he knows what he is doing."[39] Even when reseeing the piece years later, Kostelanetz could laud *Prune Flat* as "a perfect piece, both visually and temporally" only "in spite of its superficial messiness."[40] Kostelanetz wanted to eliminate the *paradoxical* phenomenality of Whitman's movie girl in favor of a simple phenomenality, a seamless integration (or reintegration) into the material world.

At Lincoln Center, VanDerBeek invoked a not dissimilar desire for the integration of performer and projected image by referencing Thomas Edison's famous "tone test" demonstrations from the early part of the century.

> One example that I was fascinated by was a test run when Edison came out with the first phonographs and they conducted this test in Carnegie Hall and behind the screen they had a phonograph . . . with a recording made by a string quartet. They then intercut between the two very carefully so that the audience was asked to say which was running, the machine or the live group, and the story is that the audience couldn't separate between the two.[41]

VanDerBeek's conclusion was that one could not similarly fool a contemporary audience, proof, to his mind, that media produced an inevitable evolution in sensory perception.

As shown by Emily Thompson, however, stories of Edison's audiences' credulity were somewhat overblown, results of an impressive campaign of advertising and spin.[42] Though presented within a paradigm of fidelity—that is, the adequation of copy to original—what was actually at issue was less the production of a perfect simulacrum than establishing the conditions by which technological reproduction could be accepted as a species of the real. Edison's tone tests developed out of a context in which the phonograph was being marketed as an "instrument" for domestic acoustical consumption: not a machine to *reproduce* sounds (which is how it had been originally offered), but a *producer* of music for the home. Phonographs, in short, delivered not copies of performances, but "real" music; the music one heard in concert would eventually have to be designated "live."

As Thompson and Jonathan Sterne emphasize, when understood through the trope of fidelity, what this transaction eliminates is the dimension of production, whether that of performers—chosen for their ability to emulate the sound and regularity of the machine—or that of the audience—actively collaborating by accepting the conventions of the "test" and listening past other acoustic qualities.[43] Such an effacement was necessary to present a direct correspondence or communication from one end of a mediated relationship to another, but also, and as part of the same thing, it was an effacement of the social and productive networks of which the media was a part. "In essence," explains Sterne, "the discourse of fidelity takes sound reproduction out of the social world and places it in the world of magic."[44]

It was no doubt a similar familiarity with advanced forms of spectacle that was being instituted in the Du Pont Pavilion in 1964. While images were becoming an increasingly prevalent form of the consumable—expanding across wider territories in ever greater varieties and speeds—Du Pont provided a forum in which the viewer (as consumer) would be further acclimatized to accepting and interacting with them as another species of real, a situation in which, as Whitman put it, TV could become a world. By

instituting an effectively magical correspondence between dancers on screen and dancers onstage, or in the much noted passing of a rose from hand to hand between live and reproduced performers, Du Pont visually demonstrated that the similarities outweighed any differences, that an effective connection between individuals had been made.

Prune Flat began with footage of a film projector, foregrounding the very mechanism (if not the social relations) that the discourse of fidelity would conceal. Whitman emphasized a desire for the audience's awareness of his performance's technical aspects.

> In *Prune Flat*, I was interested in the separation between the audience and the stage, which I tried to keep and make ever stronger. . . .
>
> It's in contrast with traditional theatre, where they try to suck you up onto the stage, to get you to believe in that world. I'm not interested in that. I want people to understand that world was manufactured. It is an object world. . . . It's very important for me to have people know that those are projectors back there and that they're making noise and shooting light out.[45]

Despite claims to the contrary, however, Whitman's presentations have little of the force of Brechtian distanciation. Although certain technical aspects are evident, they hover in back of the viewer's mind, overcome by a visual fascination: what one strives to see in *Prune Flat* is not the revelation of the mechanism, but the achievement of an effect. This relation to the image Whitman termed "plastic empathy": "seducing somebody into your world in terms of rhythm and colors and images that are pictorial or audio."[46]

With this seduction, something other than estrangement is taking place. In *Prune Flat*, we are in a space, a media space, where the type of dialectical oppositions defended by the interior no longer hold. In expanded cinema, montage gives way to what McLuhan called "mosaic."[47] But against the ideological representation of a holistic seamless connection, which would unify

expanded cinema with the aims pursued by Du Pont, something in *Prune Flat* refuses complete sublimation. There is thus some degree of truth value to Kostelanetz's frustration at the movie girl's refusal to fully unify with her projection. "Something . . . about that sequence in *Prune. Flat.* [sic] in which the filmed image of a nude figure is projected upon a white-smocked girl," Kostelanetz confided to Whitman, "haunts me."[48]

Whitman is famously interested in haunting, which he has connected to projected images. "I've always been interested in ghosts and spirits and weird things," he said in 1971, in the midst of his high-tech experiments with optics. "I've been trying to do that for a long time—ethereal images."[49] Several years earlier, Whitman had discussed ghosts in relation to film, telling Toby Mussman, "Even though [film] has its own artificial limits, that is, it is not a natural phenomenon like cold air, it can be used to bring out a ghostlike record of an actual event. Films represent the ghosts of actuality, something like the memory of things past."[50]

What seems to have obsessed Whitman was image's shadowy near phenomenality, the fact that it came so close to material existence, that it could, so to speak, "ghost" actuality. "Movies are fantasies," he said elsewhere.[51] Not only, for him, did these fantasies have the ability to impact the actual world—as movies, to "do things to the space"—but as fantastic images they took on a phenomenality of their own.[52] "At a certain point," he insisted, "fantasy is an object in the physical world. It is like a street or rain. It is a product of physical events. . . . The fantasy exists as an object, as a central physical entity."[53]

We have come across a similarly paradoxical existence before, in *Prune Flat*'s movie girl, who regained a divested corporality through the addition of a ghostly record of her own body—the projection of an image of her body onto her body, which, through prior projection, had already become an image. Such an effect, the return of an expropriated body, has been described by Jacques Derrida, in *Specters of Marx* and elsewhere, as the very structure of haunting. After the body has been alienated, abstracted into a type of image, "once this autonomization is effected . . . and only then,

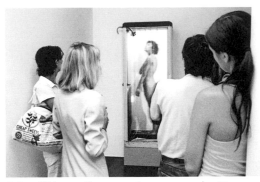

Robert Whitman, *Shower*, c. 1964, reconstructed at Dia, 2003

the ghostly moment comes upon it, adds to it a supplementary dimension, one more simulacrum, alienation or expropriation. Namely, a body!" Derrida continues, "For there to be ghost, there must be a return to the body, but to a body that is more abstract than ever. The spectrogenic process corresponds therefore to a paradoxical incorporation." Like "ideas or thoughts," once images "are detached from their substratum, one engenders some ghost by *giving them a body*."[54]

Prior to *Prune Flat*, Whitman had given body to an image—produced "the tangible intangibility of a proper body without flesh, but still the body of some*one* as some*one* other" that Derrida sees as proper to the specter—in the multimedia sculpture *Shower* (c. 1964).[55] Fashioned by projecting a bathing woman into a functioning shower stall, *Shower* has primarily been discussed in terms of a reality effect that approaches *trompe l'oeil*. Updating the story of Edison's tone tests, witnesses are said to have mistaken the work for an actual showering woman.[56] Those who lingered, however, would likely have found the piece less startling than uncanny; not so much because the woman appears alive, but because as either body or image she appears at once there and not there. Here, the work's thematic breakdown of the division between private and public space, common to *Prune Flat* and all of Whitman's Cinema Piece sculptures, works with its implicit voyeurism to virtualize the space within the room. That we see the woman's private activities though she gives no sign of reacting puts her in a space both proximate and distant.

The Eva-Tone flexi-disk Whitman made for the 1968 exhibition *4 Cinema Pieces* accentuated this effect.[57] One of the most

persistent sounds is of a telephone, a reminder of the virtual interconnection of spaces that recording shares with communication technologies. Evoking unseen soundscapes, the record adds an aural dimension to the sculptures that acts more like an acoustical shadow than an audio completion of the visual works. The artist's voice moves through the space, fading in and out as it comments on the pieces—there, once again, and simultaneously not there, as though to thematize the effect of haunting. Whitman's voice dwells for the longest time on *Shower,* finally seeming, impossibly, to occupy its virtual space. "When I made it," he intones, "I was outside the shower looking in. Now I'm in it getting wet and [changed] and cleaned by all the colored water." Heightening the disquieting aspect of this almost threatening proximity, Whitman accentuates his virtual voyeurism: "I'm looking in," he says. "She doesn't even know she's changing colors." As though to underscore the role of technological reproduction, this phrase, like others, is repeated before the recording ends.

By asserting *Shower*'s uncanniness against its seamless integration with reality, Whitman inverted the early genealogy of recording technology. For it was precisely such a haunting that Edison's tone tests had sought to eliminate. The uncanniness of the reproduced voice, its amalgam of organic and inorganic, living and dead, was present from the phonograph's invention, which Edison championed for its capacity to "preserv[e] the sayings, the voices, and the last words of the dying member of the family."[58] Despite Edison's lifelong pursuit of a machine to contact the dead, successful marketing of the phonograph necessitated acclimatizing early audiences to react to disembodied voices without the frisson such an aural experience could produce. As such, the tone tests explicitly countered the type of morbid anxieties stoked by less professional demonstrations of the time, such as that of the Kentucky minister who, in 1905, organized a massive public event by using a phonograph to preside over his own funeral. "The voice of him who lay dead in the coffin gave out the hymn," the *Edison Phonograph Monthly* reported, "and half-frightened, the mountaineers rose and sang."[59]

The spectral is that which disturbs the seamless reality effect of media: it refuses the type of closure desired by Kostelanetz, but without the evident disjunction sought by Mekas. It is all that VanDerBeek would eliminate in his call for a transparent, universal "culture intercom." Accepting reproduction seamlessly as a facet of the real (even if, via fidelity, one judges the reproduction inferior) necessitates covering over the spectral, uncanny, haunting presence of the dead—the dead that are nothing other than what Karl Marx called the "phantom-like objectivity" of the "congealed quantities of homogeneous human labour" accumulated within the commodity.[60]

It was, of course, in *Capital* that Marx explained the manner in which labor, as abstract labor time, is objectified within the commodity, how incommensurable material activities are abstracted so they can be exchanged. Such abstraction is the alienation not only of time, which is congealed into an object or spectacular image-object, but of the qualitative differences of that time. It is in discussing that very elimination, Thomas Keenan explains in his deconstructive reading of *Capital*, that Marx has recourse to a ghost. Or, what is the same thing in the paradoxical process Marx describes, it is by the ghost that this reduction is made possible:

> [Marx's] ghost is the ineffaceable excess, the oddly material if non-sensible "jelly" of a remnant that resists incorporation, and the condition of possibility for the operation that must have already happened in order to leave it behind. The maneuver succeeds (as it does all the time) only to the extent that the commodity as ghost is a figure for the most rigorous of reductions, the radical elimination of all traces of use-value, with one exception: the residue of the abstraction itself. This enables the thing to survive, as a ghost, and not just disappear, and this residue serves as the "common something" on which exchange can be based because it marks, however negatively, all commodities with the trace of resemblance.[61]

If a certain time, human labor-time, is what is bound up in the commodity or image—if that is what is effaced in a spectacular exchange which has reason therefore to see ever more

instantaneity—it is perhaps by extending that time that the ineffaceable residue, or ghost, will reappear. "Whitman's pieces," Mekas once observed, "have to take a certain time, they cannot be rushed, they have to work themselves into you and out."[62] Whitman himself has always insisted on the importance of time to his work: "The thing about theatre that most interests me is that it takes time," he stated. "Time for me is something material. . . . Time is the medium that I use to demonstrate what I know about, what I think people need to know about."[63] This time, the necessary time of Whitman's expanded cinema, is experienced through a layering of projected images. "The images," Whitman explained, "make real the experience of time." They give "the depth of the experience of the real time of the piece. The direct presentation of the images and the character of the time are the most important things."[64] Here, as before, Whitman's logic demands decoding. For as we have seen, images, film images, are for Whitman "ghosts of actuality"; they bring forth ghosts akin to "the memory of things past." Memories of things that have passed, like people who have passed, who have died and as ghosts of their former actuality returned as memories: Whitman's paradoxically direct temporality, a time suffused with images, is thus a time opened to the memory of the dead; it is, in other words, a type of *mourning*.

Layering the dead upon the living in a palimpsest that allows the dead, as image, to persist, *Prune Flat* splits time in much the same way as it virtualizes space. Irreducible to the Pop embrace of the simulacral, Whitman's "real time" is also not the phenomenological time of Minimalism, which would oppose the depth of the body against its spectacular expropriation. As those who assimilated Whitman to the predominant discourse of expanded cinema understood, his work participates in the very mechanisms by which the body and its labor are expropriated into image and then returned to the world as a separate, separated thing. Whitman does not negate such expropriation; his time is still abstract time. Yet it is not spectacular time, the reified, homogenous, exchangeable time in which congealed, commodified,

dead labor reins over the living, the time of consumption, which as Guy Debord stated, is ever the same.[65]

Whitman's time is a "real time" presented directly despite the mediation of images, or, as he insisted, presented directly and in "depth" *because* of that very mediation. Whitman's deliberate, layered, bifurcated temporality allows a ghostly difference, a haunting deferral, to inhabit the moments that it puts on display. Unlike the dancers in the Du Pont pavilion, *Prune Flat*'s movie girl never attains the solidity of an image-object that can seamlessly be appropriated as part of the real. She is always ghosted by a haunting or enchantment that restores to her a measure of uncanny fascination. Nor does Whitman's performance attain to a "visual velocity" by which such uncanny remnants would be congealed, covered over, or forgotten in an ever more rapid moment of exchange. Whitman's time proceeds too slowly and deliberately for any such operation to be fully effective (which, of course, it never fully is).

In a work of mourning never to be achieved, never to be successful in psychoanalytic terms, Whitman refuses to let go of the memory of the dead that hovers about his every image. His work thus ultimately refuses the narcissism of the subjectively expansive global village. For mourning is not only an effect of time, but also of space. It partakes of a certain interiority, or interior, in which the memory of the dead lives on. But unlike an ideal narcissism, in which the other or the image of the other is absorbed, appropriated, fully and completely consumed without difference or remainder, mourning is a form of introjection which is never complete, in which the alterity of the other, the alterity of the death of the other, refuses absorption within the self. As Derrida writes on this interminable work of mourning,

> The one who looks at us in us—and for whom we are—is no longer; he is completely other, infinitely other, as he has always been, and death has more than ever entrusted him, given him over, distanced him, in this infinite alterity. However narcissistic it may be, our subjective speculation can no longer seize and appropriate

this gaze before which we appear at the moment when, bearing it
in us, bearing it along with every movement of our bearing or
comportment, we can get over our mourning of him only by getting
over our mourning, by getting over, by ourselves, the mourning
of ourselves, I mean the mourning of our autonomy, of everything
that would make us the measure of ourselves.[66]

Whitman's temporality allows for a delay or deferral to inhabit
the moments of image exchange, appropriation, and consumption.
Such a procedure, Derrida once again explains, "does not eliminate
the death and expropriation at the heart of the living; it calls one
back to what always defers the work of mourning," what always
defers, we can say, *within* the work of mourning: a "differance or
deferral" which is "a delay of reappropriation."[67]

It was precisely such an interminable *work of mourning* that
Barbara Rose went out of her way to eliminate while defending
Whitman's collaboration on the EAT pavilion at Expo '70 in
Osaka. The pavilion, she wrote, "accepts art as part of life, as an
experience as ephemeral and changing in its form as life itself.
Gone is the commemorative function of art. . . . The focus is not
on absolutes or immortality or the afterlife emphasized by death-
oriented cultures, but on the here and now, on the present, and on
the concreteness, directness, and reality of the moment at hand."[68]

If the EAT pavilion seemed such a temple of self-presence, the
culmination of a certain rhetoric of expanded cinema, the mirrored
environment Whitman installed at the US pavilion in Osaka was a
chamber of alienation. Similarly producing real image reflections,
Whitman's room replicated the visitor's face a thousand times and
from the side, never resolving in either number or orientation in
such a way that one could identify with it as anything other than
an image-object. To this, Whitman added reflected everyday items,
which, unlike the imagery in *Flower*, were unrelated by either theme
or symbolism. Scientist John Forkner listed them as "a clock, an
artificial fern, a pear, a cabbage, an electric drill, a brick, a knife, a
wad of crumpled paper, and a tank of live goldfish."[69] Max Kozloff
wrote that these "mirror projections . . . were as imaginatively

pointless as they were physically disembodied," while David Antin noted more caustically that Whitman's "usually brainless imagery was this time unaccompanied either by focused dumbness or his customary glamour."[70] Yet, the fact that these objects had nothing in common except that they could be exchanged emphasized their roles as commodities.

Although Forkner recalled being puzzled by Whitman's fascination with the "seemingly trivial phenomenon" of real images, it should by now be somewhat understandable.[71] Like *Prune Flat*'s movie girl, the reflections' apparent three-dimensionality provides the image with a body, transforming it from simulacrum to specter, specifically the type of specter that animates the commodity. It is worthwhile here to recall Marx's famous description of the table, which, as commodity, "not only stands with its feet on the ground, but, in relation to all other commodities, . . . stands on its head, and evolves out of its wooden brain grotesque ideas, far more wonderful than if it were to begin dancing of its own free will."[72] As Forkner recalled, this was precisely what visitors to the US pavilion encountered: "The 'ghost' image of each object would suddenly appear in space as one of the miniature spotlights on the ceiling switched on; the image . . . was seemingly detached from any reflecting surface, and as the mirrors began to pulsate, would advance toward the viewer, then disappear as the light shut off."[73] As real images, which are reflected upside down, these objects had already stood on their heads. Had Whitman and Forkner succeeded in their pursuit of "pseudoscopic" reflections, they would have turned themselves inside out for the viewer as well.[74]

Here again Whitman cannot be said to be estranging the commodity, if by that one means revealing the mechanism by which human labor is abstracted, expropriated, and congealed. His US pavilion installation never criticized its state, corporate, or industrial sponsors. But neither did it entirely paper over its relations to them. Rather, in literalizing the effect of the commodity's enchantment, in ghosting its actuality, Whitman's images restored some measure of its uncanniness. Like a "good magician," Whitman did not fully reveal the sleight of hand that produced the image-object—enough

fascination remained to cover for it—yet something about it nevertheless continued to haunt.

Unlike a euphoric ideology of expanded cinema, which mistook capitalism's overcoming of simple oppositions—between interior and exterior, life and death, real and image—as an access to or return to presence, Whitman presented expanded cinema as a generalized extension and heightening of spectralization. Such is perhaps the true nature of his uncanny closeness to corporate spectacle, as well as the potential continued importance of his art. For if Whitman himself did not effect a critique, his work would nonetheless serve as a reminder that the ghost is there.

December 18, 2003

Notes

1 Ken Dewey, Henry Geldzahler, et al., "Expanded Cinema: A Symposium, N.Y. Film Festival 1966," *Film Culture* 43 (Winter 1966), pp. 1–2.

2 Jack Kroll, "Situations and Environments," *Art News* 60, no. 5 (September 1961), p. 16.

3 Richard Kostelanetz, *On Innovative Performance(s)* (Jefferson, N.C.: McFarland & Co., 1994), pp. 144–45.

4 "Expanded Cinema: A Symposium," p. 1.

5 Ibid.

6 "Expanded Cinema: A Symposium," p. 1, and Stan VanDerBeek, "'Culture: Intercom' and Expanded Cinema," *Tulane Drama Review* 11, no. 1. (Fall 1966), p. 47. On VanDerBeek and Marshall McLuhan, see Gloria Sutton, "Stan VanDerBeek's Movie-Drome: Networking the Subject," in *Future Cinema: The Cinematic Imaginary After Film*, ed. Jeffrey Shaw and Peter Weibel (Cambridge, Mass.: MIT Press, 2003), pp. 136–43.

7 VanDerBeek, "Re:Vision" (1965), *Perspecta* 11 (1967), p. 119.

8 "Expanded Cinema: A Symposium," p. 1.

9 VanDerBeek, "Culture: Intercom," pp. 47, 48; and VanDerBeek, "Re:Vision," p. 119.

10 "Expanded Cinema: A Symposium," p. 1. See George Baker, "The Anti-Images of Robert Whitman: The *Dante Drawings*, 1974–75," in *Robert Whitman: Playback*, ed. Lynne Cooke, Karen Kelly, and Bettina Funcke (New York: Dia Art Foundation, 2003), pp. 114–42.

11 Robert Whitman, quoted in "Chronology," in *Robert Whitman: Playback*, p. 209.

12 Calvin Tomkins, "Outside Art," in *Pavilion by Experiments in Art and Technology*, ed. Billy Klüver, Julie Martin, and Barbara Rose (New York: E. P. Dutton and Co., 1972), p. 115.

13 "Cosmorama: Mirror Dome," *Architectural Design* (January 1970), p. 2.

14 Gene Youngblood, *Expanded Cinema* (New York: Dutton, 1970), pp. 416–17.

15 Elsa Garmire, "An Overview," in *Pavilion*, p. 204.

16 Barbara Rose, "Art as Experience, Environment, Process," in *Pavilion*, pp. 99 and 101. Rose explicitly invokes McLuhan on p. 97.

17 Annette Michelson, "Film and the Radical Aspiration," in *The New American Cinema*, ed. Gregory Battcock (New York: Dutton, 1967), p. 101.

18 Jonas Mekas, "Movies at the World's Fair" (July 9, 1964), in *Film Culture* 43
 (Winter 1966), p. 11.

19 Mekas, "More on Expanded Cinema: Rauschenberg, Oldenburg, Whitman"
 (December 23, 1965), in Jonas Mekas, *Movie Journal: The Rise of a New American
 Cinema, 1959–1971* (New York: Macmillan, 1972), p. 221.

20 Michael Kirby, "The Uses of Film in the New Theatre," *Tulane Drama Review* 11,
 no. 1 (Fall 1966), pp. 57 and 59.

21 Ibid., pp. 58–59.

22 Ibid., p. 61.

23 Walter Benjamin, "Paris, the Capital of the Nineteenth Century," trans. Howard
 Eiland, in *Walter Benjamin: Selected Writings*, vol. 3, ed. Howard Eiland and
 Michael W. Jennings (Cambridge, Mass.: Harvard University Press, 2002), p. 41.
 On the commodity and the world exposition, see pp. 36–39.

24 Ibid., p. 39. Adorno discusses the notion of the *Gesamtkunstwerk* in Theodor W.
 Adorno, *In Search of Wagner*, trans. Rodney Livingstone (London: Verso, 1981),
 especially chapter six, "Phantasmagoria," pp. 85–96.

25 Søren Kierkegaard, quoted in Adorno, *Kierkegaard: Construction of the Aesthetic*,
 trans. and ed. Robert Hullot-Kentor (Minneapolis: University of Minnesota Press,
 1989), p. 43.

26 Adorno, *Kierkegaard*, p. 44.

27 Allan Kaprow, *Assemblage, Environments and Happenings* (New York: Harry N.
 Abrams, 1966).

28 Kaprow, "A Statement," in *Happenings: An Illustrated Anthology*, ed. Michael Kirby
 (New York: E.P. Dutton and Co., 1965), p. 50.

29 See Tom McDonough, "Robert Whitman's *American Moon*: A Reading in Four
 Phases," pp. 105–27 in this volume.

30 On *Flower*, see Kirby, *Happenings*, pp. 158–71 and the interviews and footage in the
 DVD included in *Robert Whitman: Playback*.

31 See Benjamin, "Paris, the Capital of the Nineteenth Century," p. 39.

32 Kaprow, "The Legacy of Jackson Pollock" (1958), in *Essays on the Blurring of Art and
 Life*, ed. Jeff Kelley (Berkeley: University of California Press, 1993), pp. 1–9.

33 On Grandville, see Benjamin, "Paris, the Capital of the Nineteenth Century,"
 p. 37. On the essentialism of Whitman's female performers, see Sally Banes,

Greenwich Village 1963: Avant-Garde Performance and the Effervescent Body (Durham, N.C.: Duke University Press, 1993), pp. 228–29.

34 Kirby, *Happenings*, p. 168.

35 See David Joselit, "Eating and Dreaming: Robert Whitman's 1960s Happenings," in *Robert Whitman: Playback*, pp. 44–58.

36 Whitman, in Kostelanetz, *The Theatre of Mixed-Means* (New York: Dial Press, 1968), p. 222.

37 Quotations from Simone Forti's handwritten performance notes to Whitman's *Prune Flat*, reproduced in *Robert Whitman: Playback*, pp. 36 and 38.

38 Kostelanetz, *On Innovative Performance(s)*, p. 147.

39 Ibid., p. 145.

40 Ibid., p. 147.

41 "Expanded Cinema: A Symposium," p. 1.

42 Emily Thompson, "Machines, Music, and the Quest for Fidelity: Marketing the Edison Phonograph in America, 1877–1925," *Musical Quarterly* 79 (Spring 1995), pp. 131–71.

43 Thompson; and Jonathan Sterne, *The Audible Past: Cultural Origins of Sound Reproduction* (Durham, N.C.: Duke University Press, 2003).

44 Sterne, p. 284.

45 Whitman, in Kostelanetz, *The Theatre of Mixed-Means*, p. 225.

46 Ibid., p. 240.

47 McLuhan, *Understanding Media: The Extensions of Man* (New York: McGraw-Hill, 1964), pp. 308–37.

48 Kostelanetz, *The Theatre of Mixed-Means*, p. 228.

49 Whitman, in Los Angeles County Museum of Art, *A Report on the Art and Technology Program of the Los Angeles County Museum of Art, 1967–1971* (Los Angeles: Los Angeles County Museum of Art, 1971), p. 341.

50 Whitman, in Toby Mussman, "The Images of Robert Whitman," in Battcock, ed., *The New American Cinema*, p. 159.

51 Whitman, in Kostelanetz, *The Theatre of Mixed-Means*, p. 224.

52 Ibid.

53 Whitman, in Kirby, *Happenings*, p. 136.

54 Jacques Derrida, *Specters of Marx: The State of the Debt, the Work of Mourning, and the New International* (New York: Routledge, 1994), p. 126.

55 Ibid., p. 7.

56 See Kirby, "The Uses of Film in the New Theatre," p. 52; Sheldon Renan, *An Introduction to the American Underground Film* (New York: E. P. Dutton and Co., 1967), p. 240; and, to a lesser extent, Mekas, "The Expanded Cinema of Robert Whitman" (June 3, 1965), in *Movie Journal*, p. 189.

57 Whitman, *Sounds for 4 Cinema Pieces* (Chicago: Museum of Contemporary Art, 1968).

58 Edison, quoted in Thompson, p. 135.

59 Cited in Sterne, p. 304.

60 Karl Marx, *Capital: A Critique of Political Economy*, trans. Ben Fowkes, vol. 1 (New York: Penguin, 1976), p. 128.

61 Thomas Keenan, "The Point Is to (Ex)Change It: Reading 'Capital,' Rhetorically," in *Fables of Responsibility: Aberrations and Predicaments in Ethics and Politics* (Stanford, Cal.: Stanford University Press, 1997), p. 116.

62 Mekas, "On the Theatre and Engineering Show" (October 27, 1966), in *Movie Journal*, p. 261.

63 Whitman, in Kirby, *Happenings*, pp. 134–36.

64 Robert Whitman, "The Night Time Sky," in *Happenings and Other Arts*, p. 110.

65 Guy Debord, *The Society of the Spectacle*, trans. Donald Nicholson-Smith (New York: Zone Books, 1994), p. 113.

66 Derrida, *The Work of Mourning* (Chicago: University of Chicago Press, 2001), p. 161.

67 Derrida, *Specters of Marx*, p. 131.

68 Rose, "Art as Experience, Environment, Process," in *Pavilion*, p. 62.

69 John Forkner, in *A Report on the Art and Technology Program of the Los Angeles County Museum of Art, 1967–1971*, p. 350.

70 Max Kozloff, "The Multimillion Dollar Art Boondoggle," *Artforum* 10, no. 2 (October 1971), p. 76; David Antin, "Art and the Corporations," *Art News* 70, no. 5 (September 1971), p. 24.

71 Forkner, p. 340.

72 Marx, pp. 163–64.

73 Forkner, p. 350.

74 Ibid, p. 342.

> We are in the year 01, the beginning of a story of which you are
> already a part. Between the mountains and the banks of the Hudson
> River, a village is forming in the forest. Families are moving in, the
> construction of streets and houses is almost finished, gardens are
> growing, and soon the playgrounds will be filled.

He imagined the ceremonial planting of a tree, animal cookies, cardboard boxes turned into play houses, a costume parade for family pets, balloons, signs decorating the entire neighborhood, and elaborate animal costumes provided for the kids to wear if they liked. Finally, he wrote in his invitation, "Just before the sun falls asleep, we will light up the night."[3]

It all went as planned. Cameras were there to capture it. Then, in film form, the day was brought back as an installation that took up an entire floor of Dia Art Foundation's exhibition space on 22nd Street in New York. The film traced something that had briefly come and gone upstate; it could only be relayed in images, the work of the artist; to put it in his terms, it could only exist as signs floating in what was now its next act. The entire business was predicated on the viewer's ability to recognize the signs piling up. First among the signs was the white cube, the hallmark of midcentury American art exhibition space.[4]

The walls of *Streamside Day Follies*, the exhibition, were covered with a set of five white panels, each with an inner lining, an underside of shimmery yellow-green-blue reflecting foil. The panels hung on ceiling tracks. At a given moment, the panels separated from the room's architecture and began to move, like swimmers; they circled around the enormous room, leaving the idea of the white cube well behind, pulling forward to make an iridescent colored container of their own, a vertical pool, at the center. It marked a place to which one felt called. Another kind of temporary community, this one of art lovers, formed around it. The film drew them inside.

The film began to tell the tale of *Streamside Day Follies*. The tale too would shake off an ancestor figure or two. Later Huyghe

would acknowledge a host of them standing in the shadows. It was clear that he had taken some inspiration from Dan Graham's *Homes for America* (1966). Graham himself had handed Huyghe *New World Utopias* (1975) by Paul Kagan; back in the day it was Kagan's book that had led Graham to the work now known as *Rock My Religion* (1982–84). Huyghe was also prone to read in many directions: there was Charles Fourier, the Edgar Allan Poe story "The Domain of Arnheim," Alexis de Tocqueville's *Democracy in America*, the ideas Robert Smithson wrote into his sites and Nonsites; it was a list that

Pierre Huyghe, *Streamside Day Follies*, 2003

constantly grew.[5] Kagan noted that Ralph Waldo Emerson once wrote a note about the state of things in America to his British friend Thomas Carlyle: "Not a reading man but has a draft of a new community in his waistcoat pocket. One man renounces the use of animal food; and another of coin; and another of domestic hired service; and another of the State."[6] They all had a yen for their utopias. And a century-and-a-half later? Huyghe came to the States from Paris and made a film that pulled away from his and our collective memory of Walt Disney's *Bambi* (1942).

As the *Streamside* film opens, night turns to day. We travel to the forest floor, there to chance upon a live rabbit, a wise owl, a busy raccoon, and a fawn. *Bambi's* opening scenes set the tempo. Instead of animation, or an imitation of the Disney characters, live animals improvise, watchful, at one point tentatively straying into one of the new homes not meant for them. What then will happen to the animals, the *Bambi* characters, when confronted with this fabricated Streamside Knolls? Therein lies the drama and the tale we are being led to expect.

Pierre Huyghe, *Streamside Day Follies*, 2003

Yet in the film no tale is told. The animals find the place awkward; they shrink back out of sight. Henceforth we will have to see the place mainly through the eyes of children. We discover the day as they do. They play. Their play passes the time. The parade, the picnic, the games, the speeches, and the songs begin and end. As for the film itself, it ends unnaturally. Suddenly we realize that two moons have risen, the harvest moon and a large lit balloon, the stage-trick used to make a moon appear on a movie set. They seem to be equivalent. Nature and imitation co-exist side by side. Neither seems empty. Both seem full. We have been made to see double.

Initially Huyghe had framed this material as a question primarily of language. As the twentieth century was turning into the twenty-first, *Streamside* joined his own much longer, and, at times, collective effort to pose the general question of the sign. In 1999 he and Philippe Parreno bought a manga character from a Japanese agency that normally sold manga elements to production companies making games, stories, or ads. The character came without a name. They baptized her Annlee. From the start they planned to free her altogether from the marketplace, making her so free that she could turn into an "it." They thought of it as something like the grin without a cat that had floated up in *Alice in Wonderland* when Alice had asked the cat for too many directions.[7] They offered Annlee to other artists to use: not to be a ghost, they carefully explained, but just as a shell. M/M, Henri Barande, Angela Bulloch and Imke Wagener, François Curlet, Lili Fleury, Liam Gillick, Dominique Gonzalez-Foerster, Pierre Joseph and Mehdi Belhaj Kacem, Mélik Ohanian, Richard Phillips, Joe Scanlon, Rirkrit Tiravanija, and

Anna-Lena Vaney all contributed projects. Around this sign, for Annlee is in the end a sign, a community gathered, everyone working on the sign's inside.[8]

Somewhere behind this group effort stood a different and important antecedent, Mamoru Oshii's 1995 animated film *Ghost in the Shell*, itself based on a manga by Shirow Masamune. There cyborg manga characters battle a challenge emanating from a hacker known only as the Puppet Master. These cyborgs each had a ghost living inside them, a faint trace of an old human existence; it gave them a virus, some texture, or caprice, or whiff, of soul. It could also give them problems. Unprompted, Major Motoku Kusangai's ghost whispered inside her head: "for now we see through a glass, darkly." The Major was quite unable to see that her ghost was feeding her a line from the Bible, and yet it came through so clearly and darkly that she blurted the line out loud. It might be said, with no exaggeration, that Annlee's inside would likewise be filled, or hacked into, by many artists with their own refracting ambitions for the word. As a result Annlee unwittingly came to speak in tongues about many things. They might or might not be coming back from the dead.

Huyghe made two films for Annlee. In the second, *One Million Kingdoms*, he realized a project he had been harboring since 1998. In his mind, two voyages, two accounts — one literary, one scientific—would be brought together at a scene set near Snæfellsjökull in Iceland. Jules Verne made it the place through which one began the *Journey to the Center of the Earth*. The astronaut Neil Armstrong had been there with the crew of Apollo 11 on a training run for the first moon landing. For this place that had sent men both down and up, Huyghe had first sketched a third scenario where Armstrong would return as an old man, remember the training, remember the moon, and read Jules Verne like a map. Three years later, the project mutated into *One Million Kingdoms*. Annlee, a girl with pointed ears, a mere outline, small and sheer, was given the role of Armstrong. She was also endowed with a synthesized voice modeled on his. She and her voice would walk forward into a digital world, performing a script based on the

Pierre Huyghe and Philippe Parreno, *A Smile Without a Cat*, 2002

message Armstrong radioed back from the Sea of Tranquility in 1969; midstream it gives way to a passage from 1864 taken from *Journey to the Center of the Earth*. Two voices and two times came together like a sandwich. In this way Annlee spoke as a man, twice, as she walked through a landscape of animated sound waves that registered her voice as peaks and valleys rising and falling in real time. She seemed to walk into her voice. Language was made lunar. Doubles and echoes took over. Then the world that is her words dissolved as she mused:

> There is nothing more powerful than this attraction of the abyss. Nothing . . . with the possible exception of . . . the state of weightlessness. For a moment I was afraid that their words might be my own, brought back to me by an echo. I listened once more, and this time I clearly heard my name thrown through space.

At which point the image shattered completely to black.

Annlee the collective project ended in 2002 with a great fireworks display over Miami Beach. Afterward there was only the night. Annlee the manga was ceremoniously withdrawn from use. According to a new legal contract specially written for the occasion, Annlee, that "it," a thing, would henceforth own the rights to itself and so, unable to act on its own, through inertia would produce its own dead end. In this real time future Annlee was supposed to exist only as a truly liberated sign.[9] Freedom meant doing exactly nothing. A character had been expanded by means of fact as well as fiction.

It was decided to commemorate the experiment with an exhibition and a book, *No Ghost Just a Shell*. Along with the artists, a number of writers were invited to contribute to Annlee's book, including Maurizio Lazzarato, Israel Rosenfield, Hans Ulrich Obrist, Jean Claude Ameisen, Maurice Pianzola, Jan Verwoert, and me. The invitation was a completely open one. Upon some reflection, I sent a script I had written in 1994, a piece of oblique prose that mixed a voice from the depths with voices from the past, some of them relayed by Stéphane Mallarmé in his *Hérodiade* (1898), all of them female.[10] One of them said, "a bright sharp breath / abyss" and withdrew into the perspectives that form inside poems. A last voice concluded quietly, "it is not a role to play / she is perfect for it / memory let go." When all the texts were assembled into the book, it was clear that no one had wanted to write the overview for Annlee; no one had taken the supreme position of the critic speaking for all. In a host of ways the Annlee project had deviated from the expectations for the treatment of a sign, or to be more precise, the received sign as it operated in mass culture.

Americans now live so closely with the postwar European response to American mass culture that it has come to structure our own perception. We have seen Las Vegas and learned from it, but we are most inclined to use Roland Barthes's idea of myth to describe the sight. Barthes's book *Mythologies* (1957), written first as a series of French newspaper articles in the 1950s, had taken Ferdinand de Saussure's concept of the sign and shown how signs in mass culture, much of which depended upon a new wave of American products, were actually corruptions: new signs were being derived from distortions of old ones; they fed on an ancestor figure, emptying it almost completely and filling it with alien, new, and usually moralized bourgeois values.[11] During the same years in the United States itself the native terms for this process had put things more plainly. The new mass culture was not generally being analyzed as a foreign language but instead simply cast as a war of opposites, a high culture versus a low culture, each angling for power.[12] Although the critical divide between avant-garde

and kitsch, where high looked down on low, was no longer being respected by the late 1960s, those terms structured the American art critical debate for two more decades until they finally collapsed.

The semiotic terms of the Europeans proved to be more durable. Huyghe had inherited them and knew the stakes when in 2003 he came to the US, took the signs from *Bambi*, and filled them not merely with voices or forms, but with actual collective life. By means of signs, he sought to animate Streamside Knolls itself. With them, he proposed to add to its reality. At the same time he was also diving into a transatlantic theoretical discussion. *Bambi*, for example, was first made and shown in 1942. When Theodor Adorno and Max Horkheimer famously wrote, "Real life is becoming indistinguishable from the movies," it was 1944, and they were in Los Angeles, working to grasp the total business of a culture industry aiming to standardize consciousness, its perceptions, pleasures, and pains.[13] Liberation from thought and from negation was being promised to everyone watching; one need only submit. The other assessments of this phenomenon as seen from Europe would add to their perspectives and expose the ideological stakes more nakedly. We still read Guy Debord's *Society of the Spectacle*, the book of 1967, as if it were written yesterday. We still ponder sentences like "All that was once directly lived has become mere representation," and some think reality exists as a pseudo-world, apart.[14] Just as famously, Jean Baudrillard, reflecting on the matter in his book *Simulations* in 1983, took the problem of representation and declared it finished, all difference having settled onto a level of sheer equivalence where no distinction matters, no debate is relevant, no depth of expression possible, no language necessary.[15] As proof he offered up a parade of examples from early 1970s America: Watergate, the television documentary of the Loud family, Disneyland, the Twin Towers, the Vietnam War, all of them presented and taken, Baudrillard claimed, as surfaces where everything is the same as everything else and nothing touched the real. Never mind the complexity of the American public's actual response to these rather different events. Never mind the new idea in America of apocalypse, of living with defeat. Never mind the

new primal scene of 58,000 Americans dead in Vietnam. For Baudrillard the simulation, the substitute real, this new stage of the sign, had triumphed.

I review this material for a reason. These concepts, while current, are not all-powerful any more than they are eternal or total unless one is using them to construct a belief system. By the same token, the forms and forces of capitalist mass culture are not all-powerful, eternal, or total unless one wants them to be so. The two moons speak darkly and clearly to this situation in their own way at the same time that they expose the signs' ultimate relation to nature. They show that nature has not submitted to language. They show language submitting to nature. The two moons also demonstrate, by example, that Huyghe was here insisting that representation had not lost its articulations and points; he had stepped back from the idea of representation as a totality; he stressed the existence of individual, willful signs. In this way, he was allying himself with the linguistics that focused on language in use, a linguistics that in the 1970s had overseen new translations of Mikhail Bakhtin and had set out the grand experiment of Gilles Deleuze and Félix Guattari in *A Thousand Plateaus* (1980). These were theories wanting to understand practice and asking that the idea of language be subordinated to the world of its use.

Huyghe too had been drawn, repeatedly, back to the 1970s in America. But his work with the 1970s sign did not for a single minute take its lead from Baudrillard. *Au contraire*: *L'Ellipse*, the double-screen projection from 1998, took as its starting point a jump cut (in French, *l'ellipse*) from Wim Wenders's dark drama *The American Friend*, a film made in 1977 and set in 1976. The American friend, who is not one, has taken advantage of one Herr Zimmermann, played by the actor Bruno Ganz. In the scene leading to the jump cut, Zimmermann, suffering from a blood disease and tricked into believing that it is terminal, that he is dying, is on the point of agreeing to commit murder for hire in Paris. We see him take the first steps toward that agreement. They are going to be the real steps toward his death. In his re-setting,

Huyghe restored the jump cut to real time by asking Ganz to perform the missing next steps in a walk that in the film had gone unseen, an eight minute walk taken by a man now visibly older, visibly himself, a character now strangely full, but certainly full of a man.

Huyghe would speak of the ellipse as full of something that could not be told exactly, something that overran language, overran the sign.[16] Barthes would give him the terms for it, calling it "The Third Meaning" in an essay he wrote in 1970. The essay represents another stage in Barthes's thinking about order in language; he had turned now to contemplate the production of disorder, the thick and obtuse clouds that reared up and interfered with sense:

> the obtuse meaning appears to extend outside culture, knowledge, information; . . . opening out into the infinity of language, it can come through as limited in the eyes of analytic reason; it belongs to the family of pun, buffoonery, useless expenditure . . . it is on the side of carnival.[17]

Huyghe decided to fill this third meaning with a person.[18] In 2000 he made another double video projection called *The Third Memory*; it featured a person too, John Wojtowicz, the man who robbed a bank in Brooklyn in 1972 to pay for his boyfriend's sex-change operation, triggering a news story that interrupted the broadcast of Nixon's Republican national convention and became a classic in 1975, when Sidney Lumet made *Dog Day Afternoon*, casting Al Pacino in the lead. *The Third Memory* expands the idea of the cut in time to bring the robber himself back into the mix, to explain, to reenact a fact years later, to fill the old signs with a surfeit of human and documentary evidence that overflows the screens. Death and irreparable tragedy mark these screens too. The third meaning is transformed into a person's third memory, the one coming after the fact, after the movie, after so many years. To move the person into the sign, the 1970s American sign, lets the sign participate in the large flow of events in the most unsystematic way; the sign is touched, and changed, by them.

This experience re-animating signs from the 1970s was brought to Annlee, who was hardly a person. The questions multiplied as a result Where does a sign begin and end? Where

Pierre Huyghe, *Streamside Day Follies*, 2003

does a person begin and end? These are *real* questions. They remain general questions, and much more than academic ones. In the context of our received wisdom, they bring a surprise. Languages thrive when found in forms of life. We have seen the person and the sign together, just like two moons at once, and it is fine. Life goes on.

By late 2003, Huyghe had begun to dispense with scripts. The *Streamside* characters were linked by memory to the live fawn and rabbit and owl, but as the film proceeds they retreat, coming back only very loosely in the costumes that the children wear. People overrun these characters, those signs, as they picnic and play. Seeing the references, seeing the doubles brings no particular order, just as it brought no story line. It is carnival. Memory lets go. The problem of the sign is rendered irrelevant. The two moons grow obtuse together. At the end of the day in Fishkill, a new stage in Huyghe's work is arriving, one where the ancestor figures are internalized, where language cedes to child's play and another order of time opens up. How, he would be led to ask, can a fiction or an event produce an endless reality? He turned to face endless reality. He searched in his books for equivalents. He came to the pages of *Chaosmosis* (1992) by Félix Guattari. A little later he would turn to Poe's story of Arthur Gordon Pym and to the no-knowledge zones of Smithson.[19] Huyghe himself took leave of the streets and the errant signs; he was more intent upon journeys that could be taken on faith.

Night had fallen again. The folly of the day and its movement had dissolved into a nothing that is at the same time something social. The celebration would not become an annual one in Streamside Knolls, as Huyghe had hoped. But it pointed to another kind of dissolve, the dissolve that is no-place. We have another word for no-place: it is utopia.

Utopias, like signs, have come and gone over time. At this point another essay drew Huyghe's attention: it was one of the first written by Gilles Deleuze, but it was only published posthumously in 2002.[20] "Causes and Reasons for Desert Islands" had launched Deleuze's work on difference and repetition, but Deleuze had kept it close, like a secret port of call. It was the story of two islands. Huyghe put the two moons in his pocket and set off to look for the islands. He would first need a ship.

January 7, 2004

Notes

1 Félix Guattari, *Chaosmose* (Paris: Galilée, 1992), p. 181. Translation mine.

2 Streamside Knolls was developed by AVR Homebuilders, who advertised it in their brochure as "A Commuters' Paradise. . . . Here, amid the intrigue and charm of more than three centuries of New York history, AVR Homebuilders is creating the incomparable Streamside Knolls community in Fishkill, mere minutes from the train station." On the mobility of American families, see Motoko Rich, "Longtime Homeowners a Relative Rarity in U. S., Census Shows," *New York Times* (November 21, 2003), p. A20.

3 Pierre Huyghe, announcement for Streamside Day Celebrations, n.d.

4 Brian O'Doherty, *Inside the White Cube: The Ideology of the Gallery Space* (2nd ed.; University of California, 1999), first appearing as a series of articles in *Artforum* in 1976.

5 Some of these inspirations were cited by Huyghe during a long conversation with me on Dec. 17, 2003.

6 As quoted by Paul Kagan, *New World Utopias: A Photographic History of the Search for Community* (New York: Penguin Books, 1975), pp. 13–14.

7 Huyghe and Philippe Parreno, *No Ghost Just a Shell* (Cologne: Walther König, 2003), p. 29

8 See the group interview in *No Ghost Just a Shell*, pp. 14–30; see also Elizabeth Bard, "Fascinated by the Journey, Not the Point of Arrival," *New York Times* (January 5, 2003), Arts & Leisure section, p. 37.

9 See his interview with Hans Ulrich Obrist, "Pierre Huyghe: Collaborating on Utopia," *Flash Art* (July 2002), p. 81

10 The script was written for a short video, *Some Gesture Vehement and Lost*, made in collaboration with Darryl Turner and Patricia Moreno in 1994.

11 Roland Barthes, *Mythologies*, trans. Annette Lavers (New York: Hill & Wang, 1972), first French edition 1957.

12 The arguments find their highest critical form in the work of Clement Greenberg's much-admired essay, "Avant-Garde and Kitsch," reprinted in Greenberg, *Art and Culture* (Boston: Beacon, 1961), pp. 3–21. In effect, the best rebuttal was written by John Berger, *Ways of Seeing* (London: Penguin, 1972).

13 Theodor Adorno and Max Horkheimer, "The Culture Industry: Enlightenment as Mass Deception," in *Dialectic of the Enlightenment*, trans. John Cumming (New York: Continuum, 1972), p. 126.

14 Guy Debord, *The Society of the Spectacle*, trans. Donald Nicholson Smith (New York: Zone Books, 1994), p. 12.

15 Jean Baudrillard, *Simulations*, trans. Phil Beitchman, Paul Foss, and Paul Patton (New York: Semiotexte, 1983).

16 Huyghe describes the ellipse in detail in the interview with Jan Estep, "Action," *New Art Examiner* (July 2000), pp. 31–35.

17 Roland Barthes, "The Third Meaning," *Image–Music–Text*, ed. and trans. Stephen Heath (New York: Hill & Wang, 1977), p. 55.

18 On *The Third Memory*, see Adrian Dannatt's interview with Huyghe, "Where Fact and Fiction Meet," *The Art Newspaper* (February 2001).

19 "No-knowledge zone" is a coinage by Huyghe to describe unexhausted or uncharted territories, ones with the potential for unmediated experience. "Going somewhere like Antarctica is an attempt to produce a place without preexisting protocol, a no-knowledge zone. It might be easier to find this in a place that's not overcrowded with meaning, rules, culture, even longitude and latitude." Huyghe, in "Remote Possibilities: A Roundtable Discussion on Land Art's Changing Terrain," *Artforum* 43, no. 10 (Summer 2005), p. 90. See also Amelia Barikin, *Parallel Presents: The Art of Pierre Huyghe* (Cambridge, Mass.: MIT Press, 2012), p. 218.

20 Gilles Deleuze, *Desert Islands and Other Texts (1953–1974)*, trans. Mike Taormina (New York: Semiotexte, 2004), first French edition 2002.

Vera Lutter and the Negative Space of Modernity

I hear the ruin of all space, shattered glass and toppling masonry, and time one livid final flame. What's left us then?

—James Joyce, *Ulysses*, 1922

Chamber

Thought begins, writes Descartes, in a darkened room. In the second of his *Meditations* (1644), the philosopher famously doubts the veracity of the view from the room where he is writing onto the street below, where enigmatic automata move, mote-like, before his gaze: "what do I see from the window beyond hats and cloaks that might cover artificial machines, whose motions might be determined by springs?"[1] He sees more accurately, it appears, in obscure seclusion; *A Discourse on Method* (1637) traces the origins of his systematic distrust of the senses to a day spent entirely alone in a well-heated room in Germany, "with full opportunity to occupy my attention with my own thoughts."[2] A third construct, however, interrupts this too easily adumbrated opposition between dark clarity and opaque illumination. It is the camera obscura, an apparatus

René Descartes, *L'homme*, 1729

Like Niépce, Lutter has kept a remnant of the frame—in her case, a column of pale bricks at the edge of the image—to suggest the shadowy volume that makes the composition.

But Lutter's work accords also with a vision of the partially illuminated room and its power to invert all expectations regarding light and time, a power that is only sketchily hinted at in Niépce's photograph is but insistently present in the literature of his time. The clearest picture of this phantasmatic space is given in the works of the Romantic autobiographer Thomas De Quincey, a writer who mentions photography explicitly only once. In the middle of a litany of technological novelties, he briefly discusses the daguerreotype: "the eye of the calmest observer is troubled; the brain is haunted as if by some jealousy of ghostly beings moving amongst us."[5] Elsewhere in the same text, *Suspiria de Profundis* (1845; literally "a sigh from the depths"; a mournful sequel to his dramatic *Confessions of an English Opium-Eater*), De Quincey seems to conjure an equally haunting photographic scene. He is concerned with the particular horror of a death in high summer; to lose a loved one at that season is to see the world in negative, the light suddenly eclipsed around the pale features of the departed. For De Quincey, it is precisely a matter of finding himself in a room that is at once illuminated and obscure. He recalls the death of his young sister, and his entering, some hours later, the room where her corpse lay:

> I imagine that it was exactly high noon when I reached the chamber door; it was locked, but the key was not taken away. Entering, I closed the door so softly, that, although it opened upon a hall which ascended through all the stories, no echo ran along the silent walls. Then turning round, I sought my sister's face. But the bed had been moved, and the back was now turned. Nothing met my eyes but one large window wide open, through which the sun of mid-summer at noonday was showering down torrents of splendour. The weather was dry, the sky was cloudless, the blue depths seemed the express

types of infinity; and it was not possible for eye to behold or for heart to conceive any symbols more pathetic of life and the glory of life.[6]

Light, it transpires, is precisely what obscures the mournful sight he is searching for, as if at that moment De Quincey is blinded by the aperture of the optical apparatus that the room has become. It is the light that he will remember. The literature of the nineteenth century offers many such examples of what seems to be a photographic process of impression upon the mind, the inscription of what De Quincey calls "the palimpsest of the human brain." In *Middlemarch* (1874), George Eliot has the scenery of Rome insinuate itself in the visual memory of her ardent heroine, Dorothea, "like a disease of the retina."[7] More typically, it is a matter of a sensibility transformed by the view from a room. Edgar Allan Poe's "The Man of the Crowd" (1840) begins with its agitated narrator's glimpsing, through a coffee-house window, the city at dusk suddenly remade as a nocturnal spectacle. His subsequent pursuit of the mysterious figure who catches his attention in the throng may be said to be nothing more or less than a lengthy exposure which ends, at dawn, in the production of an obscured negative: the narrator's failure to properly cast light on his quarry. In *The Absence of Presence: May 2, 1994*, Lutter uses her apartment's fireplace (we may recall here the grisly contents of the fireplace in Poe's "The Murders in the Rue Morgue") to photograph a room which has in turn been used to photograph the city outside. The product of that earlier experiment becomes part of the later image, a negative cityscape now brightly inverted and attended by the luminous offering of a small still life: a vase of flowers, a wine bottle, and a glass. The apartment contains a triptych of deceptive views. That of the city is a rephotographed negative; what seems to be a doorway to a room beyond is in fact a mirror propped against the wall, reflecting a portion of the room adjacent to the fireplace; a glass-paned door appears to give out onto nothingness, onto blazing light—in Lutter's inverted universe, onto darkness.

Factory

This inversion and doubling of negative space in Lutter's work would eventually come to dominate and define her images of defunct industrial architecture. The serried, symmetrical space of the factory is not only reflected back on itself but skewed and diverted to odd new angles, perspectives on its own form that are also oblique reflections on its past utility, on the regimented movements permitted there, on the weary vision of the workers who once labored there. Initially, however, Lutter essays an attitude to the volume of the modern factory that seeks to replicate its original quest for seamless space. In Lutter's photographs, the factory of the first half of the twentieth century is revealed to have been the product of a long prehistory in which the requirements for space and light led to an ever-expanding form. As Gillian Darley puts it, reflecting on the cultural and architectural history of the factory, "At the beginning of the twentieth century the modern factory could be seen as the perfectly functional building, built with improved or new materials and building technology, expressive of efficient procedures and management systems, owing its plan and its form to the specific nature and organization of the industrial process. Most significantly of all, it would be powered by electricity, becoming clean, bright and pleasant."[8] The introduction of gas lighting had already extended the factory laterally, while iron columns effected the requisite attenuation of interior armature. But it was the advent of reinforced concrete that resulted in the distinctive perspectives exploited by Lutter.

The factory is ideally a layer (or layers) of light, punctuated subtly, if at all, by supporting columns. The substance of the building is supposed to evanesce, to cede the space to other sorts of division—those of the production that, in Lutter's photographs, has conspicuously vanished. In the earliest of Lutter's experiments at the former Nabisco factory in Beacon, New York, *Nabisco Factory, Beacon, I: July 19–22, 1999,* a classical perspective coincides with more unruly reminders of the former function of the building. Columns recede into the distance, framing on one side a row of large windows that have been darkened by exposure to the camera

obscura. A grid of ducts and lights follows the rectilinear pattern of columns. Below, a number of desks and chairs seem to have congregated in anticipation of something, perhaps of the very luminous transformation that the image itself has allowed to happen. Despite these scattered arrivals, the image retains a certain symmetry. By contrast, *Nabisco Factory, Beacon, VI: October 21–December 22, 1999*, a photograph produced at an angle to the march of concrete mushroom columns on the basement level of the same site suggests a different experience of the space. The columns (they are more dendritic than fungal) advance out of the light and into the darkness of the foreground. The individual column no longer looks like a support, nor does it appear to divide and quantify the space of the factory in the same way. The invention of Robert Maillart, a Swiss engineer, in 1912, the mushroom column, writes Darley, "appeared to flow into the lightweight floor slab via a sinuous column head or capital, an elegant, fluid solution which simplified the traditional and now irrelevant junction between post, ceiling slab, joist and beam that perpetuated the forms of wooden or metal structures."9 Once again, the factory is conceived of as a medium for light; the darkened columns might well be a series of searchlights pointed at the ceiling, which has become, before Lutter's infinitely patient apparatus, a pure stratum of white light.

In *Inside Looking In, Studio VII: August 15–September 12, 2003*, Lutter hangs the original images of the factory in her studio, where they are turned back into positives. The columns, once the markers of a uniformly illumined and airy modernity, now look obsolete, dingy, hopeless. And yet they still seek to replicate themselves in the mirror Lutter placed before them, as if the expanding space of the factory could carry on reproducing itself endlessly. In fact, it has been definitively consigned to the past, overtaken by the sturdier, boxlike setting of the studio. In *Mind Set, Studio III: April 2–18, 2003*, the remains of a Pepsi-Cola plant by the East River are subject to the same process of doubling. Here, two images of industrial debris appear in a mirror placed by the studio window. The window itself looks out on a patch of bare brick.

Rooftop

In his poem "The Attic Which Is Desire:" (1930), William Carlos Williams framed the coincidence of three pictorial planes that comprise the city at night: window, sign, and sky:

Here

from the street
by

 * * *
 * S *
 * O *
 * D *
 * A *
 * * *

ringed with
running lights

the darkened
pane

exactly
down the center

is
transfixed[10]

In the images Lutter produced in 1998 of the iconic Pepsi-Cola sign erected in 1936 atop the company's factory, it is rather the sign itself that seems "transfixed"—seduced by the view across the river, of Manhattan. On the other side of the perfectly still expanse of water in Lutter's work, acres of distant, high-reaching glass look back at a landmark that seems ramshackle and antique.

Modernism portrayed the city as a ground from which text seemed to drift free, to hover in the air as it rehearsed its spectral message; in *Ulysses*, James Joyce has an advertising billboard literally come to life, each letter a sandwich-boarded individual trotting along a Dublin street. Lutter's work reveals the flimsy support by which the Pepsi-Cola sign is made to float above the city. She constructs her camera behind the lettering (in the process making the text read from left to right again, righting her customarily reversed image), so that its thin, rigid grid stands out against the darkened sky. In fact, the whole rooftop is aglow, in negative, with the stage machinery that shows both interior and exterior to mere theatrical sets. Ducts, skylights, air-conditioning equipment, and other unidentified structures lit and obscured by Lutter's negative are all part of an elaborate sham: the city, under X-ray, gives itself away. Later, it will submit to the necessary amputation of its now useless, vestigial members: the sign will be removed and brought down to earth, reassembled three hundred feet to the south. Inside her own temporary dwelling, Lutter watches as the text is erased: "Since Monday, they took the bottle, the P, E, P, S, the I, and the hyphen. And today they set their hands on the C in 'Cola.'"[11] From her attic, Lutter sees the framed patch of sky in front of her darken, and one version of the city's modernity disappear.

Airport

In the prologue to his *Non-Places: Introduction to an Anthropology of Supermodernity* (1992), Marc Augé imagines a contemporary journey by air as a seamless continuum from one space to another, from car park to check-in desk, terminal to aircraft. The traveller proceeds as if already pressurized against anxiety or weariness: everything in his immediate vicinity conspires to produce a weightless state of untaxing distraction and unenervating comfort. Yet this airlocked condition is precisely a reminder of earlier, more troubling environments, the transient spaces of nostalgia, regret, and anticipation:

Vera Lutter, *Cargo Field, Frankfurt Airport, XIII: May 2, 2001*, 2001

> These days, surely, it was in these crowded places where thousands
> of individual itineraries converged for a moment, unaware of one
> another, that there survived something of the uncertain charm of the
> waste lands, the yards and building sites, the station platforms and
> waiting rooms where travellers break step, of all the chance meeting
> places where fugitive feelings occur of the possibility of continuing
> adventure, the feeling that all there is to do is to "see what happens."[12]

The photographs that Lutter produced at Frankfurt Airport, in
2001, suggest something of this congruence of comfort and unease.
The airport is characterized by an inhuman efficiency, but ghosted
by actual bodies. As always in Lutter's long exposures, people
have disappeared; what remains is the evidence of their ceaseless
movement and toil to make the airport function as a place of pure
passage, of transport. (Several of these works were produced using
a camera obscura fashioned from an old traveling trunk.)

It is the aircraft itself, in Lutter's work, that seems most
clearly—because most obscurely—to demonstrate the confused
timescale of contemporary flight. The most protracted of photographic
processes is used to render the fastest machines, but the technology
depicted here is already out of time. Like the brief memory of
the observation platform at Paris Orly Airport that frames Chris
Marker's 1962 film *La Jetée*, the aircraft and airport are exposed
by Lutter as the relics of an earlier age: the era of modernist

fetishizing of the
aircraft's myriad
forms. Lutter's
static airliners—
alternately opaque
or transparent,
depending on how
long they have
stalled before the
camera obscura—are
ghostly descendents

Chris Marker, *La Jetée*, 1962

of the shapes that so exercised Le Corbusier, for example, in 1935,
when he finally projected twenty years of obsession with flight
onto the pages of his book *Aircraft*. For Le Corbusier, the aircraft
promised "a new state of modern conscience. A new plastic vision.
A new aesthetic."[13] Where Marinetti and the Futurists imagined
the aircraft almost entirely in terms of movement and momentum,
the architect's favored aeronautical fantasies are curiously serene;
even when moving, they appear to embody his vision of a flight
arrested in architecture. The photographs reproduced in *Aircraft* are
chosen primarily for the form of the object itself, not for its motive
power. (There is, of course, another narrative at work here: that of
the potential destruction and rebirth of the city that the airplane
promises.) The photographed curves already suggest the sweeping
canvas forms of Le Corbusier's Pavillon des Temps Nouveaux,
designed for the 1937 World Exhibition in Paris (with its scale
model of a Bloch 174 twin-engine bomber, perched on a nine-foot
pole), or the descending curve of the roof of his Ronchamp Chapel.
Lutter is equally interested in the lower curves of her aircraft: in the
way they seem to sway, swag-bellied, above her.

But this moment of modernist attraction to the stark outline of
the object has passed. The aircraft in Lutter's photographs appear as
intermittent, flickering wraiths: they are present and not present. In
reality, they have either failed to impress themselves with sufficient
force upon the medium, or are in fact several aircraft in one, their
outlines confusedly intersecting. In *Hangar 5: May 16–17, 2001*,

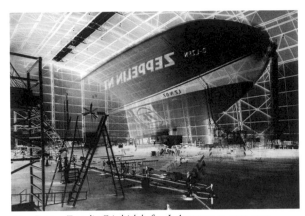

Vera Lutter, *Zeppelin Friedrichshafen, I: August 10–13, 1999*, 1999

at least four aircraft, each bearing the logo of Lufthansa, compose a phantasmic assembly. None of the four is vivid enough to fulfill Le Corbusier's dream of a pristine new form; each is about to fade into the gray shadows of the hangar. The starkest of Lutter's demonstrations of the frail contemporary form of our once muscular aerial imaginary comes, however, in her 1999 photographs of a reanimated airship. In the second of these, the zeppelin—for over six decades the symbol of an abandoned aeronautical future, of a cumbersome yet stately progress through the skies (albeit also a machine with almost as much destructive potential as an airplane)—remained immobile for four days. Almost nothing of the delicately outlined hangar around it seems to have been altered in that time. (Its human attendants, of course, have quite vanished.) Only a single propeller appears to have been rotated, leaving a couple of ghostly traces, as if even now it is gently twirling on the surface of the image. But a photograph produced a few days earlier is a chaos of blurred, conjectural forms. The floor of the hangar is scattered with unidentifiable, umbral entities: the shadows of machinery, vehicles, scaffolding, ladders. The airship itself is barely there, its bow only really recognizable by its livery; it might otherwise be only a vast shadow beneath the pale roof of the hangar. Its stern has disappeared completely. It is impossible to look at it without recalling the most famous images of its precursor, the *Hindenburg*, photographed near Lakehurst, New Jersey, in 1937, its stern already ablaze, one gleaming, aerial future about to be vaporized in the darkness.

Power Station

In 2004, Lutter photographed an iconic edifice of the *Hindenburg* era. In an engineer's record picture taken in 1939, the fully functioning power station at Battersea, in London, looks oddly similar to its current incarnation as a brooding ruin, bordered by the provisional structures of construction and renovation. The image shows the building of the B station, the second part of the installation, which came into service in 1941. But the whole elegant structure might as easily be in the process of having its vast boiler hall ripped out as having it extended: Battersea has always, in a sense, been

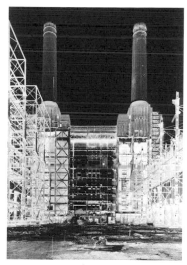

Vera Lutter, *Battersea Power Station, XIII: July 13, 2004*, 2004

a site in the making, an unfinished emblem of the city it served for fifty years. Planned in the 1920s, the power station took five years to build, during which time it generated a good deal of controversy. Fears were expressed that its sulfur emissions would damage London's parks, buildings, and artworks, and assault the health of its citizens. Once completed, it consumed ten thousand tons of coal a week, and eventually supplied one-fifth of the city's electricity.

The history of the site is itself intriguing, but its real significance seems to have started with the closure of the station in the early 1980s. The iconic status of the ruin is not fully explained by the grandeur of Sir Giles Gilbert Scott's design, nor by the station's historic importance. Rather, the ruin has come to symbolize a kind of fantasy version of London: a city never given a chance to exist, but which might have been made of many such towering mid-century wonders, traversed by the shadows of airships. As an icon, it risks a certain sort of nostalgia, or even kitsch, but as a site, and as an object, it is infinitely more complex. With its cathedral-like spaces, ornate interiors, and fraught relationship to the territory and communities around it, Battersea is a monument not only to the

optimism of Britain's recent industrial and architectural past, but to the circulation of other energies in the city: utopianism, dread, mourning, and memory.

Lutter's images of Battersea Power Station disregard the view of the building that has made it such a familiar emblem for the city: at no point do its four huge, pale chimneys rise together in front of her apparatus. Instead, she places the camera obscura first inside the boiler hall, revealing the glowing convolution of ironwork that lies behind the building's soaring brick facades. The interior turns out to be ravishingly complex, despite having had its working parts removed. In the negative image, volumes become deceptive: the space recedes into light, protrudes into darkness. Recesses appear to have retained some residual energy. David Sylvester wrote of the station's upper reaches, "the columns seem to be containers of deep reserves of light. They offer an infinite supply of it."[14] But here the chimneys have faded, graying, into the artificial night, while it is the obscure corners and interstices that shine like small caves of light. Lutter turns the abandoned station, soon to be redeveloped, into a map of its own connections to the city around it. It was the hot, thrumming center of energy for the city, an enclosed space from which the future of London could be imagined. Like Joseph Paxton's Crystal Palace before it, it seems to have been designed not only to be photographed, but to function as a kind of camera, a chamber in which the populace might see its vision of the future develop. In 1852, Benjamin Brecknell Turner photographed the Crystal Palace; all evidence of the Great Exhibition of the previous year has been removed, leaving only the huge elm trees that had been enclosed by the structure. In Turner's negative, the white trees rise eerily towards the bright lattice of the building's upper arches, reaching for a darkened sky. Vera Lutter's vast compositions might be said to imagine the same strange growth of something glowing, living, dreaming in the dark spaces of our modernity.

July 6, 2005

Notes

1 René Descartes, *Meditations on the First Philosophy* [1644], in *Discourse on Method and the Meditations*, trans. John Veitch (Amherst, NY: Prometheus Books, 1989), p. 84.

2 Descartes, *Discourse on Method* [1637], in *Discourse on Method and the Meditations*, p. 17.

3 Descartes, *Optics* [1637], in *The Philosophical Writings of Descartes*, trans. John Cottingham, Robert Stoothoff, and Dugald Murdoch, vol. 1 (Cambridge, UK: Cambridge University Press, 1985), p. 166.

4 Blaise Pascal, *Pensées* [1669], trans. W.F. Trotter (New York: E. P. Dutton, 1958), p. 39.

5 Thomas De Quincey, *Suspiria de Profundis, Being a Sequel to the Confessions of an English Opium-Eater* [1845], in *Confessions of an English Opium Eater: And Other Writings*, ed. Grevel Lindop (New York: Oxford University Press, 1985), p. 87.

6 Ibid., p. 103.

7 George Eliot, *Middlemarch,* ed. Bert Hornback, Norton Critical Editions, 2nd ed. (1874; New York: Norton, 2000), p. 124.

8 Gillian Darley, *Factory* (London: Reaktion Books, 2003), p. 116.

9 Ibid., p. 114.

10 William Carlos Williams, "The Attic Which Is Desire:," in *The Collected Poems of William Carlos Williams*, vol. 1, ed. A. Walton Litz and Christopher MacGowan (New York: New Directions, 1986), pp. 325–26.

11 Vera Lutter, in Blake Eskin, "Pepsi Degeneration," *New Yorker* (March 29, 2004), p. 40.

12 Marc Augé, *Non-Places: Introduction to an Anthropology of Supermodernity*, trans. John Howe (New York: Verso, 1995), p. 3. First French edition 1992.

13 Le Corbusier, *Aircraft* (1935; New York: Universe Books, 1988), p. 35.

14 David Sylvester, "A London View," in *Vera Lutter: Battersea* (London: Gagosian Gallery, 2004), p. 7.

Contributors

BENJAMIN H. D. BUCHLOH is Andrew W. Mellon Professor of Modern Art at Harvard University, an editor of *October*, and one of the authors of *Art Since 1900* (Thames & Hudson, 2004). He is the author of essays on Richard Hamilton, Candida Höfer, Gabriel Orozco, Raymond Pettibon, Sigmar Polke, and Richard Serra, among others. Buchloh is editor of an anthology of writings on Gerhard Richter, published by MIT Press as part of its October Files series in 2009. His essays on the postwar avant-garde were collected in the volume *Neo-Avantgarde and Culture Industry* (MIT Press, 2000).

REBECCA COMAY is professor of philosophy and comparative literature at the University of Toronto, where she is also the director of the Program in Literary Studies. Her writing has appeared in *Discourse*, *South Atlantic Quarterly*, *New German Critique*, and *October*. Comay edited *Lost in the Archives* (Alphabet City Media, 2002) and coedited, with John McCumber, *Endings: Questions of Memory in Hegel and Heidegger* (Northwestern University Press, 1999). Her most recent book is *Mourning Sickness: Hegel and the French Revolution* (Stanford University Press, 2011).

BRIAN DILLON is tutor in critical writing in art and design at the Royal College of Art and UK editor of *Cabinet* magazine. He is a regular contributor to the *Guardian*, the *London Review of Books*, *frieze,* and *Artforum*. His publications include *In the Dark Room* (Penguin, 2005), *Tormented Hope: Nine Hypochondriac Lives* (Penguin, 2009), *Sanctuary* (Sternberg Press, 2011), *I Am Sitting in a Room* (Cabinet, 2012), and *Objects in This Mirror* (Sternberg Press, 2014). Dillon is editor of the anthology *Ruins* (2011), part

of the series Documents of Contemporary Art, co-published by Whitechapel Gallery and MIT Press.

MARK GODFREY is curator of international art at Tate Modern, where he has organized exhibitions of the work of Francis Alÿs, Alighiero e Boetti, Richard Hamilton, and Gerhard Richter, among others. His recent publications include essays on Peter Fischli and David Weiss, Sigmar Polke, Frances Stark, Simon Starling, James Welling, and Christopher Williams. Godfrey's writing has appeared in *frieze*, *October*, and *Afterall*. He is the author of *Abstraction and the Holocaust* (Yale University Press, 2007) and *Alighiero e Boetti* (Yale University Press, 2011).

BRANDEN W. JOSEPH is Frank Gallipoli Professor of Modern and Contemporary Art at Columbia University and a founding editor of *Grey Room*. His writing has appeared in *Artforum*, *October*, *Critical Inquiry*, and *Parkett*. Joseph's books include *Beyond the Dream Syndicate: Tony Conrad and the Arts after Cage* (Zone Books, 2008) and *The Roh and the Cooked: Tony Conrad and Beverly Grant in Europe* (August Verlag Berlin, 2012). He edited an anthology of texts on Robert Rauschenberg as part of the October Files series, published by MIT Press in 2002.

TOM MCDONOUGH is associate professor and chair of art history at Binghamton University, State University of New York, where he teaches the history and theory of modern and contemporary art. He is editor of the anthologies *Guy Debord and the Situationist International: Texts and Documents* (MIT Press, 2002) and *The Situationists and the City* (Verso, 2009), and author of *"The Beautiful*

Language of My Century": Reinventing the Language of Contestation in Postwar France, 1945–1968 (MIT Press, 2007). He publishes art criticism regularly in journals such as *Afterall*, *Artforum*, and *Fantom*, and was formerly an editor at *Grey Room*.

MOLLY NESBIT is chair and professor in the department of art at Vassar College and a contributing editor of *Artforum*. She is author of the books *Atget's Seven Albums* (Yale University Press, 1992) and *Their Common Sense* (Black Dog, 2000). *The Pragmatism in the History of Art*, the first in a series of her essays and lectures, was published by Gutenberg Periscope in 2013. Since 2002, together with Hans Ulrich Obrist and Rirkrit Tiravanija, she has curated *Utopia Station*, an ongoing book, exhibition, seminar, website, and street project.

MARINA WARNER is professor in the Department of Literature, Film, and Theatre Studies at University of Essex, as well as Distinguished Visiting Professor of Literature at New York University Abu Dhabi. She is coeditor, with Philip F. Kennedy, of the anthology *Scheherazade's Children: Global Encounters with the Arabian Nights* (New York University Press, 2013), and author of, most recently, *Stranger Magic: Charmed States and the Arabian Nights* (Chatto & Windus, 2011) and *Phantasmagoria: Spirit Visions, Metaphors, and Media into the Twenty-first Century* (Oxford University Press, 2006). Her novels include *The Leto Bundle* (Chatto & Windus, 2001) and *Indigo* (Chatto & Windus, 1992).

Photo Credits